PRAISE FOR *POWER AND MAJESTY*

"Of all of Africa's charismatic wildlife it is perhaps the elephant that stirs the most passion. A decade of poaching has reduced the population by a third, but there are still reasons to be optimistic for this unique animal's future. This timely and beautiful book by Larry Laverty – through thoughtful text and stunning images – shows just why the elephant is cherished by so many and why that deep affection may just be what saves it."
DR TIM DAVENPORT, Director, Species Conservation (Africa), Wildlife Conservation Society (WCS)

"This book is upsettingly good. It is deeply moving as Larry Laverty makes you think hard about who these extraordinary individuals and families are. The photographs are extraordinary, each and every one. Each frame inspires, and each left me hard pressed to move on to the next, imbuing me with memories of times on another continent when I was a child and spent time with a captive elephant who never knew such a life."
INGRID NEWKIRK, Co-Founder and President, People for the Ethical Treatment of Animals (PETA)

"I'm always thrilled when I meet people who love elephants like I do. When I first met Larry, I could tell he is deeply in love with elephants and his perfect photos show this. Even if you know nothing about elephants, this book will help you understand their lives, and I am sure that you will come to love them as Larry does and I do."
NORAH NJIRAINI, Research Assistant, Amboseli Trust for Elephants, Kenya

"I am so encouraged by the way Larry Laverty explains elephants and humans and their similarities. In this day and age, we need to focus on what makes us the same not what sets us apart. Humans and animals have lived together side by side for centuries and we need to relearn tolerance for them and for each other. Larry's photos share a very important message of how we are all connected."
KATIE ROWE, Founder and Manager, Reteti Elephant Sanctuary, Kenya

"Larry Laverty's wildlife photos are exquisite, capturing the full spirit of elephants and other species in their natural habitats. His intent that these photos inspire viewers to do more to protect this precious living splendor is noble and compelling. I very much hope that people who see these wonderful pictures will indeed respond the way Laverty seeks."
DR BILL CLARK, INTERPOL Wildlife Crimes Group Chairman; Kenya Wildlife Service (KWS) Honorary Warden; Animal Welfare Institute; International Wildlife Program Specialist

"Larry Laverty's stunning photography captures the very essence of wild living animals, inspiring awe and respect for the breathtakingly beautiful beings whom we share our planet with."
CAROL BUCKLEY, Founder, Elephant Aid International

"Wilderness areas such as Tsavo truly benefit from conservationists such as Larry Laverty, whose remarkable photos of Tsavo's Big Tusker elephants will help to attract visitors and to raise awareness and support for conserving Tsavo's wildlife, especially the few remaining Big Tuskers. Tsavo Trust hopes this book inspires those who already care about elephants to do more and awakens the hearts of those who still are unaware."
RICHARD MOLLER, Co-Founder and Chief Executive Officer, Tsavo Trust, Kenya

"Larry Laverty is a compassionate and caring human being who expresses his unconditional love for nonhumans using his extraordinary photography. Every single image as seen through the lens of his heart reflects authenticity, creativity, purity and sacredness. His images instill reverence for nature and wildlife and inspire people to conserve and protect."
SANGITA IYER, Biologist; award-winning journalist and filmmaker; Producer and Director of *Gods in Shackles*

"A man with a special heart for elephants, Larry Laverty is a happy Lion King from the urban jungle on a mission to save the mighty jungle elephant. I congratulate Larry for his great mission to save the elephant from extinction."
DAVID OLE MOONKA, Maasai Senior Elder, Tanzania; Manager, Osupuko Lodge

DEDICATION

I dedicate this book to our natural world and to the elephants who inhabit it with such majesty, to my parents, Gordon and Marjorie Laverty, who taught me love and empathy, and to my uncle, Bruce Laverty, who gave me the gift of unconditional respect and in the end made this book and my efforts to save Africa's elephants possible.

NOTE: The captioning of locations has been excluded so as to respect the security of the elephants pictured.

Published by
LID Publishing Inc.
524 Broadway, 11th Floor, Suite 08-120,
New York, NY 10012, US

The Record Hall, Studio 204,
16-16a Baldwins Gardens,
London EC1N 7RJ, UK

info@lidpublishing.com
www.lidpublishing.com

A member of:

BPR
Business Publishers Roundtable

www.businesspublishersroundtable.com

Printed in China through Globalink, LLC.
ISBN: 978-0-9991871-4-2

Cover and page design: Caroline Li

LARRY LAVERTY

POWER AND MAJESTY

THE PLIGHT AND PRESERVATION OF THE AFRICAN ELEPHANT

LONDON NEW YORK SHANGHAI
MADRID BARCELONA BOGOTA
MEXICO CITY MONTERREY BUENOS AIRES

CONTENTS

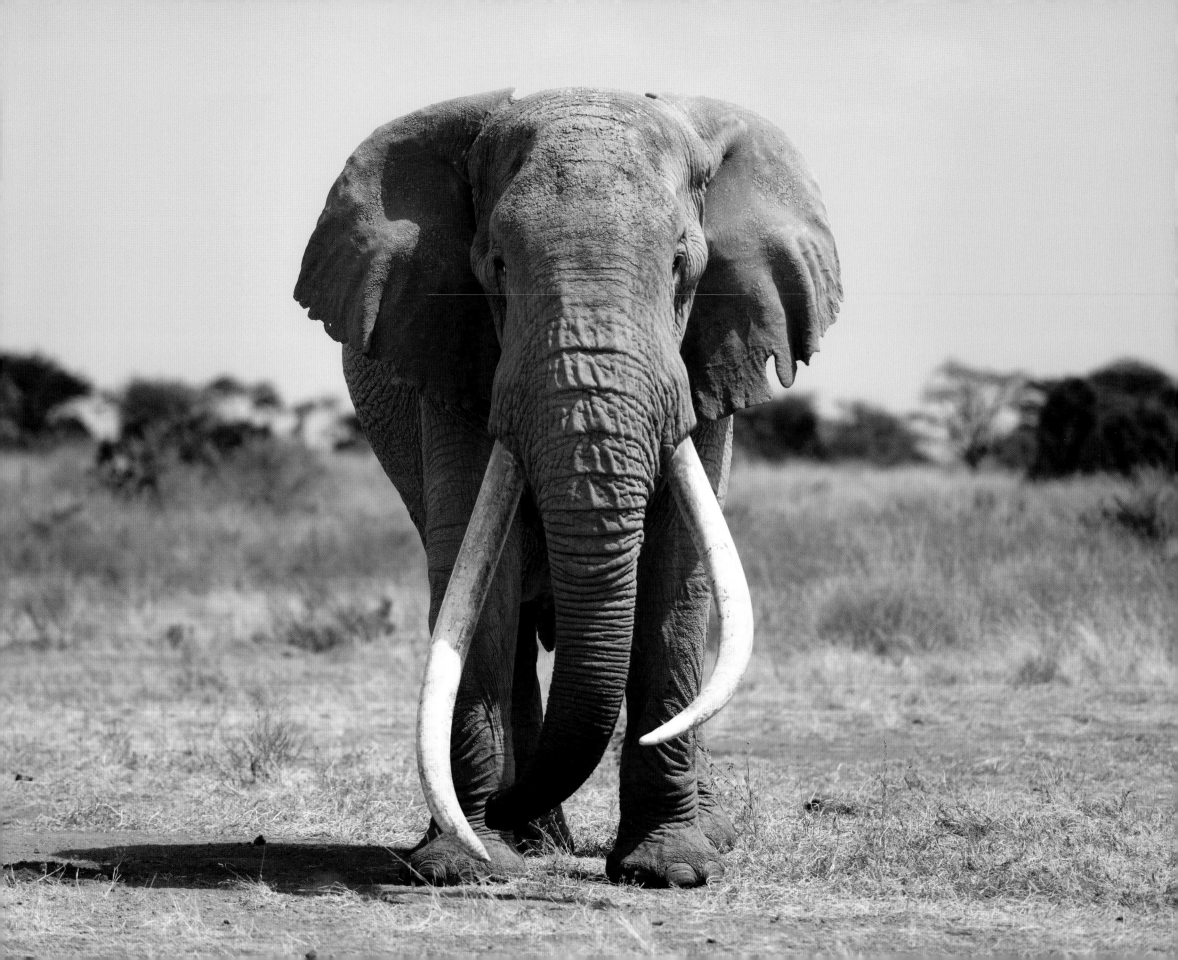

ACKNOWLEDGMENTS

Dating back to my earliest childhood memories, I have always felt a bond and a preference for our natural world. As my life unfolded, conservation organizations caught my interest and individuals came forward to support my pursuits. As an 11-year-old boy, I joined the Sierra Club and the Audubon Society. In 1997, my passion and concern for the iconic buffalo who live in and around America's Yellowstone Park met with the founding of the conservation group Buffalo Field Campaign by Mike Mease and Rosalie Little Thunder. I still support their efforts to this day. But it was in 2013 when a sequence of events cemented my passion for wildlife conservation, and I embarked on a path of action.

My first-grade teacher and lifelong friend, Elfie Larkin, had followed her teaching career with a 20-year career as a docent at the nearby Oakland Zoo. In 2013, the zoo published an endorsement of the first Global March for Elephants in San Francisco. Never having protested a darn thing in my life, I marched and met the organizer and friend of elephants Lois Olmstead. Consumed by the horrific injustice committed against harmless beings, I educated myself, becoming an outspoken activist on ending the ivory trade and improving the lives of elephants held in captivity. My voice then drew the attention of Jen Samuel, founder of the conservation group Elephants DC. "Would I come to Washington D.C. to speak?" she asked. Feeling wholly unqualified, I respectfully declined and proceeded to book my first visit to Africa to learn about the realities of elephants in the wild along with the ivory trade.

This juncture is where my story took a pivotal turn. I was determined that if I was going to travel to the opposite side of the earth, I was going to photograph the adventure. Returning to photography after a 20-year hiatus, I upgraded my equipment and recorded all I saw. Utilizing social media, I shared the images, and before long enjoyed an enthusiastic following of thousands of elephant lovers around the world. It is to each and every one of you caring, generous, people who appreciated how I saw the world of elephants that I owe the inspiration for this book. Your encouragement in both the fight for the elephants and in the effort required to create this photographic collection spur me on today.

Once the scope of the book became clear, still more trips were required to ever more remote destinations in Africa. The logistics of booking transport and lodging fell to my trusty travel agency, The Wild Source, headed by wildlife biologist Bill Given. His assistants Darcie Carr, Annie Garner and Shannon Gore each patiently dealt with weeks of modifications as each trip's itinerary fell into place.

On the ground in Africa, a host of knowledgeable drivers, guides and camp staff ensured that I got to join the elephants each day. Their names could fill a page and to each I am forever indebted. Among them, Francois Gowaseb of Ultimate Safaris gave all he had to ensure that I located Namibia's rare and elusive

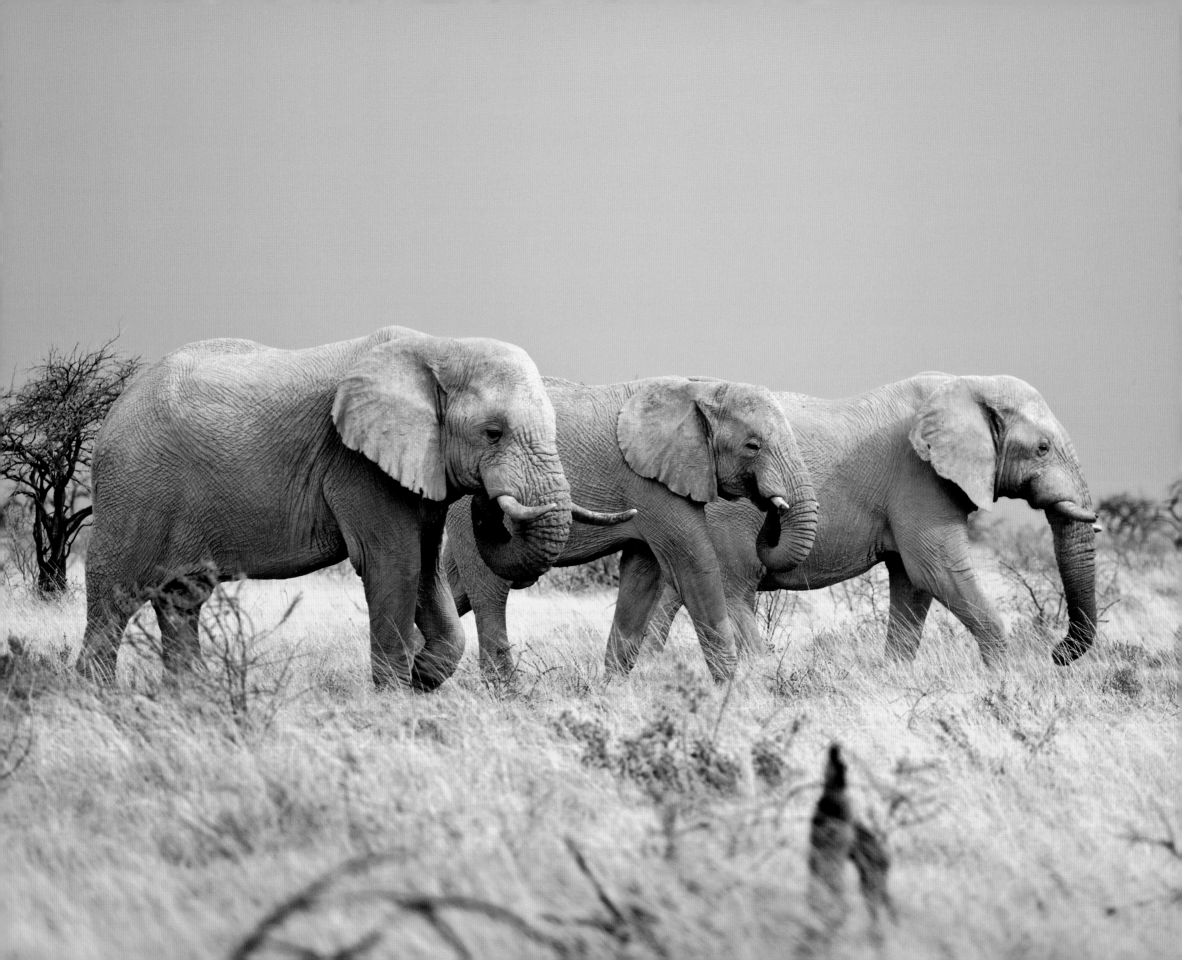

"One of Jane's [Goodall] great accomplishments was showing us that chimpanzees are individuals with distinct personalities of their own ... Cynthia [Moss] was doing the same for elephants I now realize. I was no longer seeing blocks of gray flesh but individual animals who were capable of thinking and had histories and family ties."

RICHARD LEAKEY
Anthropologist and conservationist; Director, National Museum of Kenya;
Director, Kenya Wildlife Service

desert-adapted elephants, day after day. In Kenya, Daniel Tipape David of Great Plains Conservation's Ol Donyo Lodge threw caution to the wind during my efforts to photograph some of Africa's few remaining tuskers. The rainy season had come in earnest just the day before I arrived. Precipitation figures already surpassed the seasonal average and went on to be the highest in over 20 years. The result was widespread flooding that nearly isolated the remote camp and the rain kept coming. As my time there was running out, I turned my attention toward locating Tim, the elephant with the largest set of tusks in the world. Tipape slept on the decision to venture out. Before dawn, we went for it, braving roads that had turned to rivers and grasslands that had turned to swamps. With the guidance of conservation group Big Life Foundation, we found Tim, photographed him for several hours and affected the lifesaving rescue of one of his mates, Ulysses, who had been wounded by a spear. In the end, our vehicle had become stuck in the deep mud, over the axels, three separate times. We were soaked and soiled, and had exhausted ourselves in the excavation efforts. Two rescue vehicles themselves became stuck, and still the rain came, but the mission was a success.

In addition to the assistance provided by Big Life Foundation's Richard Bonham, Nikki Best and Jeremy Goss among others, I owe gratitude for logistical assistance to Tsavo Trust's founder Richard Moller and his crew, Amboseli Trust for Elephants' Norah Njiraini, David Sheldrick Wildlife Trust's Edwin Lusichi and pioneering forest elephant scientist Andrea Turkalo.

I took strength each day of the project inspired by the exploits and conversations shared with fellow photographers Billy Dodson and Marc Mol. And as I set out on each trip, I set standards of photography for myself inspired by the craft's most successful wildlife photographer, Thomas Mangelsen.

Once I had all the images I needed in hand, I turned to my longtime friend, creative director Janet Petros, for her

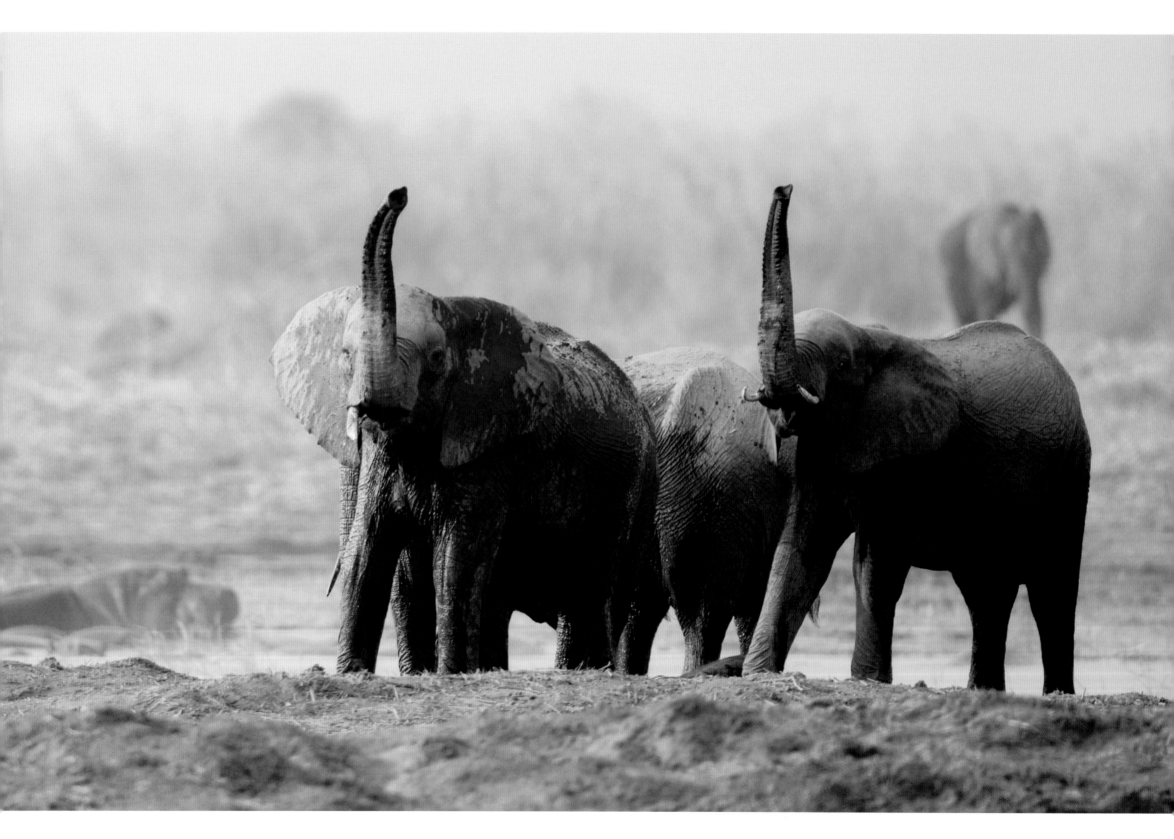

"It is not a very hard thing to go off into the wilderness and kill an elephant, or a white rhino, or a reticulated giraffe, or giant eland, but it is a very hard thing to get good photographs of them ... Really, I would be ashamed of myself sometimes, for I felt as if I was having all the fun. I would kill the rhinoceros or whatever it was and then they [his assistants] would go out and do the solid, hard work of preparing it."

THEODORE ROOSEVELT
Upon completion of The Smithsonian-Roosevelt
African Expedition, 1910

meticulous assistance in polishing up each and every photograph.

The search for a publisher for someone new to the world of books was just as challenging as engineering the trips to Africa and consumed more than a year. Along the way, I turned to high-powered literary agent and author Peter Beren. He in turn introduced me to the publisher of this book, London-based LID Publishing. For turning my dream into a reality I'll always be grateful to editorial director Sara Taheri, project editor Susan Furber, art director Caroline Li and communications manager Marion Bernstein among others.

And finally, I'm so very grateful to my sister, Annette Laverty, who supported me along every step, including cheerful drives to and from the airport for each trip; to my dear friend, marketing guru Leeann Alameda who provided invaluable commentary on the manuscript and patiently guided me through numerous challenges on the computer; to creative director Iain Morris for his enthusiastic talent and encouragement; and to longtime friend and art director Ron Pereira for his encouragement and marketing contributions.

I joined the worldwide effort to save the surviving elephants of Africa fairly late in the game. For a variety of reasons, I simply did not realize what was taking place in Africa and at every outlet around the world where ivory was sold. For millions of elephants and their families, the global effort came too late. At the end of my life, I know now for certain that my reflection will not be filled with celebration of my accomplishments in sports, in the entertainment industry, or of the mountains I've climbed. My final look back will be filled with wishing I could have done more on behalf of the wise and gentle giants of this earth, the elephants.

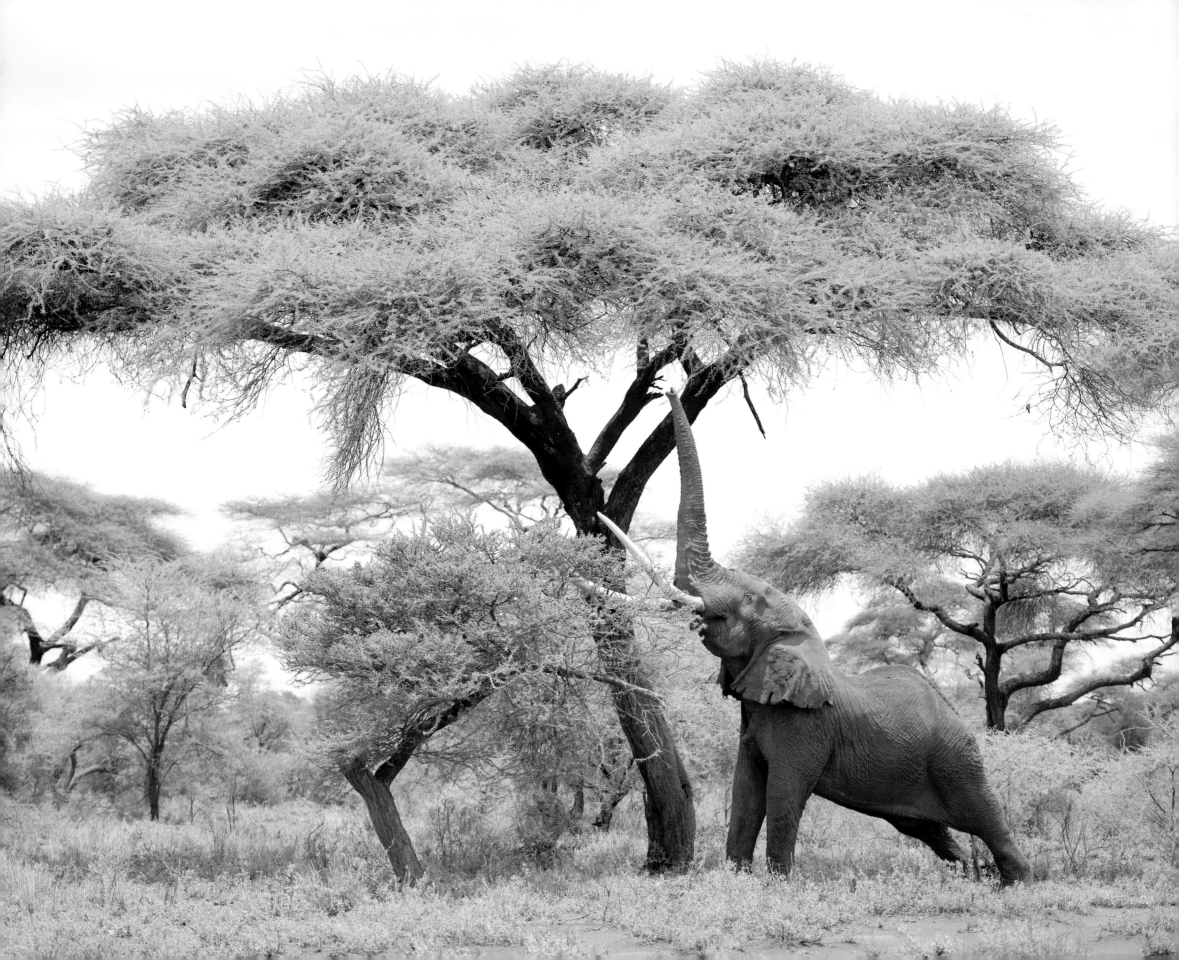

INTRODUCTION

Over the spellbinding expanse of land, from the Mediterranean Sea in the north to the Cape of Good Hope in the south, more than 20 million elephants lived at one time across the continent of Africa. From the Atlantic Ocean in the west to the Indian Ocean in the east, elephants flourished, alongside all wildlife species of those days, days when the landscape was in a healthy balance. The years went by and trails were etched into the surface of the earth as elephants migrated from one place to the next looking for food and water, following the same routes century after century. So great was the demand for both commodities that movement was constant and the paths they travelled wore deeper and deeper. Like a modern-day highway map, the network of elephant trails in many places in Africa persists to this day and segments can be seen from high in the earth's atmosphere. Even though heartless human beings have subsequently killed off 95% of Africa's elephants for sport and for ivory, many of the paths of migration were still in use in the year I came into this world.

During the 100 years prior to my birth, Africa had been carved up and carried away, primarily to the nations of Europe. As the harvest grew, these same nations laid claim to vast portions of the continent, creating new nations, several bearing the names of the conquistador's countries of origin such as the Belgian Congo, Dutch South Africa, French Guyana, German South-West Africa and Portuguese East Africa. Even before the period of colonization, the Chinese and the Arabs had made inroads into north and east Africa. Then, following the European rush, the United States joined in the exploitation. Slaves captured in the interior, bound for the Western world, were forced to carry ivory tusks on their way out to the coast. Live elephants and other iconic wildlife, once unknown to the outside world, were captured and shipped away to appear as curiosities in zoos and circuses in far-off lands.

In my childhood home, like so many of my generation, I grew up playing the piano; a piano equipped with keys of ivory. At a friend's home, I played pool on a pool table sporting perfectly round ivory balls. I'd visit relatives who had sculptures and figurines on display in their living rooms, even combs in the water closet, all made of ivory. Other relatives had fancy serving utensils with ivory handles. My family would occasionally meet friends at local Chinese restaurants, where lobbies and walls would be decorated with vast collections of ivory art, right down to the chopsticks on the table. Meanwhile, my family – like most American families – would rush down to the circus when it came to town each year, cheering the loudest as the elephants entered the big top. At one small, mum-and-pops travelling circus, I rode wide-eyed on the back of a little baby elephant. And there were regular trips, school field trips, to the local zoo with the highlight being the big, grey, gentle giants with

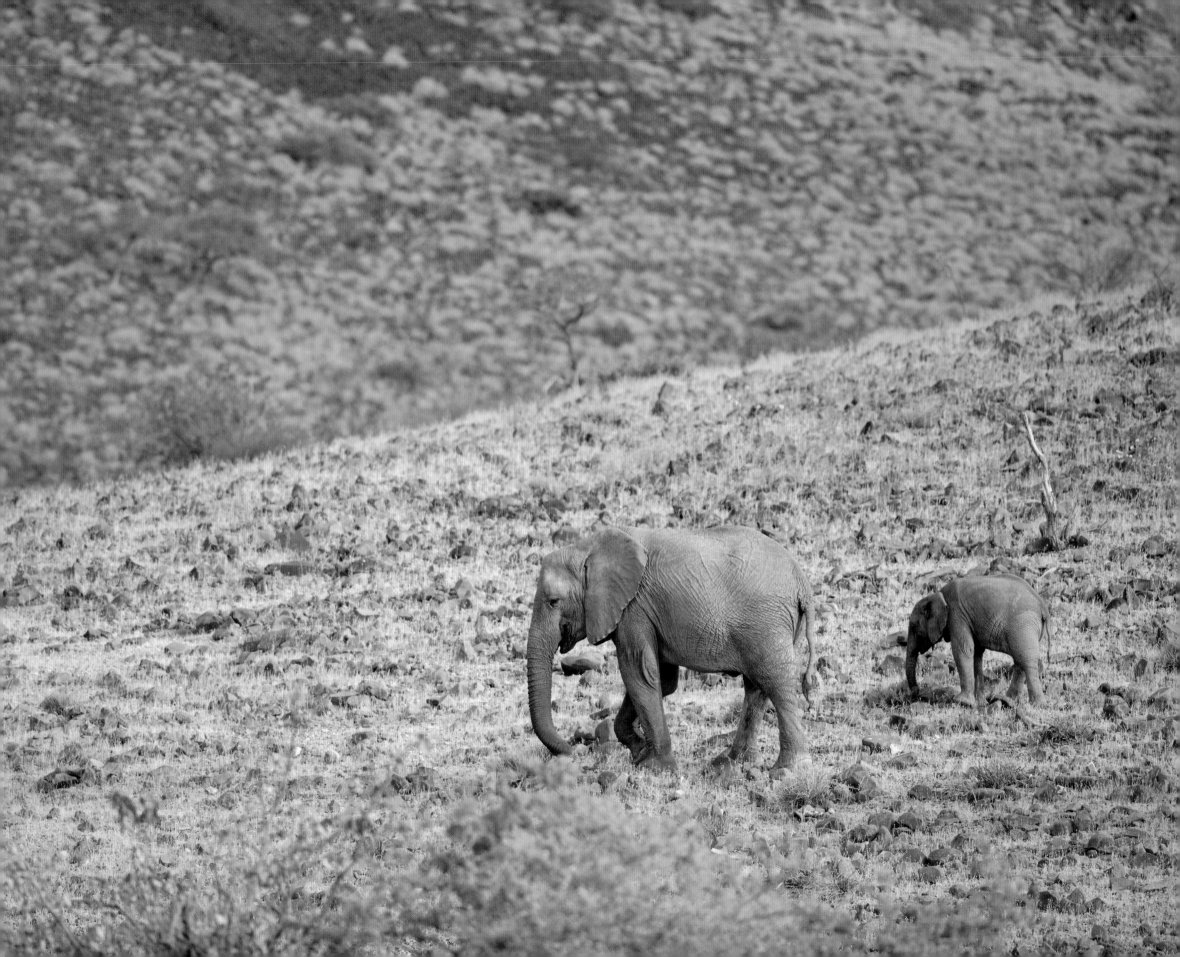

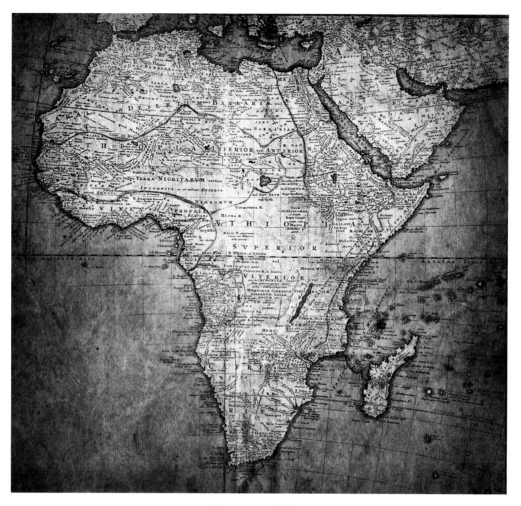
Vintage map of Africa

the big ears and long trunks. Such was the world I was born into.

But I've always enjoyed and cared deeply for the non-human beings we share this earth with. As a young boy, I remember running as fast as I could to follow butterflies just to see where they went. I joined conservation organizations such as the Sierra Club and the Audubon Society at the age of 11. I've rescued wayward dogs from death on freeways. I've made countless financial contributions towards wildlife conservation and domestic animal welfare organizations. And I've lamented the slow but sure annihilation of wildlife habitats around the world by the growing population of man. All along though, my attention was dominated by excelling in a career, pursuing various hobbies and having my share of good times with friends.

While the days of my life were passing by with selfish aspirations and entertainment, half of all life forms on the earth had become extinct since the time of my birth. Meanwhile, mankind's population had more than doubled, bringing environmental destruction on a massive scale. It was in this context that one day, as I was going about my daily routine, I came across an article in the newspaper announcing the local zoo's endorsement of an event called 'The Global March for Elephants'. To this day – I can't fully explain why – but on the first Saturday of October 2013, I travelled to San Francisco to take part in this march and my life changed forever.

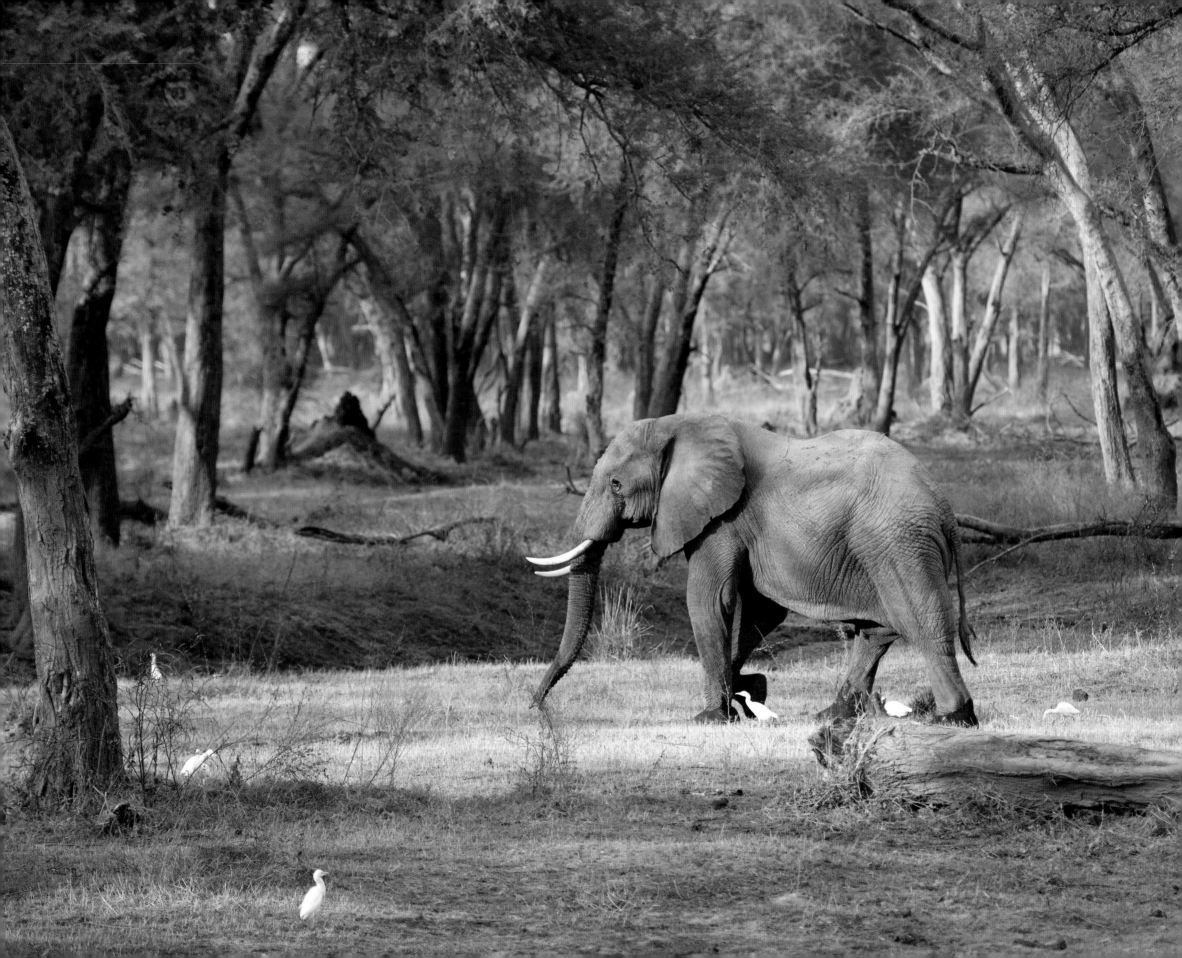

Zambia. One of the results of elephant poaching and human-elephant conflict is orphaned babies. Several elephant orphanages have been created on the continent to save as many orphans as possible. Just outside Zambia's capital of Lusaka are the facilities of the Elephant Orphanage Project. Game Rangers International and several other organizations run the operation. Once the babies brought here are deemed able, they're transferred to a facility in Kafue National Park where they begin a transition back to life in the wild.

It was the first time I'd protested for or against anything in this world and it was also the first time in the history of mankind that such a march, on a global scale, had been organized on behalf of another species. The elephant.

Day by day, what had mattered most to me for so many years began to fade away. My career, my hobbies, my social calendar, all faded in importance, replaced by a passionate dedication to right the endless wrongs brought by humanity upon the world's elephants. I set out to study all the science I could find about them. I began making numerous trips to Africa to spend time with them, observing, studying and photographing. Today, based on all I've observed, I hold them in greater regard than a good portion of the human race. Their abilities to love, to remember, to function as families and to survive under some of earth's harshest conditions provide the human race with examples to aspire to.

Since 2013, I've travelled to ten African nations in search of elephants and have spent months and months of my life out in the wilds with them. I learned that they live in every type of ecosystem found on the continent and I've ventured into each of these distinct places, from swamps to deserts. The images you're about to see draw from the three classifications of elephants in Africa: the savanna elephant species, the forest elephant species and the desert-adapted savanna elephants. Through the following collection of photographs and accompanying observations, I hope that you too will be uplifted to appreciate elephants more fully and be inspired to do all you can to join in the global effort to save them from the evils of this world. For in my eyes, their welfare is as critical as our own. If we can't save the world's remaining elephants, earth's largest living land being, we stand little hope of saving ourselves from ourselves as our human population continues to grow without restraint.

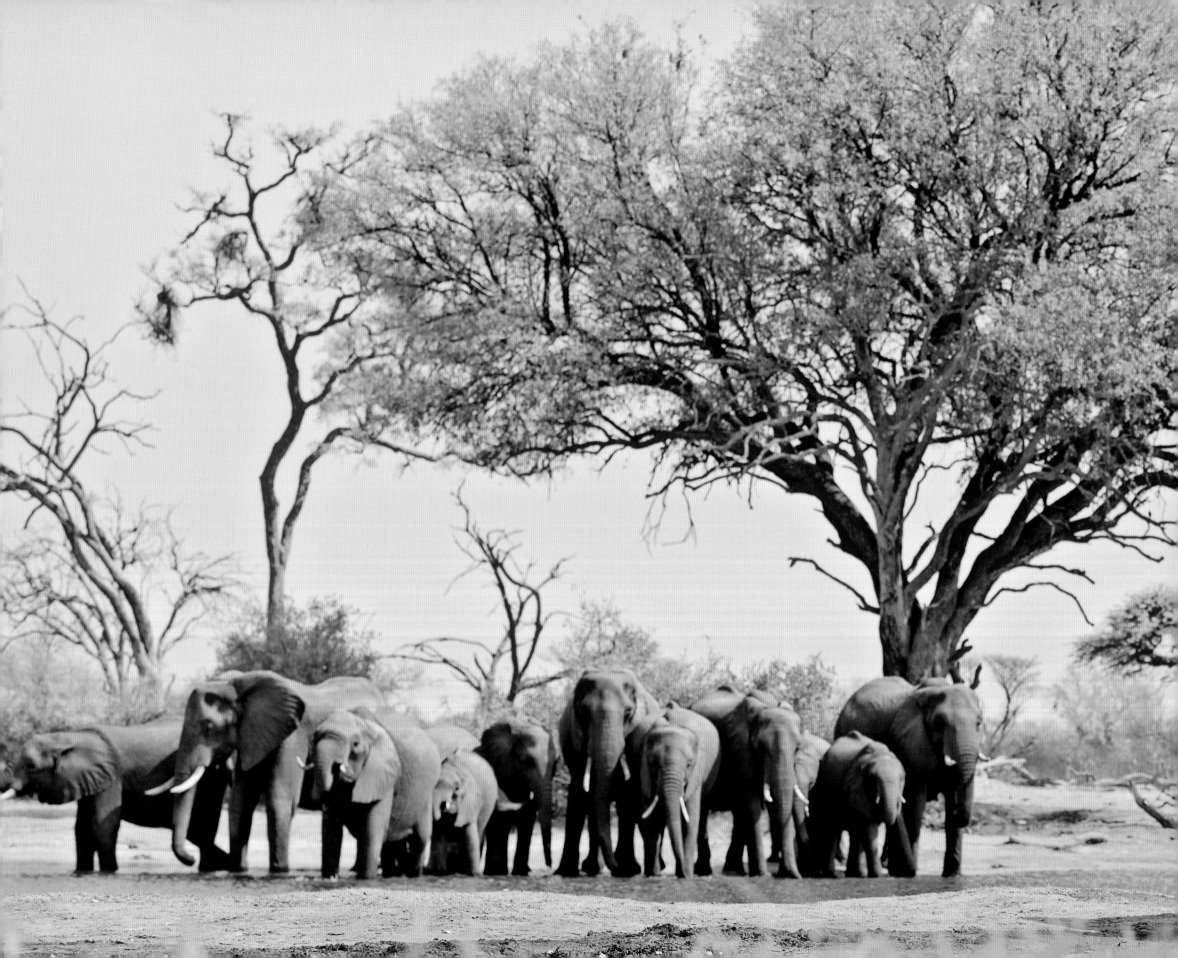

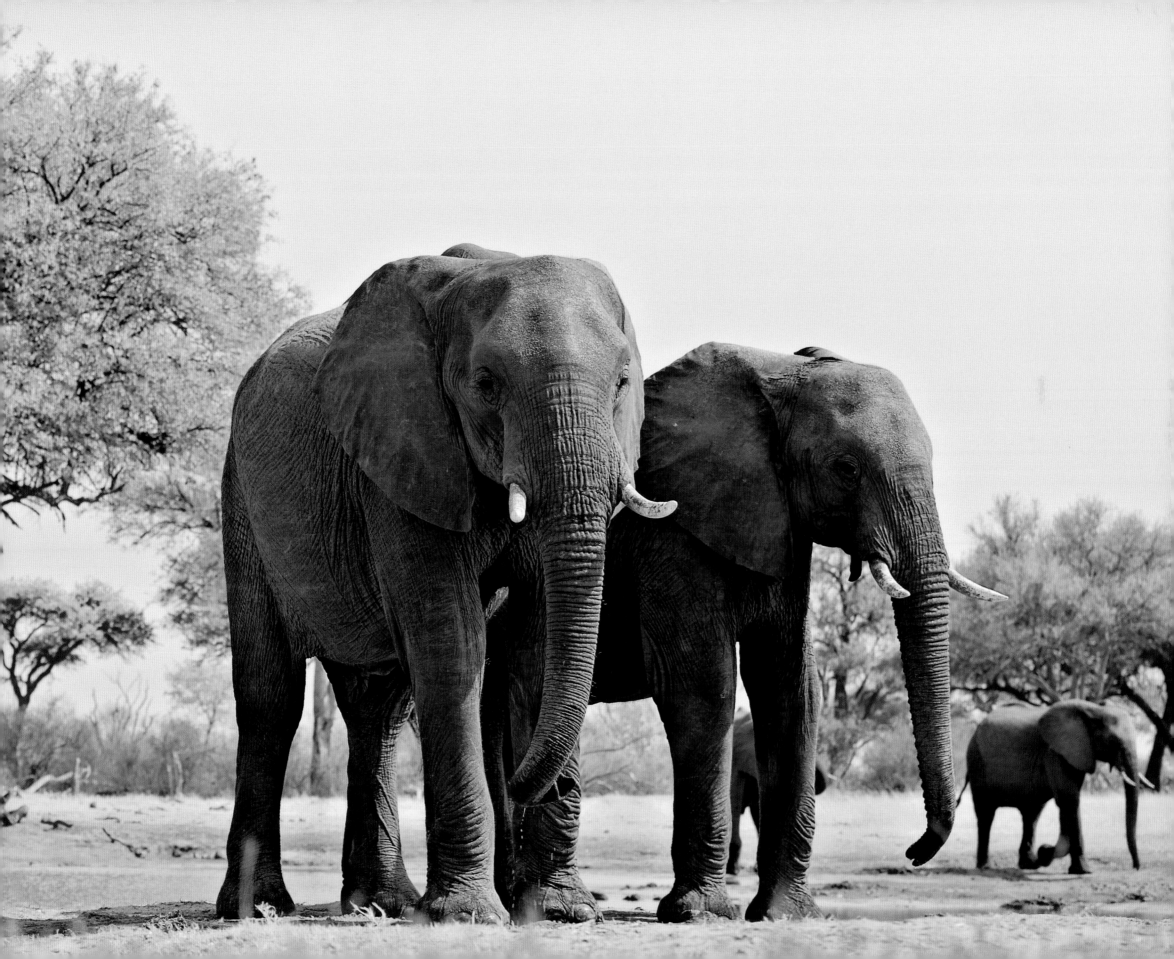

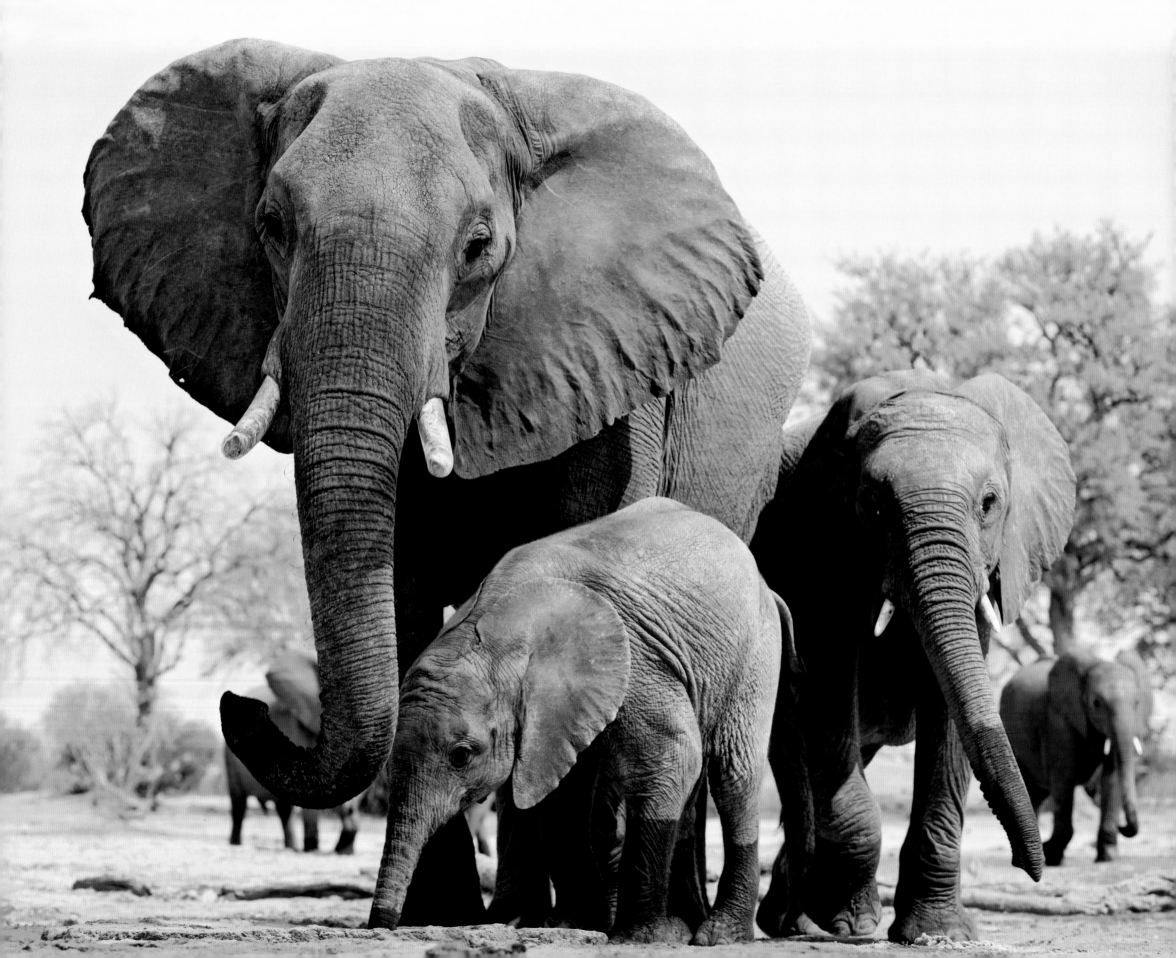

LASAYEN

By the year 1840, several European nations had established trading posts along the coast of Africa. Strong economic and political rivalries among these nations spurred still more interest in the fertile continent and by 1870, 10% of Africa was under the control of European interests. As competition and growth in Europe continued, so too did the so-called 'Scramble for Africa'. Formalized at a 14-nation conference in Germany held in 1885, the consumption of Africa was in full swing. By 1915, roughly 90% of the continent was controlled by seven European nations. As part of Britain's strategic efforts to maximize its acquisitions, the Uganda Railway Project was begun at the port city of Mombasa in 1896. The railroad pushed deep into the interior of Africa; its destination, the shores of Lake Victoria in Uganda with nearly 700 miles of railroad as the goal. In 1899, halfway to the proposed terminus, a supply depot was built in an uninhabited swampy area. Near this depot was a watering hole known by the local Maasai people as Enkare Nairobi.

While the railway pushed on, the little watering hole of Nairobi bore witness to an explosion of human development and population that continues unrestrained to this day. At first, the area south of the growing community was appreciated by the colonists as a wild area where Maasai tribesmen lived and tended their cattle among a habitat of iconic wild animals. But, as the human population grew, predictable conflicts with the wildlife increased. The first six men buried at the brand-new cemetery had been killed by lions. It's been recorded that many residents began routinely carrying guns in case of an encounter with the big cats. Meanwhile, the more respectable folks complained of giraffes and zebras trampling their flower beds. Fed up with a passing family of zebras running through town, an individual shot and killed a female zebra right in front of the Episcopal church. The years passed while farming and ranching pushed the remaining wildlife away. One man, who had been born in Nairobi, lamented the loss of the area's wildness. This one man, Mervyn Cowie, single-handedly led a campaign to set aside a piece of the last remaining local wild land and in 1946 Nairobi National Park was born, with Mervyn Cowie as its first director.

Nairobi National Park today is an improbable wildlife reserve, struggling to exist within the city limits of metropolitan Nairobi and within easy sight of the city's high-rise buildings. Here though, in 1963, the David Sheldrick Wildlife Trust opened a sanctuary for orphaned elephants and other vulnerable animals. To this day, and from all over Kenya, the little elephant survivors arrive, some having witnessed their mothers and family members brutally killed by poachers, others having become separated from their families as the result of difficulties navigating the increasingly human-dominated landscape.

My first participation with the David Sheldrick Wildlife Trust was through

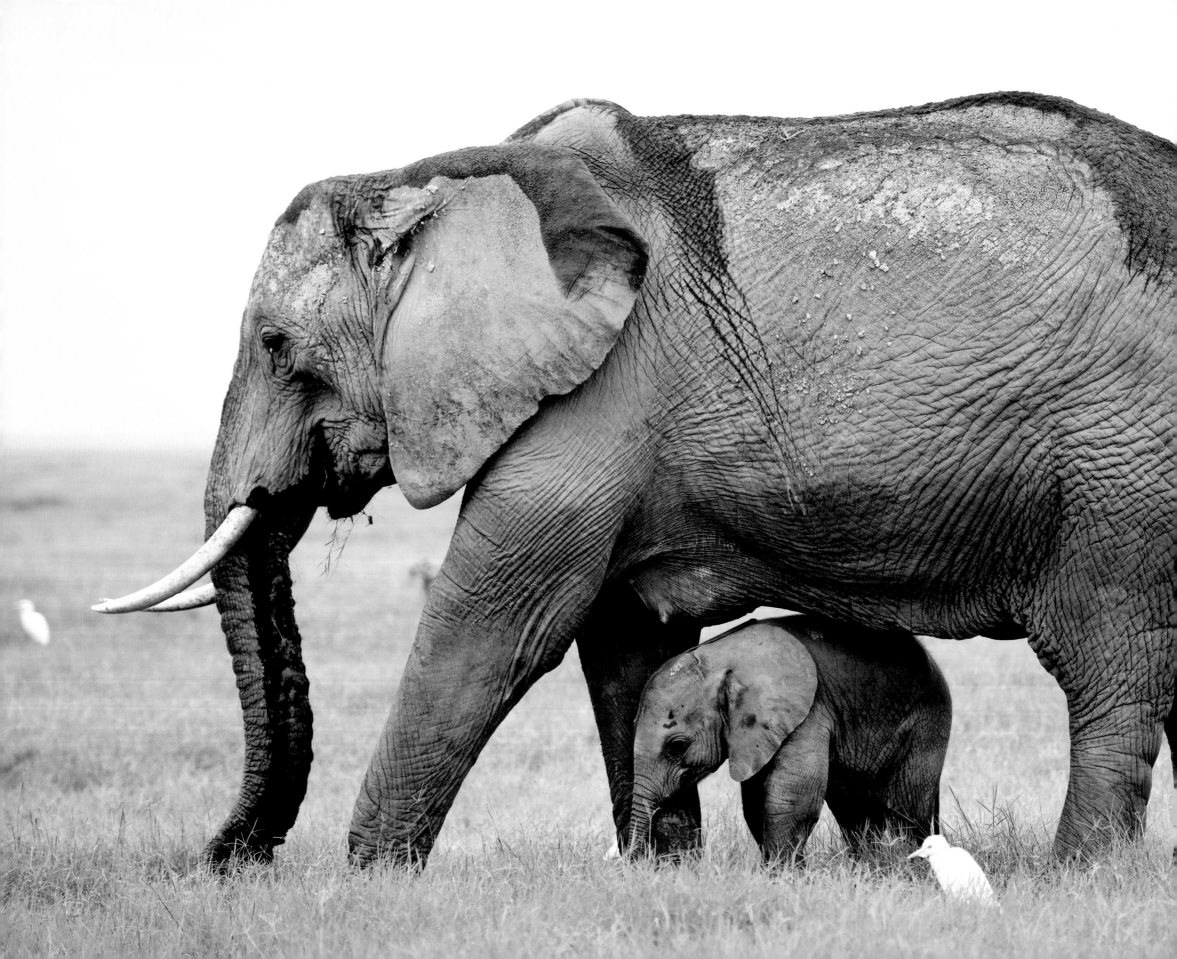

their orphan fostering program. The first little orphan I chose to support was called Lasayen. By doing so, I joined many other people from around the world who donated financially to make the work at the orphanage possible, for Lasayen and for many others. Lasayen had been found trapped in a well, one month old, his family nowhere to be seen. Flown to Nairobi under intensive care from the Samburu region north of Nairobi, no one knew if the little elephant would survive. When I saw him in person, eight months had passed since his rescue and he still appeared extremely fragile. Today, he's several years old and an active member of the elephant nursery's community. He'll never have a normal elephant's life and the future of his species is uncertain. But thanks to the Sheldrick family, financial donors around the world and the heroic men in green who work with the little ones at the orphanage, Lasayen is alive today and may one day get a second chance to live in the wilds that he so briefly experienced as an infant.

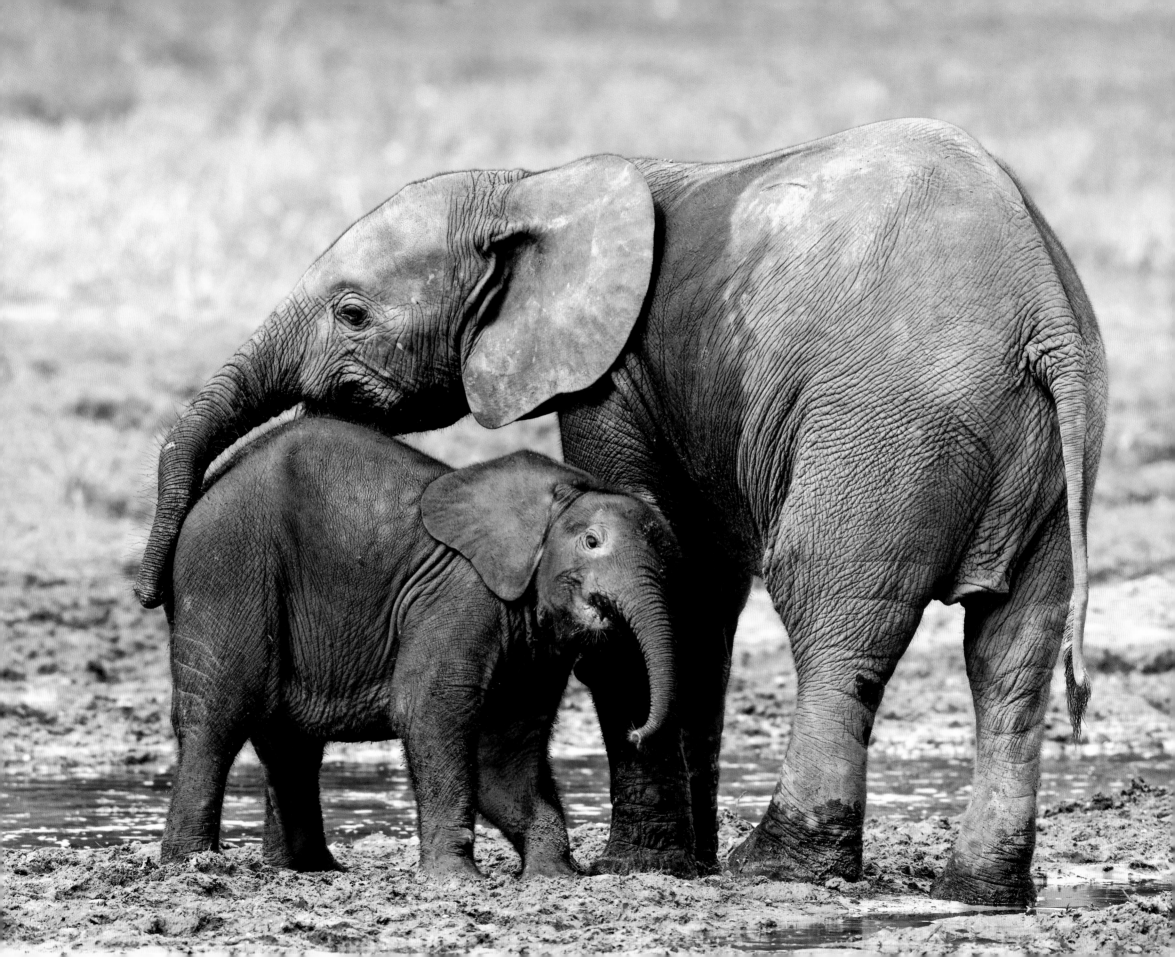

"If you are neutral in situations of injustice, you have chosen the side of the oppressor. If an elephant has its foot on the tail of a mouse and you say that you are neutral, the mouse will not appreciate your neutrality."

DESMOND TUTU
South African Anglican Priest and human rights activist

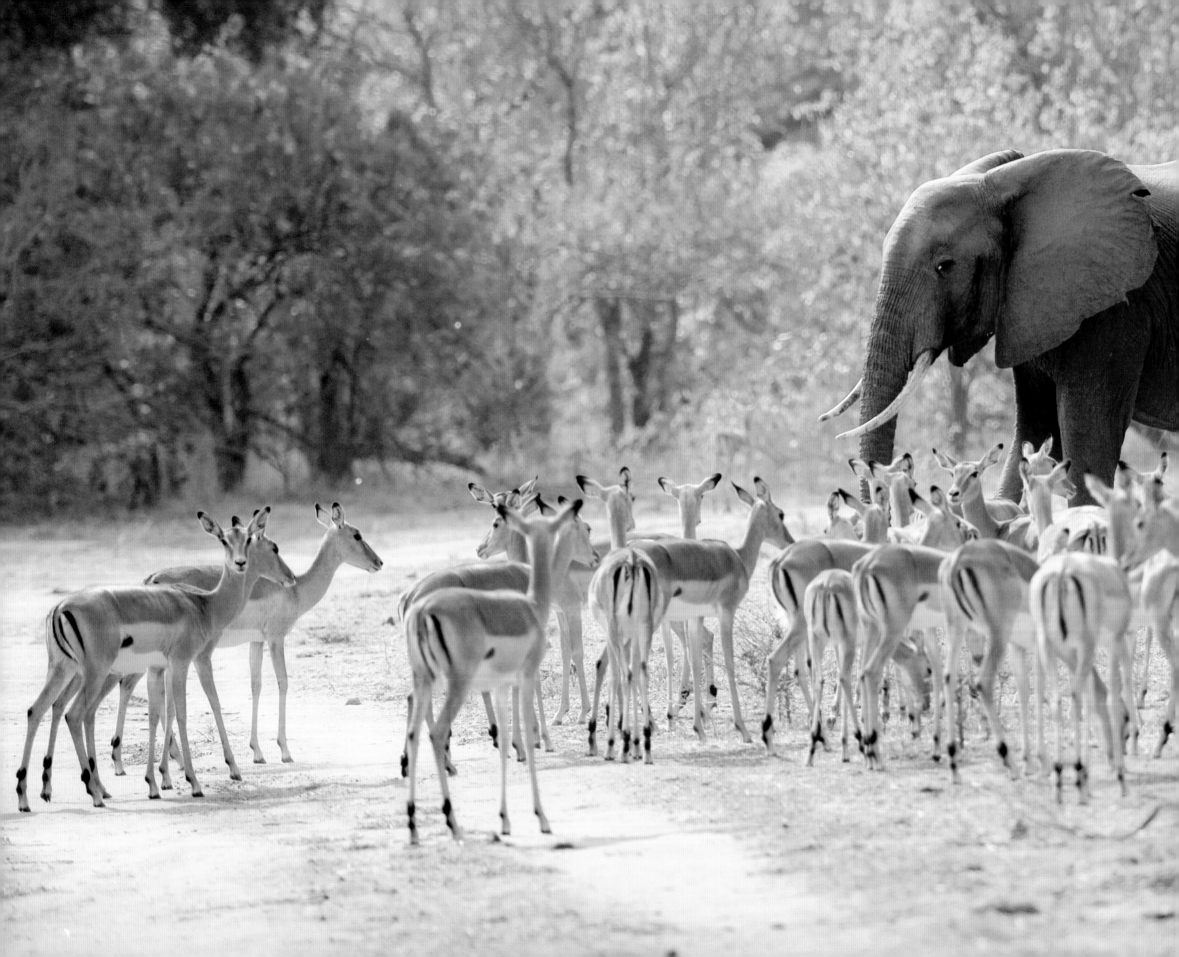

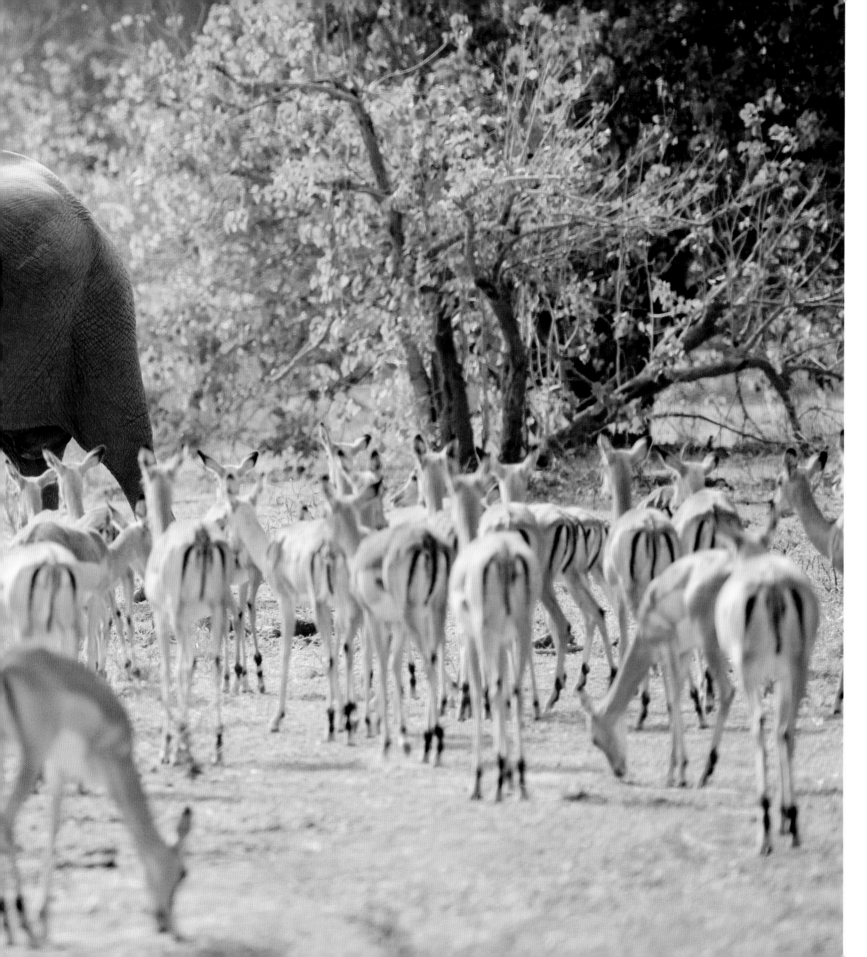

The largest elephant ever known to mankind was discovered in Angola. He enjoyed the company of other bachelors, thriving in a fertile landscape. His height reached 13 feet, 2 inches, and he was just over 27 feet long and weighed roughly 12 tons. In November of 1955, mortally wounded, then chased for over three miles, his life was cut short by a white hunter from Spain. For the past 60 years, his remains have greeted six million visitors annually from his forever-home in the rotunda of the Smithsonian Museum of Natural History in Washington, D.C.

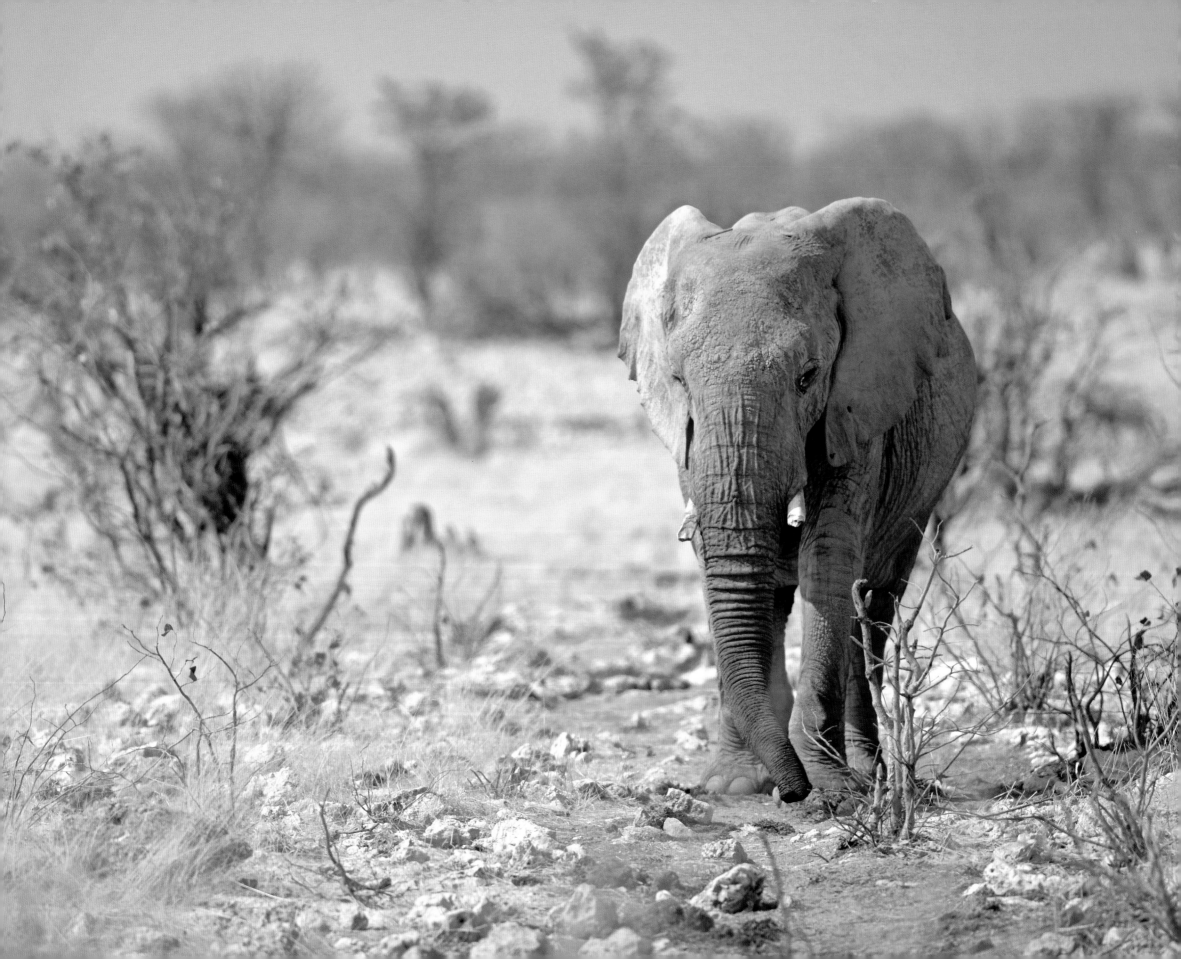

MOUNTAIN BULL

Family is everything to elephants. So much so that females will generally stay with their birth families – their mother, their aunts, their sisters, their nieces, their daughters, their granddaughters – for the entirety of their lives. Males, on the other hand, live quite differently. Once into the early teenage years of puberty, males will separate themselves both voluntarily and with urging from their birth families. In the great wisdom of nature and in the best interest of the gene pool, males wander off to begin a life of solitude that often leads to bonding with other adult males in bachelor groups, punctuated with periods of breeding with ready females. The shock of living on their own for males is at first tempered by occasionally joining up with other family groups or by wandering from family to family. Over the landscape of Africa, the presence of these wandering bull elephants is a touching sight in our knowledge that they, as all elephants, have an extreme appreciation of family.

Perhaps the most powerful driver in mature male elephants to roam the landscape is a hormonal cycle that overcomes them once each year. For those in their late 20s, the period will last just a week, for those in their late 40s the period can last several months. The impetus for the movement is extremely high levels of testosterone that generate an urgent need to find ready females to breed with. Known as musth, the dynamics of bachelor groups change frequently as members enter and exit the cycle and individuals meanwhile are inspired to move off for their impassioned searches.

The routes by which all elephants migrate across the continent of Africa in search of breeding partners, food and water are often well-warn footpaths carved into the earth by centuries of use. As gracefully and efficiently as elephants walk, these paths tend to be only 15-20 inches wide and to view the older ones is to catch a glimpse of the history of the elephant in Africa. At times, I've come upon those that are several inches deep, even wearing down through solid rock. Given the number of these paths throughout the continent to various destinations, an elephant is not guaranteed a reward for simply following one. Among the many wondrous qualities of elephants is their ability to remember, to store information about things such as the route of their footpaths in their minds. Like the use of a road map, elephants pass the knowledge of their migration routes from generation to generation.

An elephant's freedom to roam over all of Africa, as needed, using these routes of migration would have likely continued until the end of time were it not for the proliferation of a certain animal who has also occupied the African landscape: Mankind. Once humans from outside of Africa began their conquest of the continent, the accompanying changes destroyed the natural order of life. Roads were built. Fences were built. Railroads were built. Cities were built.

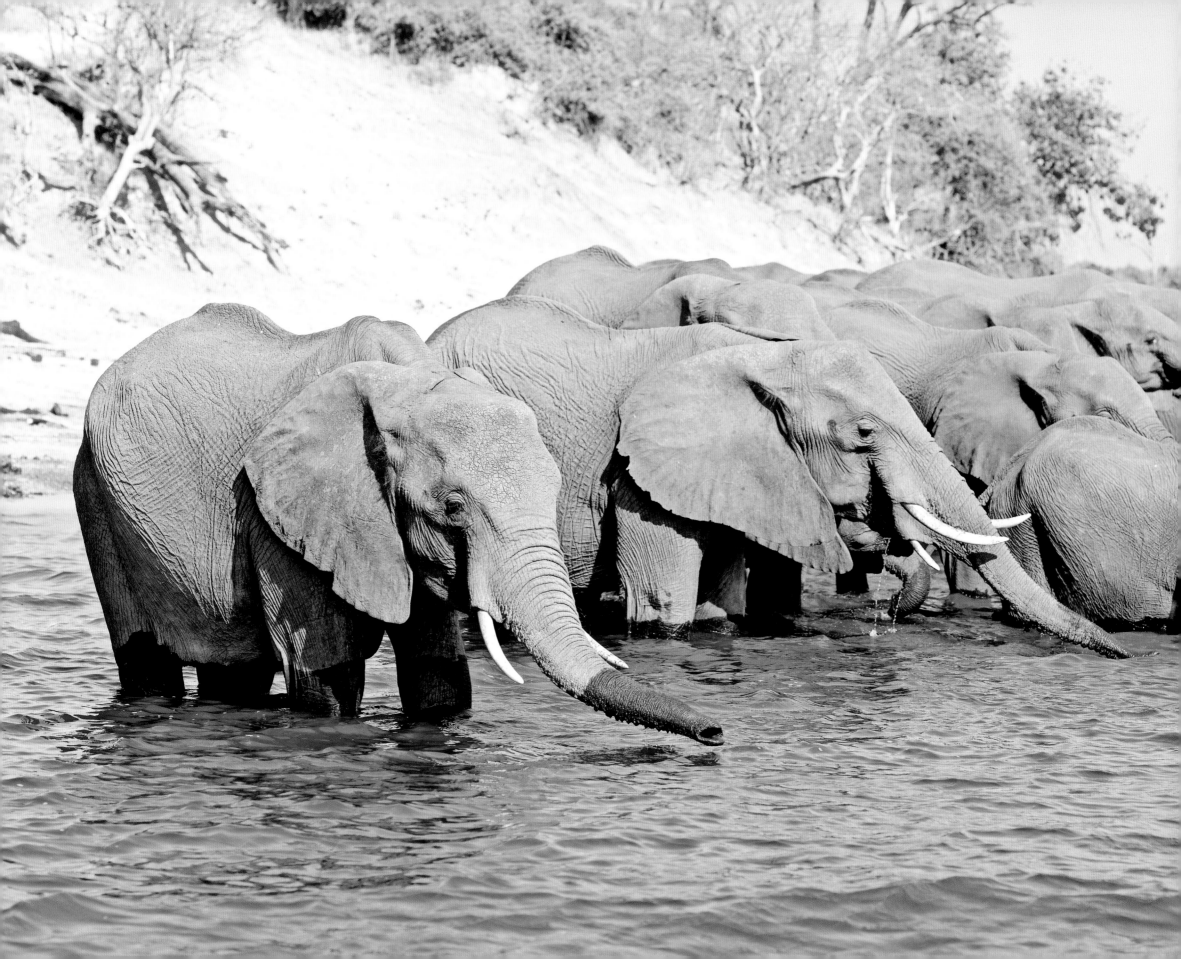

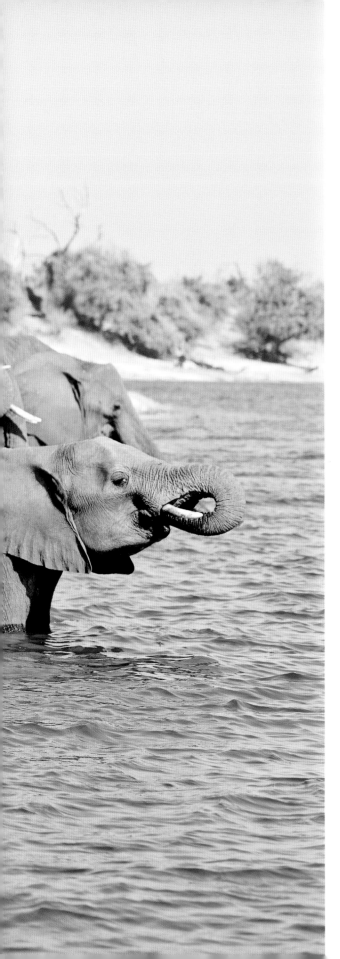

Botswana. This nation is home to Dr Mike Chase and the conservation group he founded, Elephants Without Borders. Mike conceived of and led the Great Elephant Census of 2015 that brought together numerous international scientists and state-of-the-art technology to determine the savanna elephant populations of 20 nations. In turn, the findings provided these nations and the world with a solid idea of just how few elephants are left alive in Africa today.

Native African child mortality was reduced by Western medicine, leading to rapid population growth. And, one by one, these human constructs began cutting off age-old migration routes used by elephants and other wildlife. Both male and female elephants were restricted to smaller and smaller ranges as the human population, both Western and native African, increased.

But in the nation of Kenya, in the year 1968, a male elephant was born who defied the new order – who asserted his right to roam freely as generations before him had. His name was Mountain Bull. From the days preceding his notoriety, he fed and watered during the dry season on the slopes of imposing Mount Kenya in the Kenyan national park of the same name. When the time came during the wet season, he would walk north to the Lewa Conservancy for his preferred food, water and companionship. Then, when he felt so moved, he'd make the return trip back to the slopes of Mount Kenya.

As Mountain Bull's life unfolded, the human population of Kenya grew rapidly. Wild areas along his migration route were ploughed under for agriculture. Fences were put up to contain livestock. Interactions between Mountain Bull and humans increased. And the main human road he had to cross became a highway, a major route linking Nairobi with the Ethiopian border.

By 2006, Mountain Bull had been recognized by scientists and tourists alike as a unique and iconic elephant, appreciated for his majestic demeanour and large tusks. During that same year, Iain Douglas-Hamilton's conservation group Save the Elephants placed a radio collar on Mountain Bull to get a better idea of his movements. In 2010, using data collected from Mountain Bull's recorded migrations, the Mount Kenya-Lewa Wildlife Conservancy Corridor Project was completed. Thanks to the joint efforts of the Mount Kenya Trust, the Lewa Wildlife Conservancy, the Kenya Wildlife Service, an additional

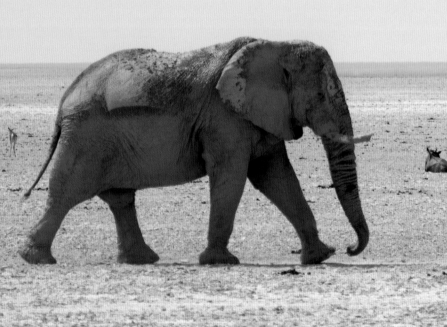

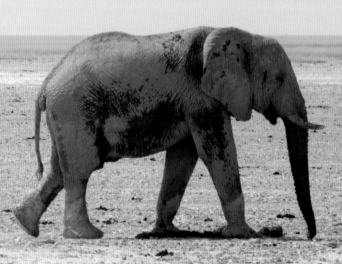

land trust and two farms, a corridor 28 kilometres long was established that enabled countless elephants, including Mountain Bull, to complete their migrations safely by minimizing their contact with humans.

By 2012, and despite the wildlife corridor, Mountain Bull had continued to plough through the growing number of fences placed in his way. He also began experiencing contact with the worst kind of humans, the kind that wanted to kill him for his handsome ivory tusks. Towards the end of that year, the Kenyan Wildlife Service, with the hope of saving both the fences and Mountain Bull,

darted him and sawed off most of his tusks. As if he understood the gravity of the situation and the humanity around him, he reportedly now kept within the protected lands and stayed away from conflict with local farmers.

While elephant migration routes have been blocked throughout Africa, altering the lives of elephants forever, this new migration corridor in Kenya can serve as a model for other wildlife conservation efforts to follow. The monitoring of Mountain Bull's movements via his radio collar continued into 2014, watched proudly by the good folks at the Lewa Conservancy. Then one day

in May of that same year, the monitor at headquarters indicated that Mountain Bull had stopped moving. Well within the border of the Mount Kenya National Park, rangers were dispatched to investigate. Following a brief search, Mountain Bull was located, lying on his side, his body covered with fresh spear wounds, the remaining stubs of his ivory tusks brutally removed. Upon further examination, the aged scars of six bullet holes were also found, leading investigators to wonder just how many prior attempts had been made to end Mountain Bull's migrations, to steal his beautiful tusks, and so bring an end to his majestic life.

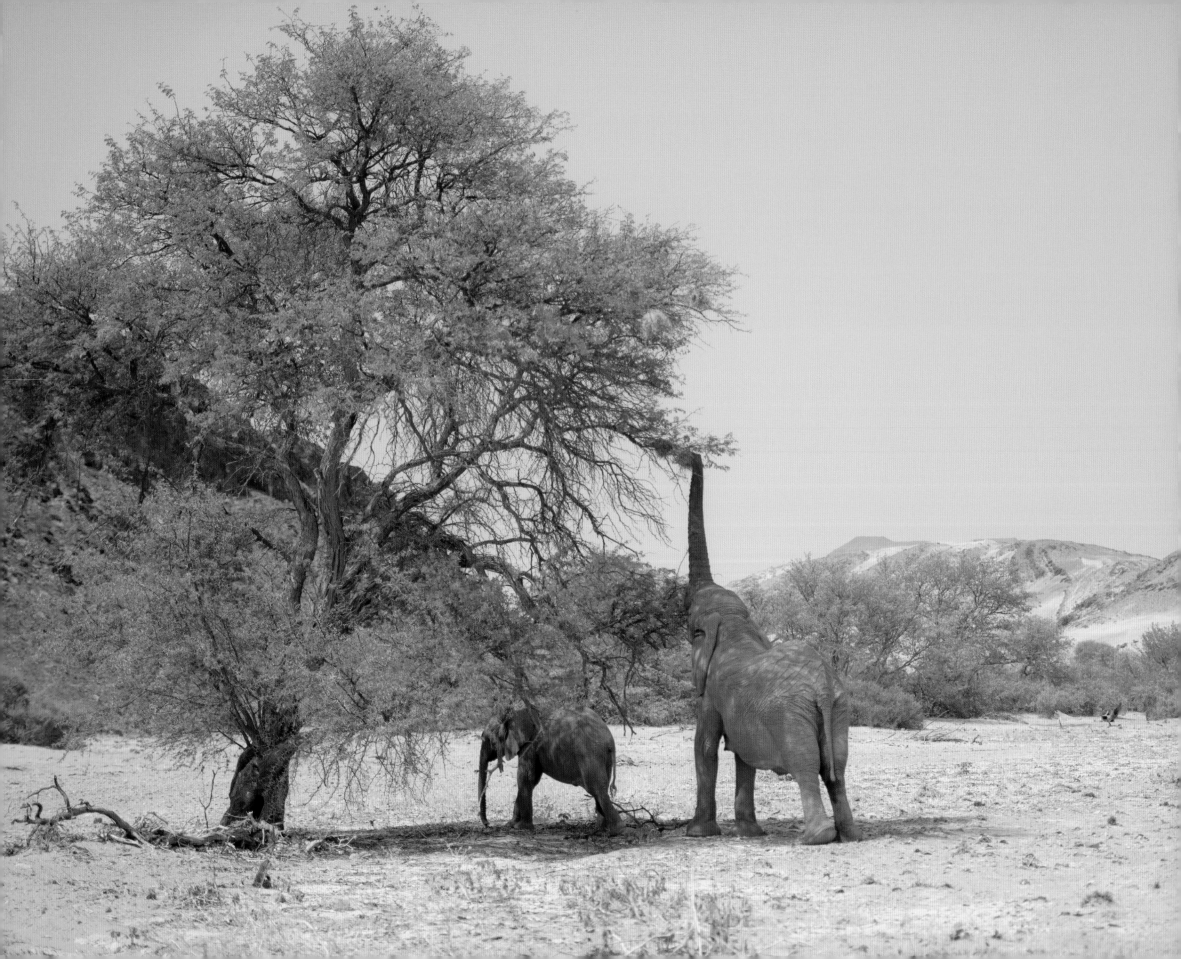

"At a gallery in Guangzhou, Gary Zeng shows me a photo of a 26-layer 'Devil's Work' ball on his iPhone. The 42-year-old Zeng has just bought two of these ivory balls from the Daxin Ivory Carving Factory, one for himself and one on behalf of an entrepreneur friend ... It will become a centerpiece in a new home Zeng is building, to 'Hold the house against devils.' ... I ask Zeng why young entrepreneurs like him are buying ivory. 'Value,' he replies, 'and art.' 'Do you think about the elephant?' I ask. 'Not at all,' he says."

BRYAN CHRISTY
"Ivory Worship," *National Geographic Magazine,* October 2012

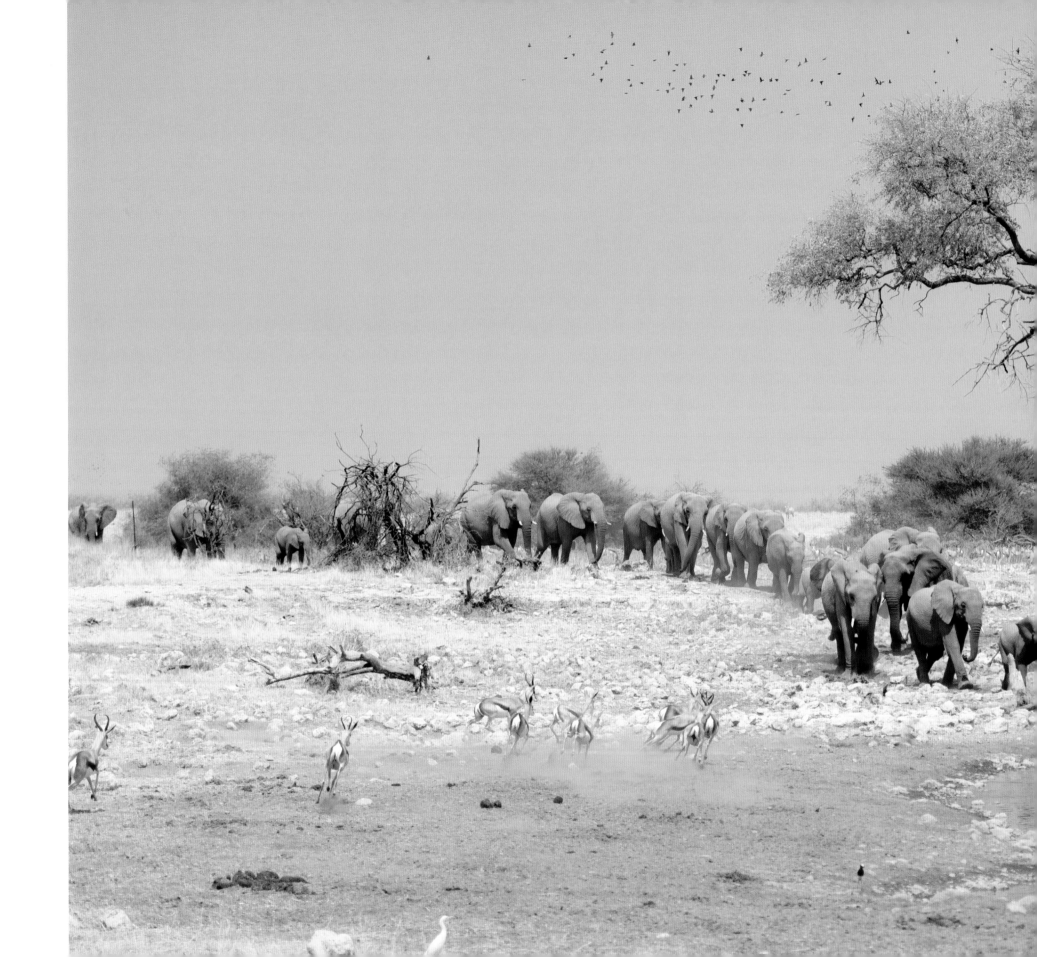

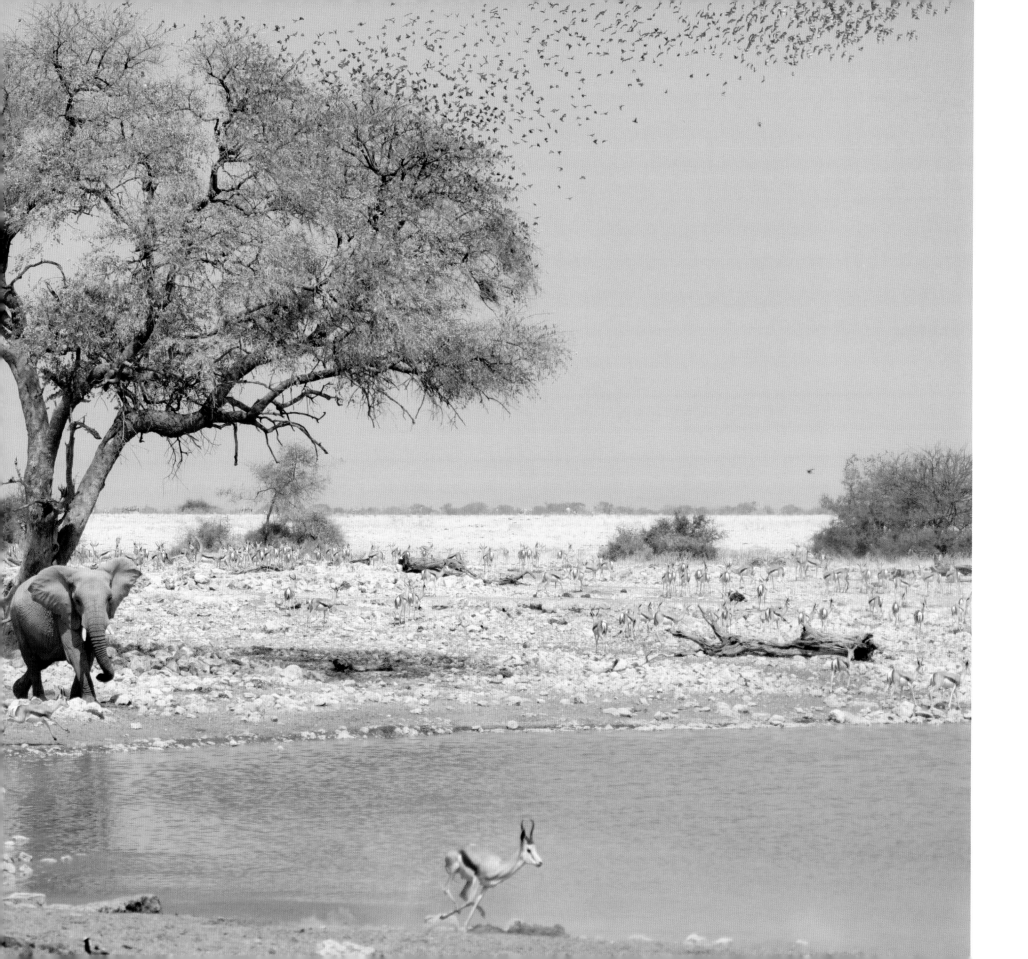

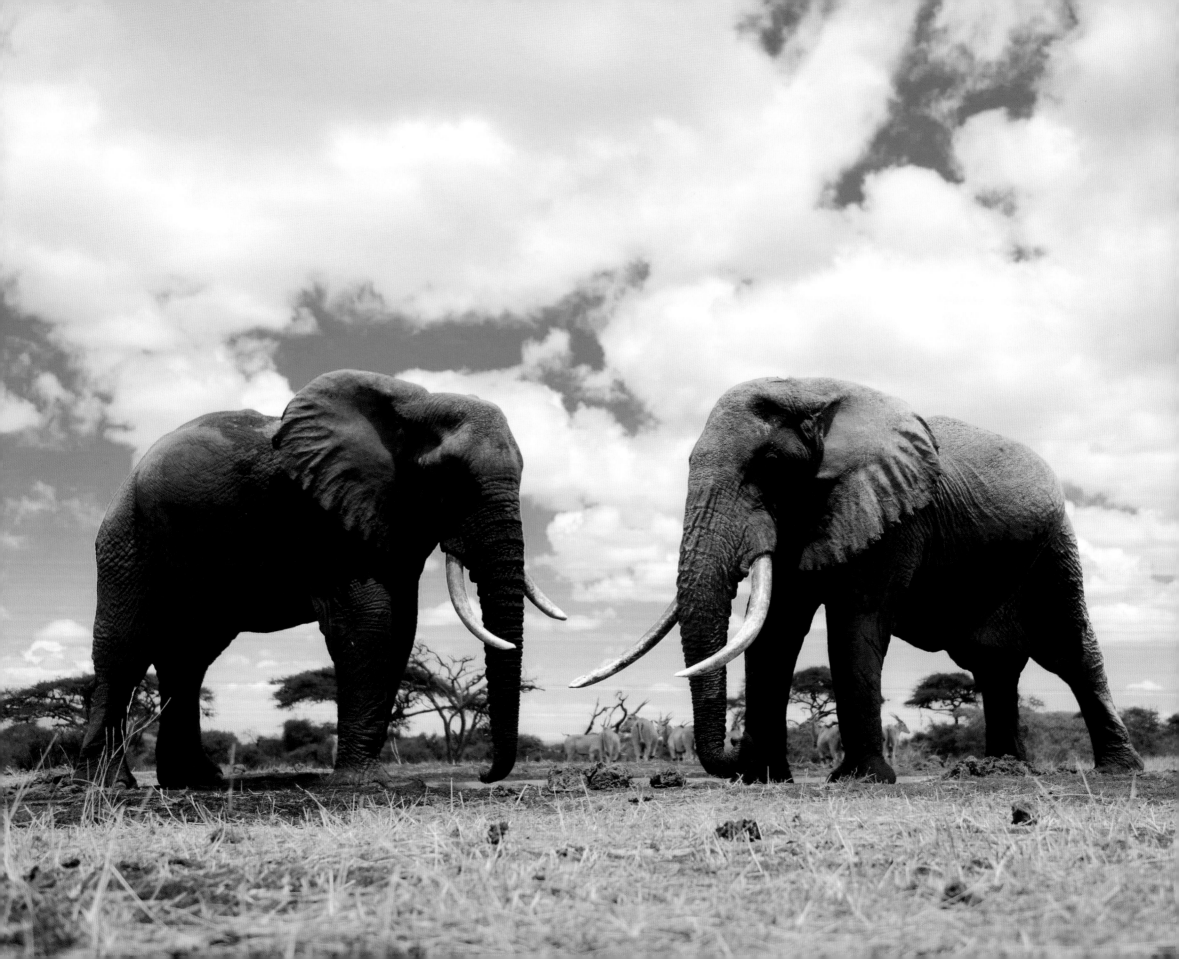

ECHO

From my explorations of Africa, several locations stand out when it comes to witnessing elephants. One such place is unique for its feeling that the earth is decidedly not round but most certainly is flat, and that, over the course of a day, time really can stand still. In this place, the elephants who live there enjoy relative ease of movement as they make their way around an ancient dried-up lake bed, swamps, savanna and dabs of woodland. In relative safety, elephants here tend to live out their full lifespans that average 60 to 70 years. In this place, family-groups average a healthy 15 members in size. Mothers can bring newborns into the world every three to five years, following their pregnancy that lasts 22 months. It was in this place that an elephant who was to become known around the world lived out her lifetime.

Echo was an elephant matriarch and had died of old age during a period of drought six years prior to my first arrival. Echo got her name from scientist Cynthia Moss of the Amboseli Trust for Elephants shortly after being fitted with a radio collar to follow her movements, her location indicated on the equipment by an echo sound. So significantly has the study of Echo and her family defined what we humans know about elephants, each time I visit this place I feel that somehow, somewhere, Echo is still alive and that many of the elephants I see seem so familiar. Thanks to the decades-long studies of Cynthia Moss and other scientists working alongside her, countless notes and books have been published and their efforts shared with the outside world in numerous documentary films.

For elephants around the world, it can't be stress enough that family is everything. The elephants of Africa live together in either bull groups, composed of bonded males from various families and generations, or in family groups, collections of females usually led by the oldest individual and including her closest female relatives, such as her sisters, her female children and her female grandchildren.

Peppered amongst these family groups are young males, under the age of 14 or so, born of the members of the group. The well-being and survival of each family group generally rests on the abilities of the oldest female, respectfully referred to by scientists as the matriarch.

Echo, as a matriarch, took over the responsibility for her family in 1968 at the age of 23, unusually young for assuming such duties. At that time, her family consisted of only seven elephants. By the year 2000, her family numbered 26, a testament to her exceptional abilities as a leader, ensuring her family's well-being through the ravages of droughts, health challenges and the daily search for food and water.

Watching respected matriarchs in action has left me fascinated on more than one occasion. Several times I've found myself surrounded by elephants going about their daily feeding. A tree branch snaps here, a shrub is uprooted there. Around 15 to 20 minutes, perhaps even half an hour will pass by,

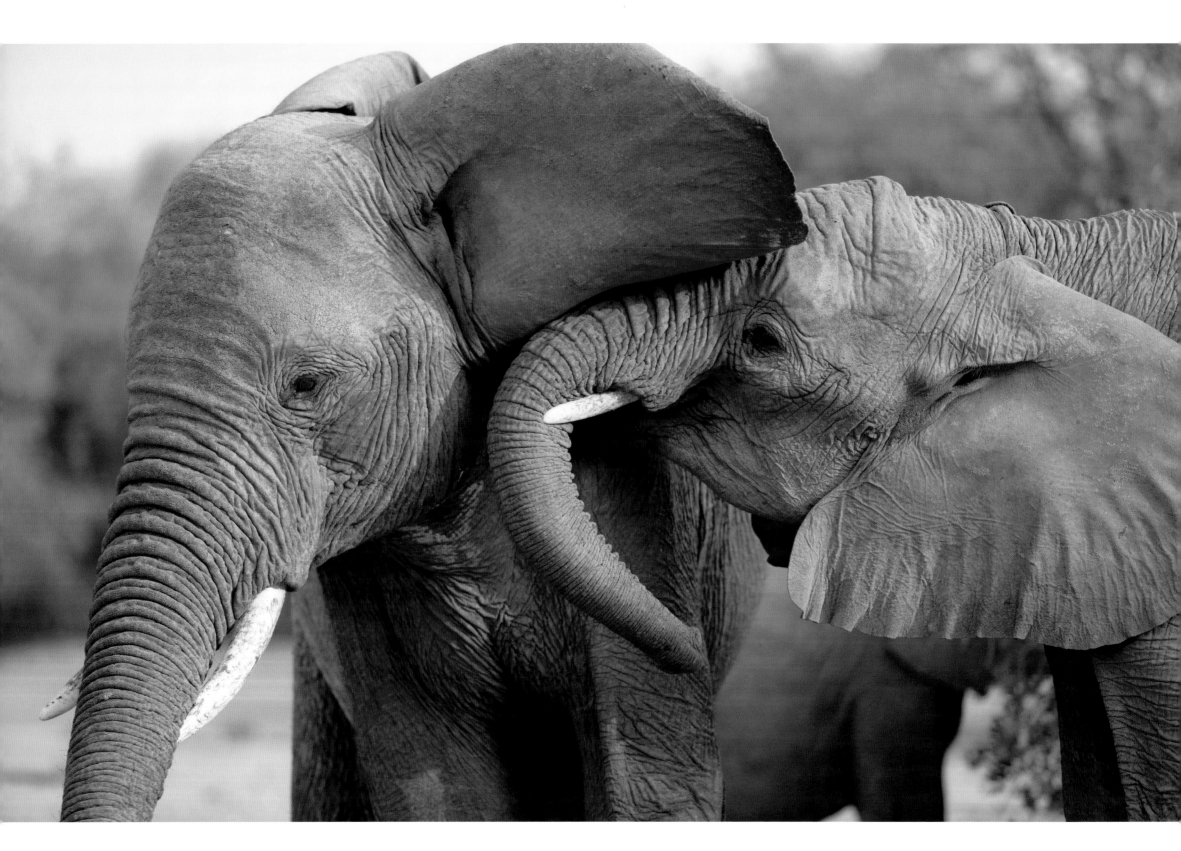

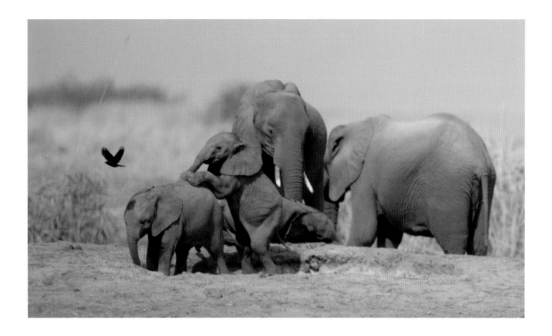

all of us co-existing in magical harmony. Then, all of a sudden, all feeding comes to an abrupt halt. As if rehearsed a thousand times, the family that just moments before had been so carefree becomes alert, closing ranks into a tight phalanx surrounding the babies and behind the matriarch. Then, all at once, the group marches off as if some great new purpose had been found or some threat was lurking nearby. Each time I've witnessed this, not a sound was made and yet it was clear that the matriarch had somehow communicated the marching orders with the entire family.

The roles of matriarchs like Echo are fulfilled largely through the unique communication abilities of elephants. While we humans depend heavily on the spoken word that travels through the air, elephants share thoughts and feelings with each other in communications that travel both through the air and in the ground. In the company of elephants in the wild, it's common to hear trumpeting sounds and rumbles, but what we humans can't perceive are the ultra-low frequency vocalizations that are transmitted from the feet of elephants into the ground, communications that can be exchanged with other elephants standing miles away. Pioneering studies of this incredible ability to communicate began in 1984 by Katy Payne who, in 1999, co-founded Cornell University's Elephant Listening Project with Andrea Turkalo. During this same time period, Caitlin O'Connell and two colleagues began their groundbreaking studies as well.

While Echo is no longer with us, many of her descendants are. Years ago, scientists like Cynthia Moss and Iain Douglas-Hamilton saw the humanness in elephants and chose to discard the numerical identification for elephants being studied in favour of giving them names. Wisely, each child born is given a name that begins with the same letter of the alphabet as the mother's name. So, thanks to the meticulous records kept by the scientists and observers of Amboseli's elephant population, we know every descendant of Echo, as well as the familial relationships among all the other elephants. We also know that there is wisdom in the structure of elephant groupings, where mature males focus on passing life skills to younger males and mature females focus on passing their skills to the younger females. And, we realize the invaluable contributions made to the advancement of the elephant species by the matriarchs, matriarchs like Echo.

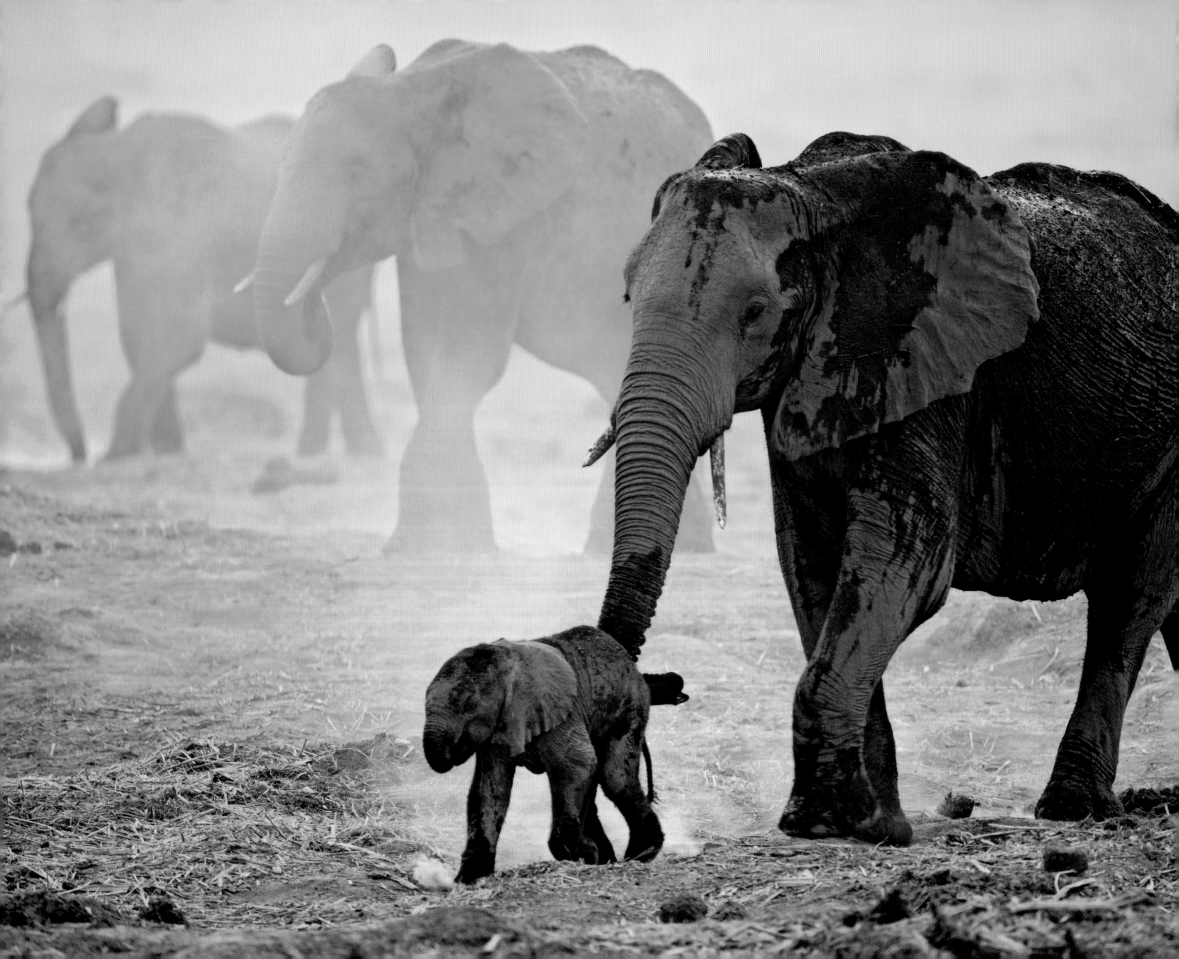

ANCIENT ANCESTRY

Turn, turn, turn. The world turns and the only thing constant is change. Our earth and everything on it is changing and ageing day by day. Thanks to the science of radiometric dating, we know that our earth is 4.5 billion years old. Through similar scientific processes we know that our species, beginning with the Homo group, began arising a good two million years ago and can be traced back to the first primate group that walked upright as far back as six million years ago. These ancient origins pale in comparison with the ancestry of the elephant; their first recorded relatives walked the earth over 58 million years ago!

Based on the latest science, it's widely believed that the birthplace of today's elephants those 58 million years ago was somewhere in North Africa's Sahara Desert. While this seems far-fetched today, scientists have determined that the Sahara Desert has gone through numerous cycles throughout its life, going back and forth between being a desert as it is today to being a savanna with pockets of lush vegetation and abundant water supply. Since the days of the origin of the elephants, the movement of the earth's tectonic plates, the rise and fall of oceans, the tilt of the earth on its axis and changes in climate have all altered the Sahara's landscape significantly. At several points throughout North Africa in recent years, fossils of ancient elephant ancestors have been found in rocks and soils that show evidence of rich vegetation that was even swamp-like in parts.

With a family history as old as the elephants possess, the look of the family tree has changed over the years. As a result, scientists have bestowed a lengthy list of names for the various ancestors and relatives who have entered the lineage along the way. Of all the scientific names given to beings with the defining trunk and tusks that characterize the elephant, one name represents the entire historical group, the Proboscidea. The first true proboscideans which evolved from amphibians tended to live near Africa's aquatic habitats of swamps and rivers. Always adapting to challenges posed by their habitats and the climate, over 300 species of proboscideans have lived over the centuries. While the earliest beings were only two to three feet tall, the order quickly evolved to their giant size. And as their populations grew, so too did the pressures on habitat to supply enough food for their giant bodies and large numbers to survive. As a result, they spread out from their origins to every corner of the African continent, then to northern Europe, to Asia and eventually to every continent except Australia. For a period of 20 million years, the proboscideans, this collection of many elephant species, populated the surface of the earth in great numbers.

Looking back, a number of defining events impacted the elephant family tree over the millennia. Approximately 16 million years ago, the evolution of the proboscideans had yielded most of what

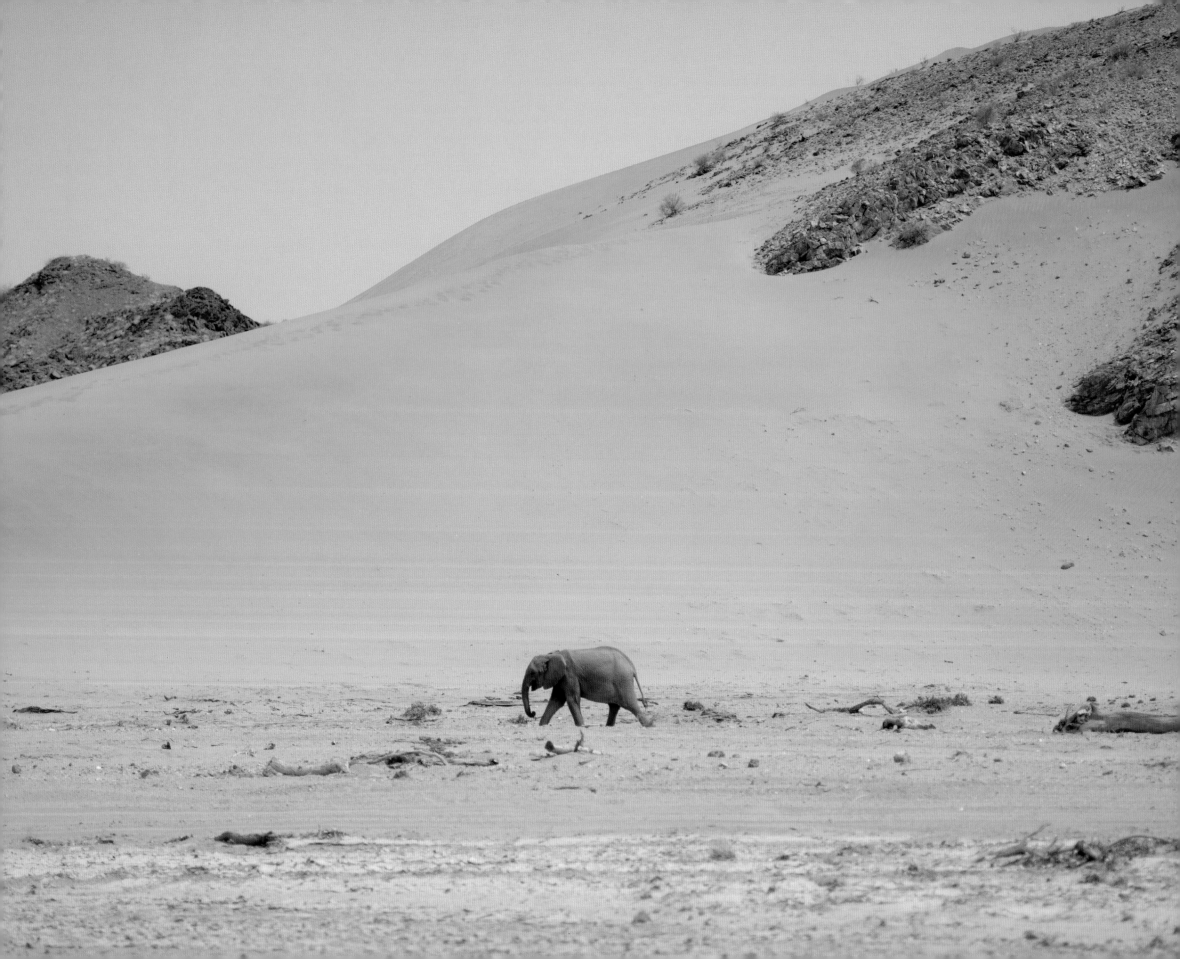

> *"Known and loved ... each of the thousands of elephants murdered had his or her own personality, place in the herd, family bonds. Each was an individual that mattered. Each deserved respect."*
>
> **JANE GOODALL**
> Conservationist, scientist, author, activist

we see in elephants today, including a more effective set of teeth that permitted survival in a broad range of habitats. Around five million years ago, Asian elephants and mammoths first appeared from the African line, with mammoths beginning their global expansion by first moving into Europe about three million years ago. Also during this broad time period, the African line split into today's surviving species of forest elephants and savanna elephants. By about 1.5 million years ago though, mammoths, for some reason, had disappeared from Africa. One million years ago, there were 12 species of proboscideans living on earth. But following a series of natural events including dramatic volcanic eruptions, the movement of earth's crust and climate change, a series of ice ages began. In the end, nine proboscidean species became extinct, leaving the three elephant species that exist today; the savanna elephant, the forest elephant

and the asian elephant. Of all the currently extinct proboscideans, only the remains of the mammoth have made it to the present day in lifelike form. This is no small miracle given that the very last of the species was a small population of less than 1,000 survivors who lived until 1650 BC and most individuals had disappeared 8,500 years before that. Indicative of just how widespread the mammoths were, in 2009, 40,000 years after his death, a 48-year-old male's skeleton, including tusks 10 feet long, was discovered at a construction site near downtown Los Angeles. In 2010, 39,000 years after her death, a baby female was discovered on an island off the coast of Russia. Apparently having been trapped in water or bogged down in a swamp, the baby died and there she was preserved. Not only did her little trunk and tongue make it through the ages, but for the first time, mammoth blood and most of a brain were recovered.

As we look back on the history of earth so far, it could be said that the elephants, the proboscideans, had a good run. Twenty million years of living in large numbers across the majority of the earth's landscape is an accomplishment that mankind is not likely to equal. However, we humans can certainly improve our future by learning from the elephant. His challenges are our challenges if we could only take note. Also, with our present interest in human ancestry stirring so much understanding of who we are as individuals, imagine the growth we humans could make as a species if we simply applied the lessons of history. One such lesson relates to our longstanding flaw of intolerance for other humans who are different from ourselves. It's little wonder therefore that given the differences between humans and other species, we've failed mightily to recognize just how similar the life experiences of these other species truly mirror our own.

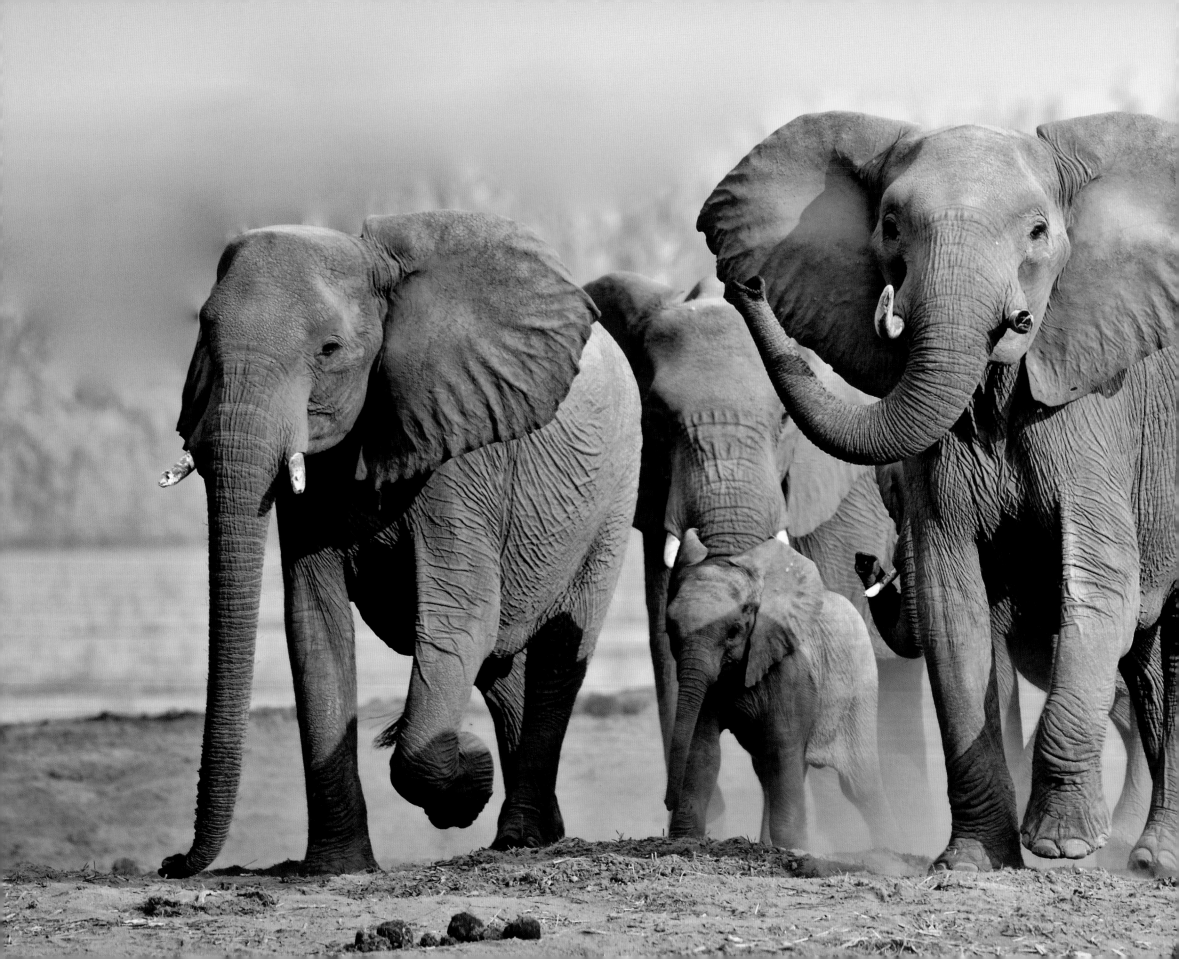

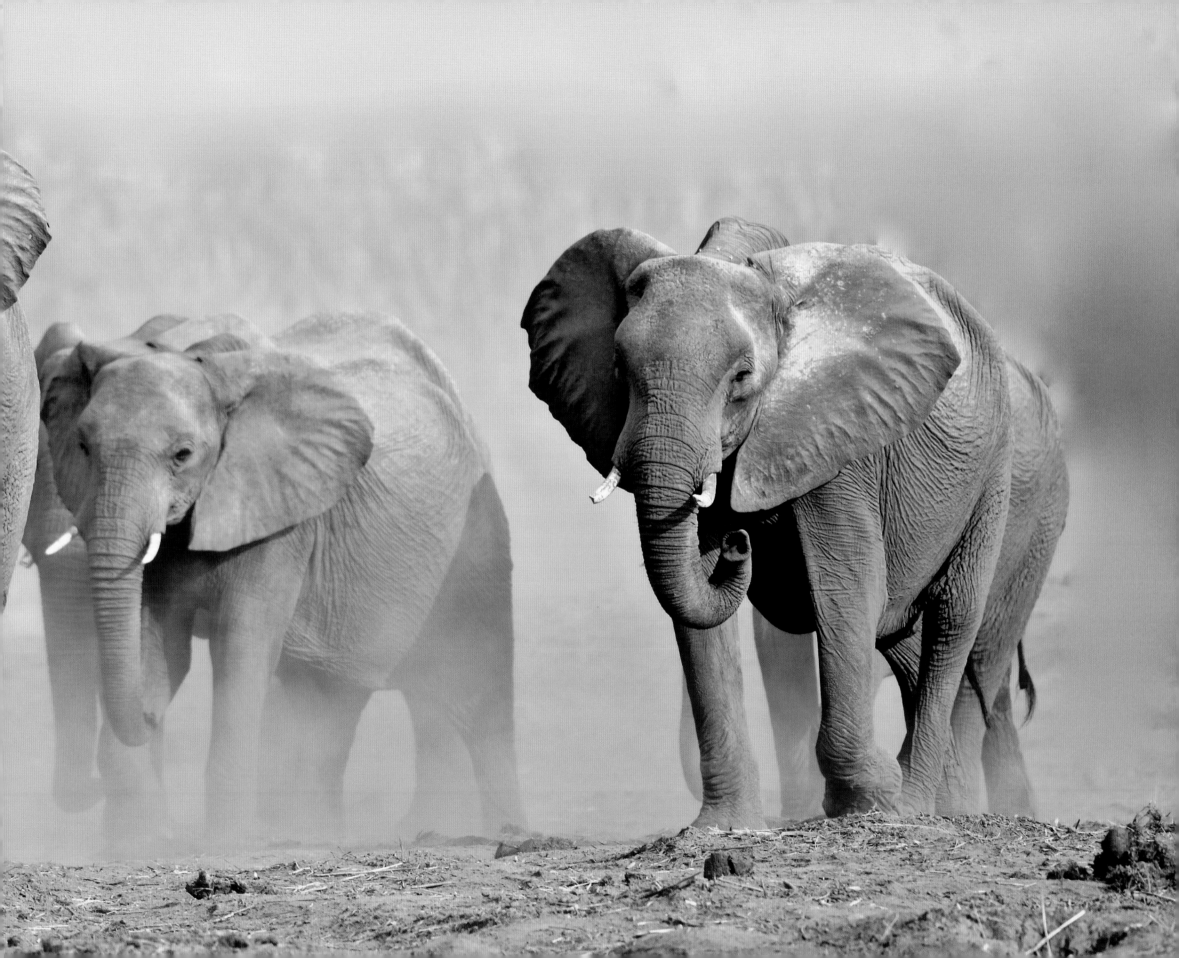

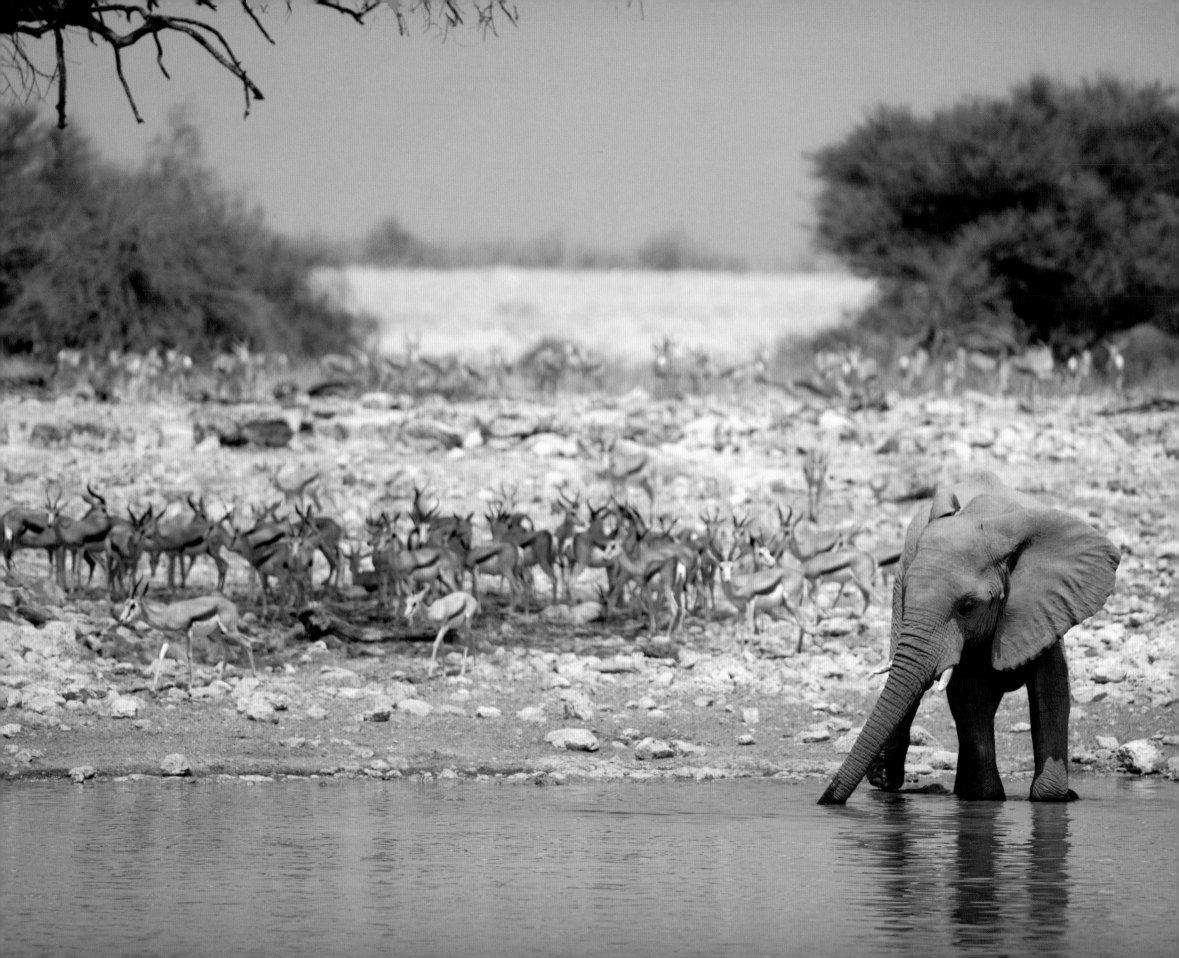

SIBUDU

With the possible exception of drought, no earthly variable has impacted the lives of elephants in Africa more than the presence of mankind. Prior to mankind's arrival on this earth, elephants and their ancestors had lived for millions of years with a freedom almost unrivaled in earth's history, free to move about the globe to anyplace desired, free of the common threats that have restricted the lives of lesser species. But with the arrival and proliferation of humans, elephants have come to know the wrath of a predator, a severe restriction of movement and, most fundamentally, a competition for the essentials of life; a place to live, food and water. Given the intelligence and sensitivity of elephants, there is little that mankind has done on the continent since his arrival that has not impaired elephants. To ponder the lives of elephants is to ponder the history of mankind.

No matter which recognized archaeological site in Ethiopia, Kenya, South Africa, or Tanzania you believe to be the birthplace of man, it's fairly safe to say that human life as well as most all other life began on the continent of Africa. From the fossil record, scientists believe early mankind survived by foraging for vegetation and at some point, came upon the kills of other animals, learning to consume those finds. All in all, the earliest humans apparently lived a very peaceful, nonviolent life for quite some time. By about 2.6 million years ago, mankind had discovered toolmaking and alongside some of the earliest tools discovered in Algeria and Ethiopia, fragments of animal bones have been found, including the bones of mastodons and elephants. How these animals died is yet to be determined but the evidence shows that by this time early mankind had become a meat eater.

Over the following centuries, mankind continued foraging and created methods to trap and ambush animals for food. By 1.5 million years ago, the inevitable happened; mankind learned to hunt using projectiles. In 2010, scientists exploring Sibudu Cave in South Africa came upon a collection of small pointed stones that were later revealed to have remnants of blood and bones on them. Additionally, a glue-like substance was identified. Dated to 64,000 years ago, these fragments are the earliest widely accepted evidence of man-made arrows or spears used for hunting. Now mankind could be more aggressive about taking the lives of animals thus creating a better food supply.

Another discovery that's believed to have taken place about 1.5 million years ago was the discovery of fire. It's widely believed though not to have been controlled by mankind until about 400,000 years ago with firm evidence of managed fire dating to just 40,000 years ago. In any case, with the mastery of fire, mankind could better control survival in various climates and environments. As a result, exploration and migration expanded, and mankind moved outside of Africa for the first time and established colonies throughout Eurasia. Despite having the tools and the power to commit murder,

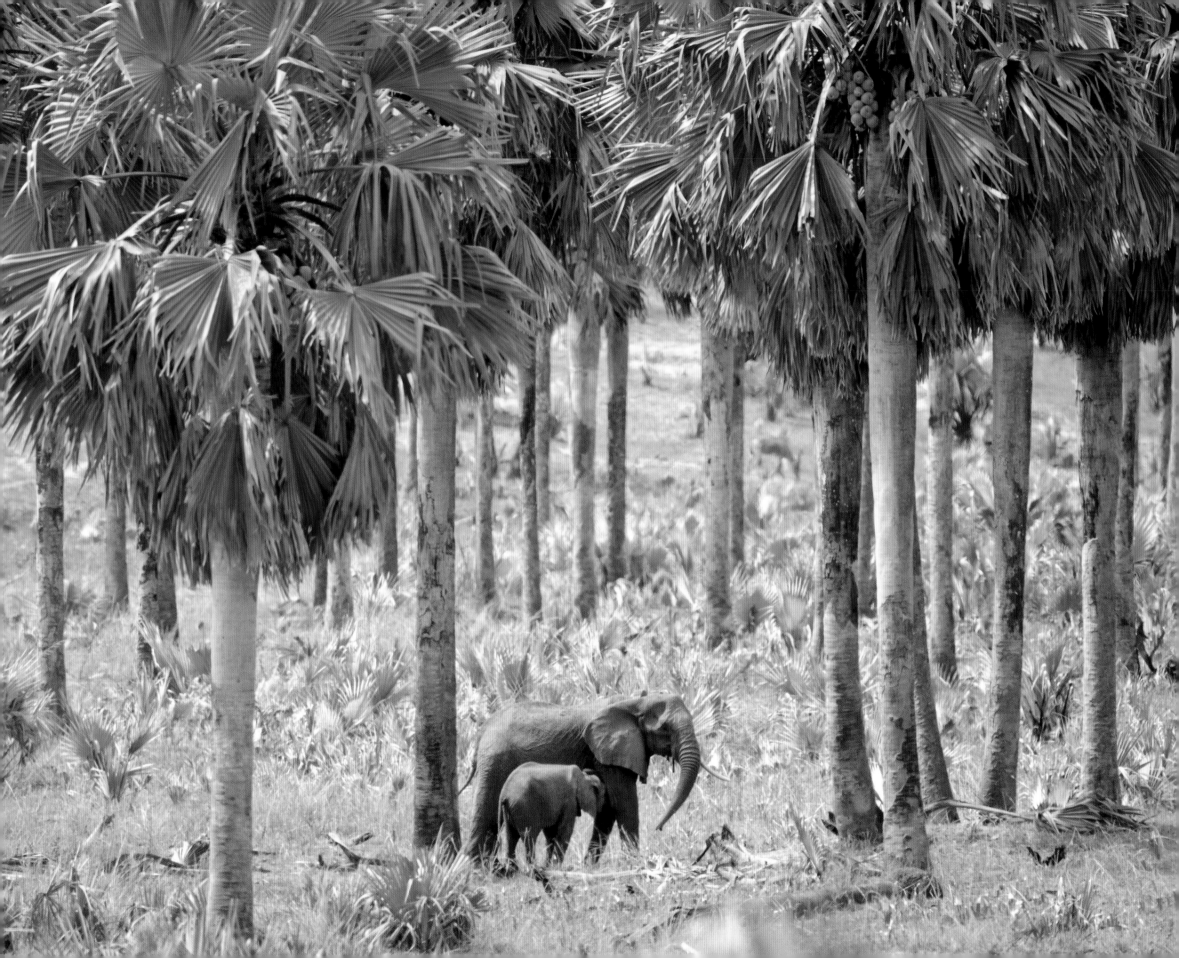

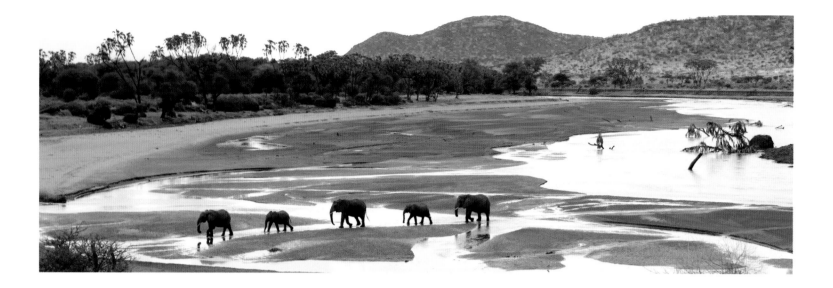

scientists believe that to this point in prehistory we were still living in peace with each other. Slowly and steadily, the human population grew, communities increased in size and humans moved into the far corners of the continent. By about 10,000 BC, grains were being cultivated in North Africa and sheep and cattle were being domesticated. It was at about this time in history though that several alarming events took place.

In present day Kenya in 2012, an archaeological site at Nataruk revealed the remains of 27 humans who had died violently at the hands of another group of humans in about 10,000 BC. The remains were comprised of 20 adults, one teenager and six children. All but two of the skeletons discovered showed signs of lesions made by pointed-stone projectiles, clubs and an axe-like weapon. The discovery added gravity to the finds made in 1964 at Jebel Sahaba, an archaeological site in northern Sudan.

The fossils here were slightly older, dated to about 13,000 BC, and were all discovered in graves at two adjacent cemeteries. Sixty-one skeletons were recovered in all with roughly half of those men, women and children found to have died from violent wounds. Once again, pointed-stone projectiles were found in the bodies, this time in 21 individuals, with cut marks found on the remains of others. Jebel Sahaba is commonly thought of as revealing the first known evidence of human warfare.

The period embracing 10,000 BC represented still another marked change in how humanity applied intelligence; the San people of southern Africa, who to this day inhabit six nations, are credited with beginning the use of poison. Among the sources were snake and scorpion venom, poisonous plants and the juice of smashed beetle larvae. The common practice they utilized was to gather the raw materials, process them

in a mix and apply the concoction to the tips of their hunting arrows. Other tribes throughout Africa including Kenya's Waliangulu elephant hunters developed their own poisons for the tips of arrows and spears, sourcing primarily local poisonous plants. In addition to its ongoing use today on the tips of hunting arrows, poison from man-made sources such as pesticides is traded cheaply in industrial quantities throughout Africa and used by poachers to taint waterholes, soak grains, mix into salt licks and bait carcasses. Hundreds of crop-raiding elephants and livestock-killing lions have died prolonged, painful deaths as a result of its use.

Extending the history of humanity can often be a very challenging thing. Sometimes, even circumstantial evidence is unavailable, and such is the case with the history of man's use of the snare trap. As rudimentary as the technology is, the use of snares certainly goes well

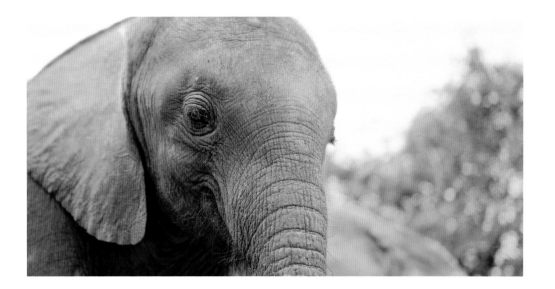

back into prehistory but the nature of the material they were constructed from in the early days makes their history elusive. One thing is certain, snares, made of wire today, are among the most dangerous hunting and poaching mechanisms used in the modern age. Thousands and thousands of animals are trapped and killed by these pieces of wire, fashioned into a loop, and left out in the wilderness to entangle the head or leg of animals all the way up in size to that of an elephant. So many of these snares are routinely set across the continent that it's estimated that the locations of over half have been forgotten by the killers who set them.

No history of mankind as we relate to elephants is complete without some mention of the gun. At some point in the numerous armed conflicts that took place over the last two centuries between native Africans armed with spears and European and Arab soldiers armed with guns, it dawned on the native Africans to acquire such weapons and so the trade began. Today, it's estimated that 100 million guns exist in Africa. By far the most popular weapon since the 1980s has been the AK-47, which can be bought in the open markets of several countries for no more than the cost of a chicken. Guns have become part of many African cultures. Four nations have gun-manufacturing factories complete with sales divisions and business is booming.

Since the period of African independence began around 1960, armed conflict has dominated the landscape. Instead of entering into a period of peace and prosperity, a majority of the continent's 54 nations have entered into periods of domestic conflict and civil war. Despite the thoughts of the outside world believing that the problems are due to tribalism or ethnic hatred, the true reasons for fragmentation are rooted in dense populations suffering from high levels of poverty and failed attempts to create balanced economies and governments. Since 1960 at least 20 nations have experienced a period of civil war. Since the year 2000, there's been a significant increase in riots, protests and terrorism while the number of violent groups has also continued to rise. As a result of the various conflicts, the more stable nations are also affected as they're forced to adjust to the social, political and economic upheaval of their neighbors. Nearly 11 million Africans in recent years have been forced to leave their homes within their native countries while over 4 million Africans have been forced to leave their native countries altogether. Africa has the second and third largest refugee camps in the world and seven of the ten largest.

And finally, there is the history of the Arabs in Africa. Going back to roughly 700 A.D., neighboring Arabs had sailed their ships to the east coast of the continent and had established trading posts.

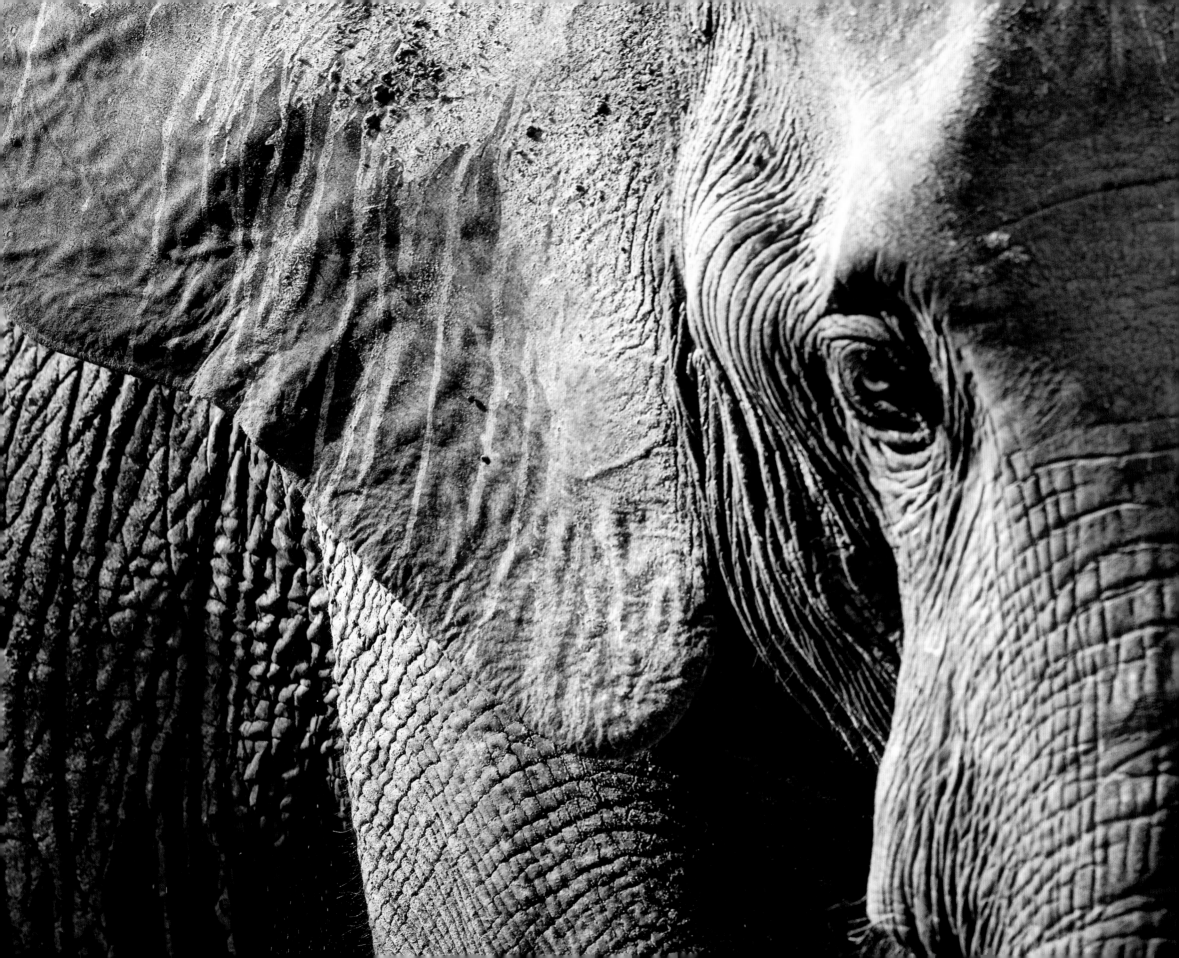

Iain Douglas-Hamilton grew up in England with a love of animals. In college, he determined to go to Africa and went on to call the continent home, becoming a pioneer in elephant research and conservation. Early on in his field studies, he was approached by a curious elephant mother he named Virgo. Together, they determined to build a relationship. Virgo and Iain would pass hours together as Iain sat in his Range Rover. Then, with Iain's new partner Oria as witness, Virgo and Iain met face-to-face on foot. Close contact continued until near the end of Iain's studies when Iain, with his three-month-old daughter Saba in his arms, walked up to Virgo and her child. During the span of this touching moment, Virgo moved the tip of her trunk over baby Saba in a delicate figure eight.

Their presence was strong and thorough, and by the arrival centuries later of the early European colonists, the Arabs had already become a major element of the social and economic fabric of East Africa. From their trading posts, the ivory trade grew significantly to meet the growing demand for ivory in Asia and the Middle East. Giant caravans bound for the African interior became commonplace with native Africans employed to carry out the ivory. In their travels throughout the interior, the Arabs discovered that native Africans had been enslaving the survivors of warfare; men, women and children. Before long, the Arabs exploited this resource and turned it into their most lucrative trade. Within a century, the infamous Arab slave trade was up and running. In the end, 28 million native Africans were captured and sold. As families were disintegrated, the Arabs focused on women and children, sending them off to the Muslim Middle East where they were sexually exploited or used as servants. Meanwhile, most of the males were castrated and put to work in military service. A staggering 80% of all the slaves captured died in transit before ever reaching their final destination.

Yes, it must be recognized that Arabs were responsible for several of the earliest and most advanced population centers in Africa outside of Egypt and Carthage. And yes, in the process of Arab exploration and commerce, many of the earliest and most important trade routes were established. But the impact of the Arab slave trade in fragmenting native African culture was very significant. Today's ongoing violence initiated by Islamic extremists in vulnerable war-torn countries is not helping matters either. While the tribes and communities of the African landscape had been forced to live with the Arab slave trade, they could not have imagined the magnitude of the upset coming several centuries later with the arrival of the Europeans, the initiation of their slave trade and their domination through government and commercial exploitation.

Mankind and elephant have both suffered immeasurably throughout the history of Africa. While we humans of the 21st century live out our relatively privileged lives, the acknowledgement of Africa's past that created the realities of today can be an uncomfortable experience. It's so much more convenient to romanticize yesterday's native African culture and a landscape that once teemed with wildlife. It's so much more enjoyable to savor the African influence in our dance, music and art. It's so much more enjoyable to embark on a photo safari in a wildlife park in Kenya. What we humans need to do, collectively, in Africa and around the world, is own the impact that our daily behaviours are having on our environment and the wild animals remaining here with us. We must realize that all of it; we humans, the animals and the environment, are interconnected. We need to take a serious look at our lives, what we're doing here, before it's too late.

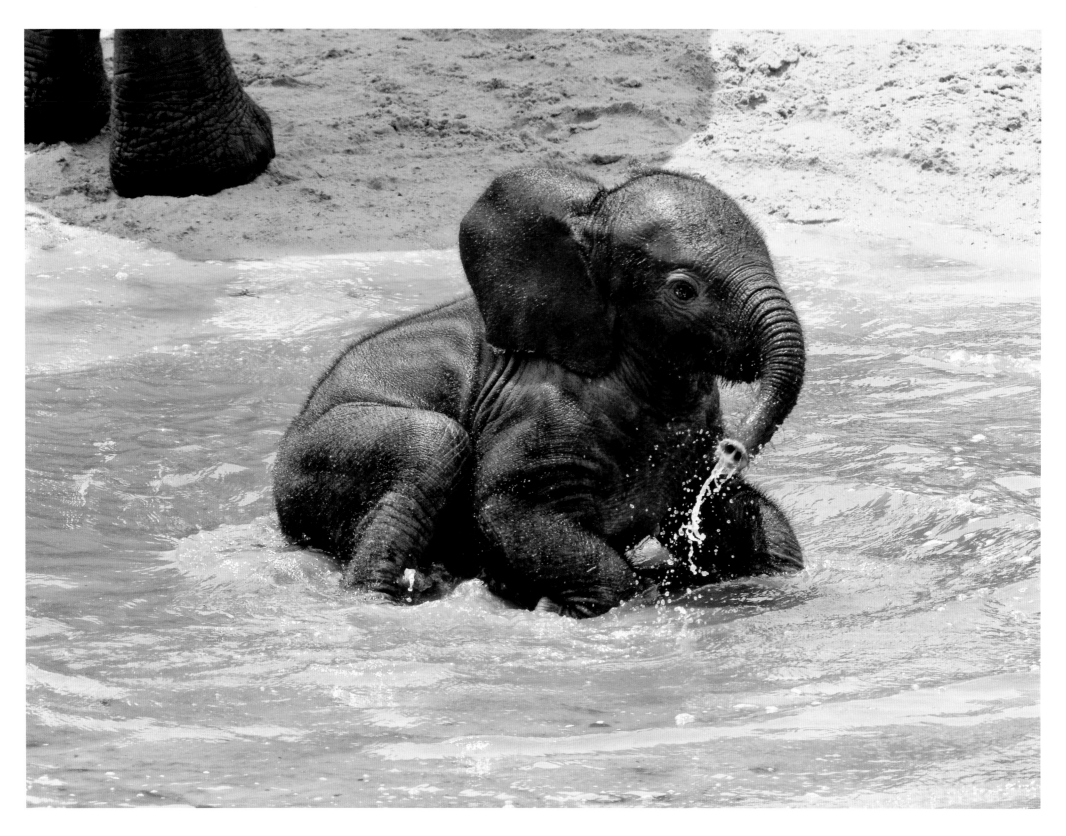

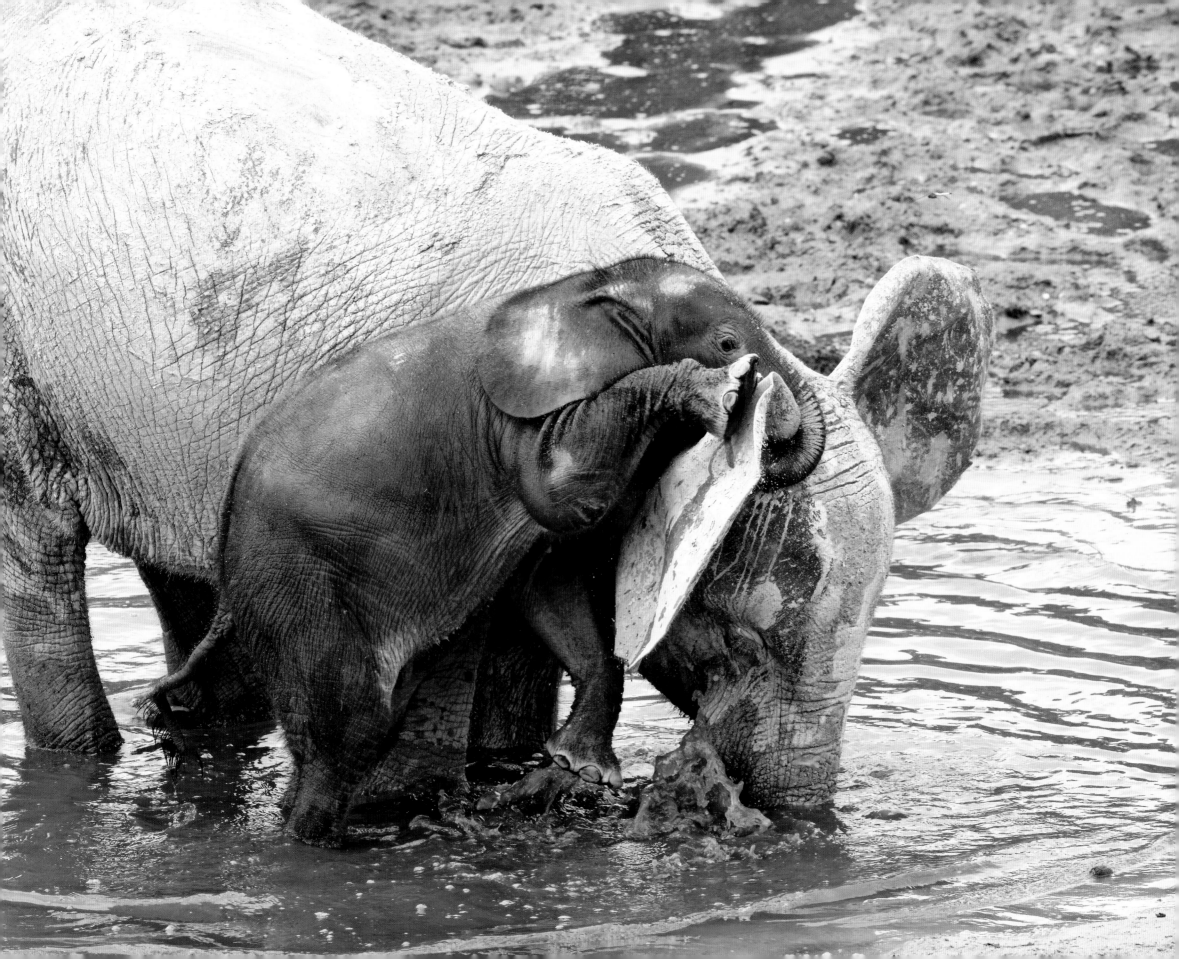

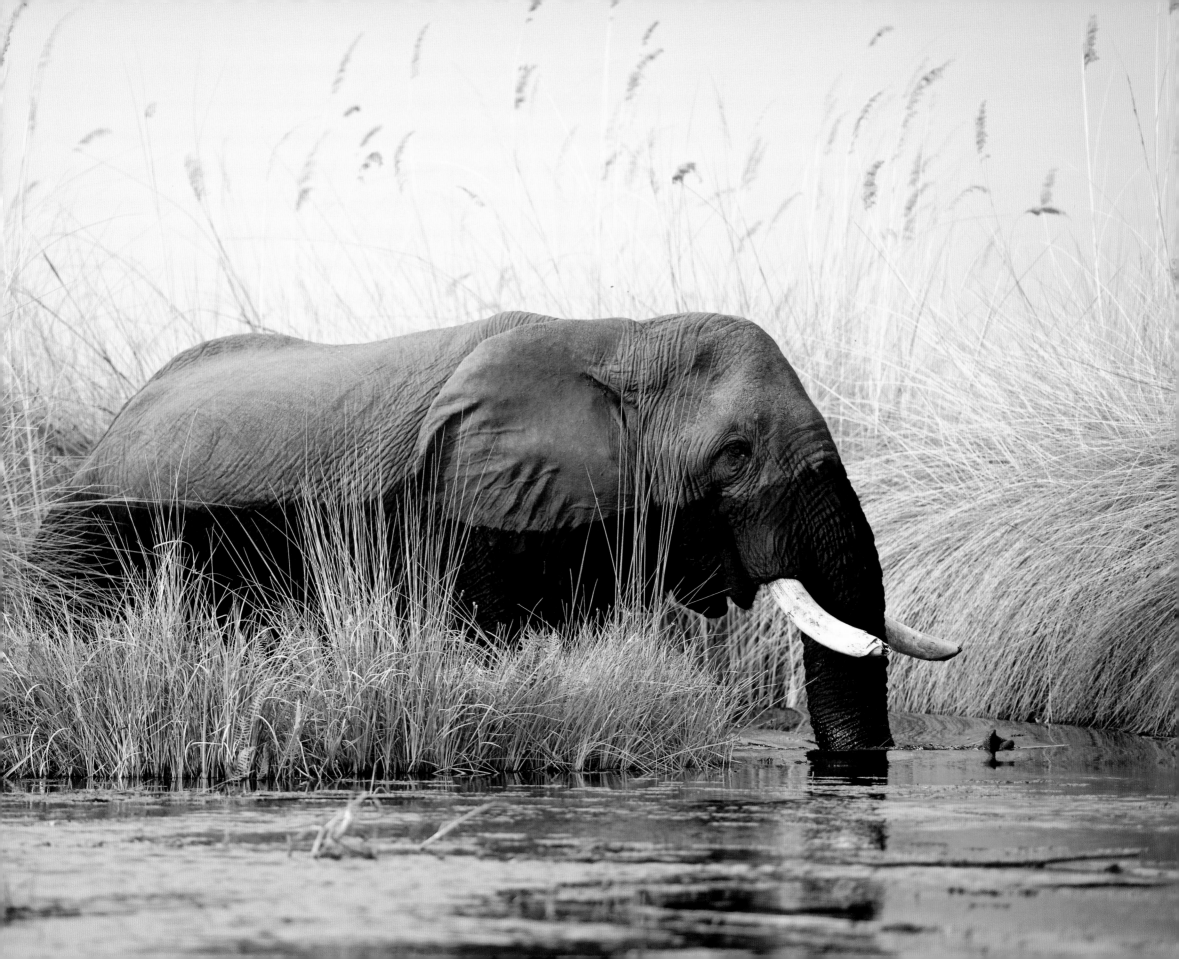

THE NITRO EXPRESS

In the history of life on earth, the continent of Africa has witnessed the evolution of countless species and subsequent migrations of these beings away to populate other continents. A balance was struck and, in the middle of the harmony, elephants flourished and multiplied to the tens of millions. Then came mankind's Age of Exploration. Something inside the human mind, particularly the Europeans, inspired scores of probes out into the world to discover what was there, subdue it, collect it and use it to advantage.

Over the course of the 19th century and early 20th century, the nations of Europe set upon Africa, carving up the land for exploitation. It was a who's who of nations that came, saw, conquered and colonized: the United Kingdom, France, Germany, Italy, Portugal and Belgium. Each one acquired land, removed raw materials to fuel industry, planted crops and founded settlements. Before long, it became clear to the colonists that the abundant wildlife

presented both a threat to success and an opportunity for further exploitation. The common resulting denominator in both scenarios was death for the native wildlife, especially for the elephants.

In Europe, big game hunting as a sport had long been a favoured pastime of the rich and famous, especially among the British. It seems there was a certain respectability, a demonstration of power and manliness in the killing of wild beings. Once commercial transportation to Africa became possible during the early 19th century, the privileged of Europe began making trips of increasing number and scope to pit their skills of manhood against the exotic and dangerous animals of this foreign land. Eventually, the common man also came to Africa and the term 'white hunter' was coined. The Swahili word for travel, safari, was borrowed to describe the hunting expeditions. And commonly, while history books recall these men as great explorers and conservationists, at their core they all

shared one commonality; they enjoyed the thrill of killing.

Over the ensuing years, names of the more prolific white hunters began to surface. There was explorer Frederick Selous (1851-1917), who killed hundreds of elephants including 78 during a two-year period before becoming an outspoken critic of his industry; R.J.Cunninghame (1871-1925), who also killed hundreds of elephants and parlayed his hunting skills into becoming one of the most notable safari leaders in history; Ian Nyschens (1923-2006), bullied as a child, a social misfit, who killed over 1,000 elephants over a 40-year career; James H. Sutherland (1872-1932), who killed 1,700 elephants and became a widely read author; Walter Bell (1880-1954), who killed 1,011 elephants including 19 in one day; Philip Percival (1886-1966), who killed scores of elephants and originated the modern hunting safari; Eric Rundgren (1918-1992), who killed 1,200 elephants; George Gilman Rushby (1900-1968), who killed 1,800 elephants;

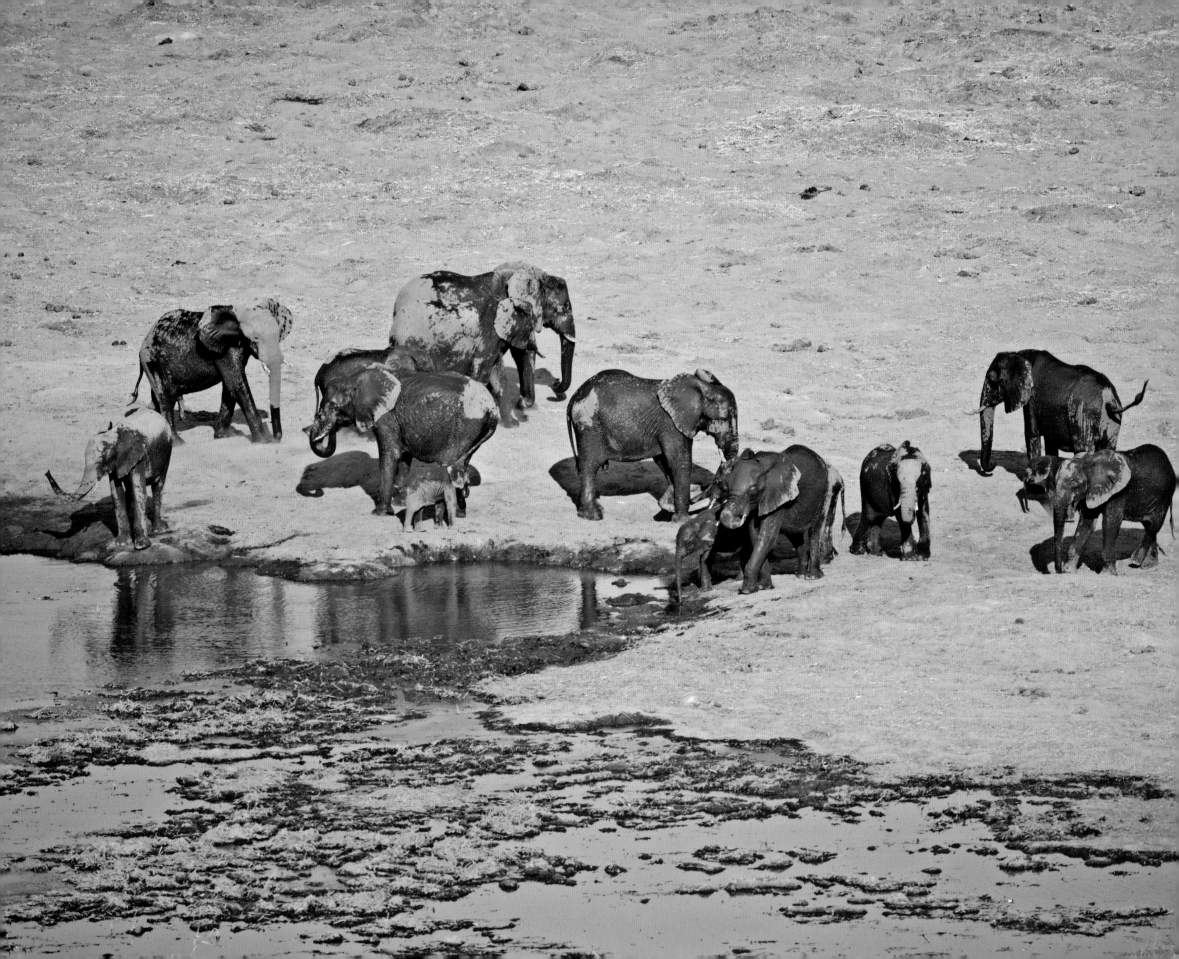

*"If anyone wants to know what elephants are like,
they are like people only more so."*

PIERRE CORNEILLE
17ᵗʰ Century French Playwright

R.J.D. "Samaki" Salmon (1888-1952) who killed 4,000 elephants; C.R.S. Pitman (1890-1975) who killed 3,992 elephants; and Paul Kambada Grobler (born 1922), who killed his first elephant at the age of 9 and is reputed to have killed more elephants than any other human, possibly as many as 10,000 including 1,000 in one year, 1949. Grobler used the proceeds from the ivory he collected to build a farming empire.

Out of all the rich, famous and bloodthirsty who have travelled to Africa to kill, one man in particular initiated the grandest safari on record that, in turn, inspired countless thousands of hunters from around the world to follow. He was among the first known Americans to hunt in Africa. He was a former president of the United States of America and his name was Theodore Roosevelt (1858-1919). Under the auspices of gathering specimens for the newly minted Smithsonian Institution Museum of Natural History,

his legendary expedition of 1909-1910 took the lives of 5,000 mammals. Roosevelt and his son alone were credited with the killing of 11 elephants. The incredible logistical requirements of this massive human undertaking and the fact that it was the former president of the United States contending with the challenge drew unprecedented worldwide publicity. It was this deluge of glorifying publicity that romanticized Africa for white hunters everywhere and for the next 50 years, boats, airplanes and trains were loaded with copycats, dressed in their costumes of khaki, coming from every corner of the earth to take home their share of the bounty.

Of course, the great wave of killing was largely made possible by technological improvements in firearms and ammunition that had come just a few years before. Initially, killing an elephant during the early days of the white hunters was an uncertain and prolonged process. It wasn't until the 1850s that

the development of a true elephant gun had begun. Even then, it was common for 19ᵗʰ century elephant hunters to fire as many as 35 rounds into an elephant in order to kill it. The hunting industry in Britain, however, was hard at work tackling this challenge, and in 1898 came up with a bullet inspired by the latest research in explosives that yielded nitrocellulose and nitroglycerine. The new bullet, immediately becoming the most popular and widely used hunting round at the turn of the 20ᵗʰ century, was called the .450 Nitro Express. The ".450" referred to the diameter in inches of the cartridge, "nitro" accounted for its propellants and "express" represented the blistering speed at which the bullet travelled, a speed and power much like that of an express train. With the dawning of the era of the Nitro Express, there were no stops and the killing machine rolled down the tracks, head-on toward every elephant in sight.

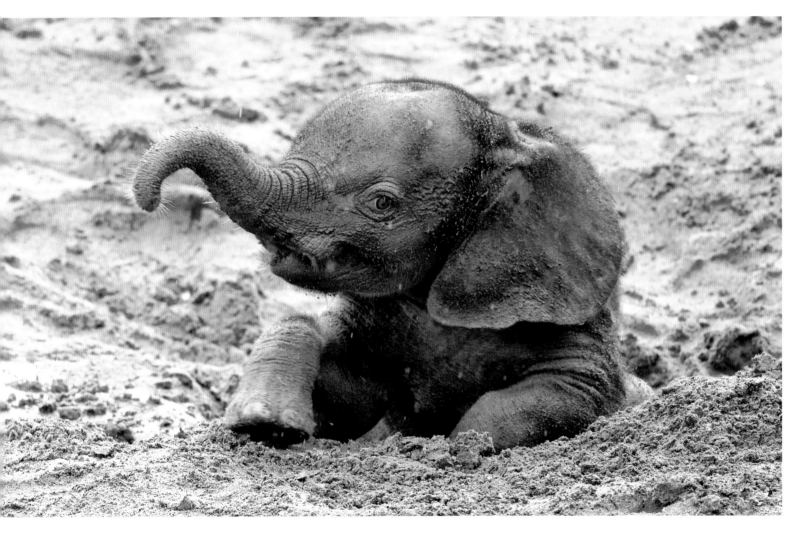

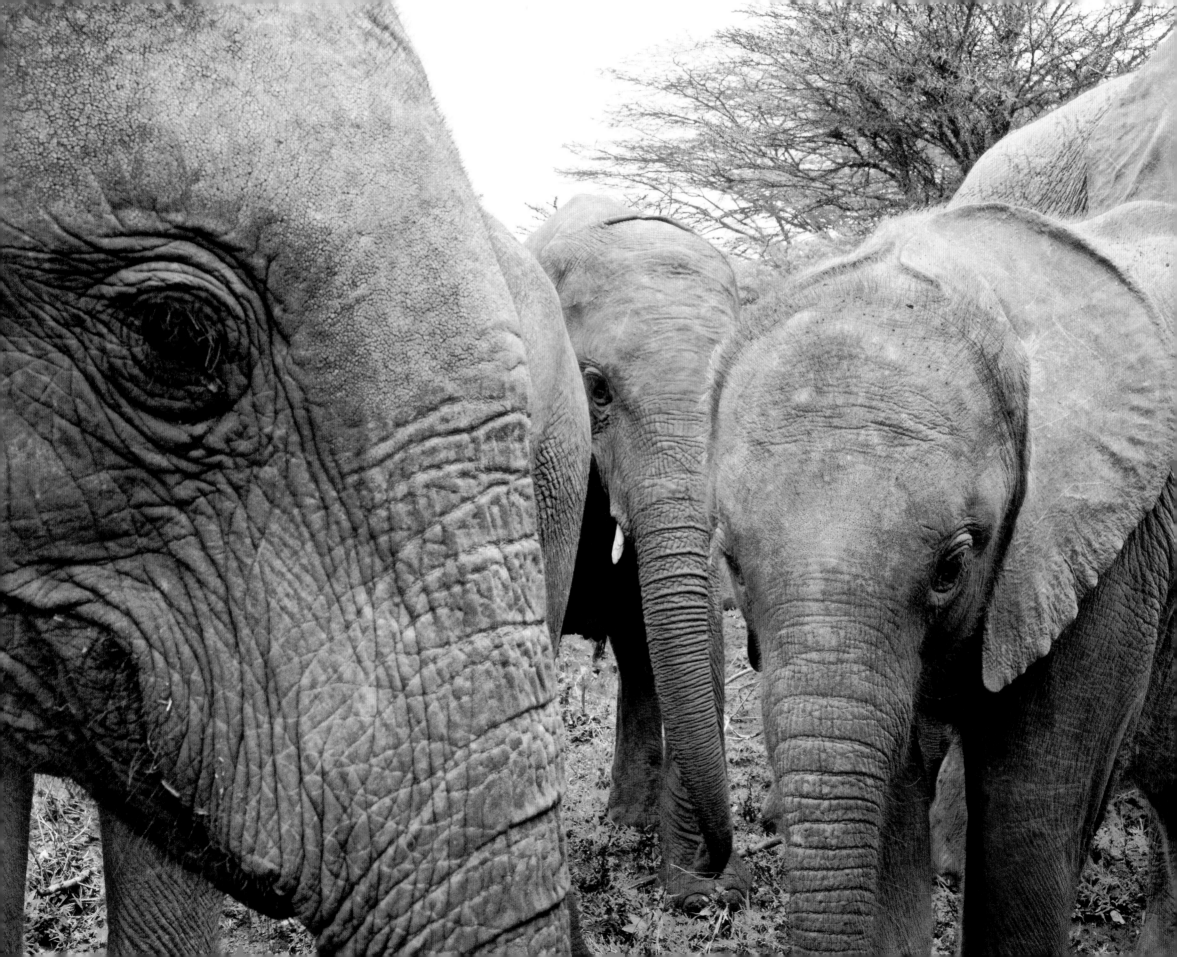

JUMBO

It's believed the little elephant was born on Christmas Eve in 1860, somewhere in Sudan or Ethiopia. Not long after his birth, he witnessed his mother being killed by native African hunters, who brutally took away her tusks and skin. A short time afterwards, the baby elephant was captured by an opportunistic Sudanese elephant hunter in the area. This man, in turn, sold the little soul to a passing Italian wildlife dealer who took him on a six-week forced march with other captured animals across a vast desert to the coast. From there, he travelled by boat across the Mediterranean Sea to Northern Italy where he was sold to a German wildlife exhibitor who took him by train to Germany. This company, though, quickly turned around and sold the little elephant to the Paris Zoo, the French eager to add the first live elephant in Europe to their collection. By the time this poor little soul had reached the age of five, he'd been traded yet again, this time to the London Zoo in exchange for one rhino, one jackal, two eagles, two dingoes, an opossum and a kangaroo. Here, the young elephant was finally given a name: Jumbo.

For the next 16 years, Europeans came by the millions to lay eyes on this never-before-seen, gentle giant from another world. The hearts of Great Britain, in particular, melted as Jumbo gave daily rides to countless children through the zoo grounds. Meanwhile, he continued to grow in size to become a very large elephant and eventually reached the age where his reproductive anatomy became conspicuously active. To the Victorian mind, this was unacceptable and there was talk of putting him down. At the same time, however, his notoriety attracted an inquiring call from the United States, from the showman P.T. Barnum. Within weeks a deal was reached and despite the public outcry to keep Jumbo, he was forced into a crate, loaded onboard a steamship and shipped across the Atlantic Ocean bound for New York Harbour and a future with the Barnum & Bailey Circus.

Since the days of Jumbo and into recent years, the capture and export of Africa's wild born elephants has quietly continued. With little news coverage, more dramatic and pressing human-based stories captivating the public ear, the tragic lives of little elephants stolen from their families in the wilds and shipped overseas have passed largely unnoticed. In 2012, Namibia shipped 18 elephants to Mexico and eight to China. In 2015, Zimbabwe shipped 27 to China and then an additional 30 to China in 2016. Also in 2016, under threat of death in Swaziland, 17 elephants were shipped to the United States to live out the remainder of their lives in three zoos. While circuses are closing down around the world, thus ending the demand for elephants in this regard, zoos continue to hold a public fascination and zookeepers continue to collect elephants from abroad. As Daphne Sheldrick pointed out though, what the public is seeing at a zoo is not an elephant, but a tragedy.

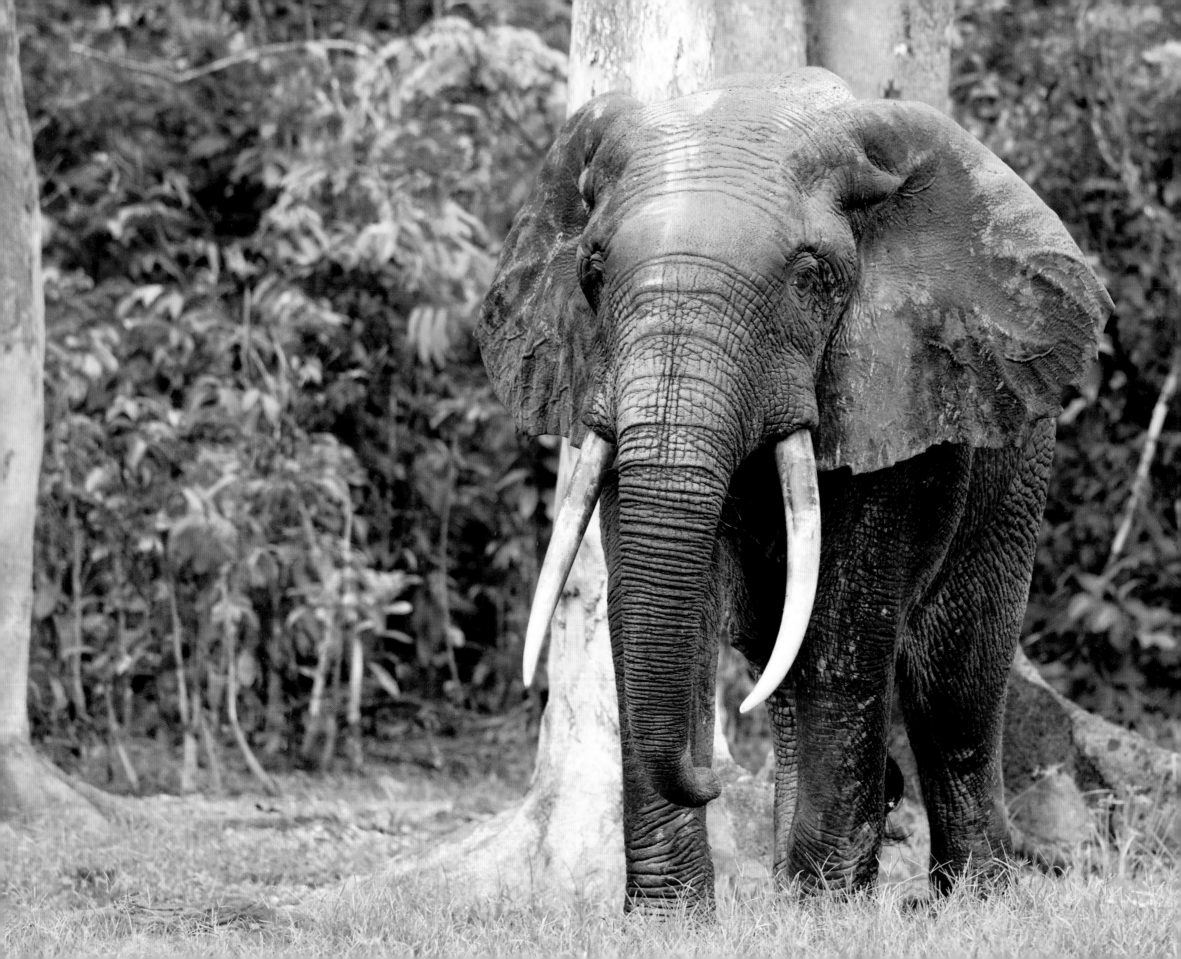

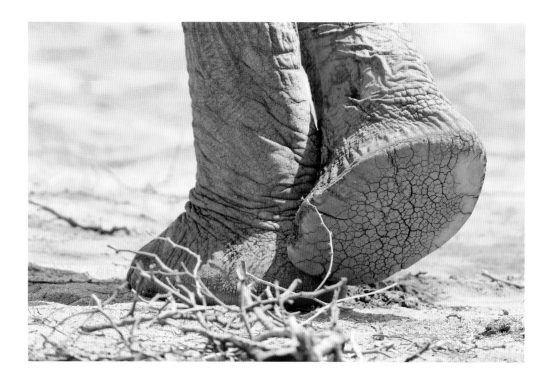

Jumbo's arrival in the United States brought out the largest crowd that New York City had ever seen. Barnum had Jumbo's crate hitched up to a team of eight horses and two elephants to be paraded up to the newly completed Madison Square Garden. In an instant, Jumbo eclipsed the unprecedented fame of Europe to become a legend, the first animal to achieve celebrity status. Over 20 million people went to see him. Advertisers exploited his name and image to sell all sorts of products and services. There were Jumbo mugs, Jumbo neckties, Jumbo earrings, Jumbo playing cards, Jumbo candy, and on and on. The name 'Jumbo' entered into the English language as a word synonymous with anything giant-sized and continues in use to this day.

It's generally recognized that by the time Jumbo had arrived in the United States, he was already suffering from chronic health issues, brought on by his life of abuse in captivity. In 1885, at just 24 years old and barely three years after joining the Barnum & Bailey Circus, the gentle, accommodating elephant Jumbo met his end. As he was being led across a railroad right-of-way on the way to his railroad car following a performance in Ontario, Canada, a train crashed into him and that was that. Barnum, true to form, wove a sympathetic story glorifying Jumbo's tragic end. But recent evidence suggests that Jumbo's death may have been engineered by the circus master himself.

All that's known for certain of Jumbo's end is that Barnum had six butchers brought in and Jumbo's body was sent to New York City where a taxidermist went to work. The elephant's skeleton was erected on a platform while his skin was installed on a separate wood and metal, elephant-shaped framework. Following months of work, Barnum added the two displays to his operation and Jumbo made the showman even more money as the famous elephant's remains made the tour of the East Coast for the next three years. The little elephant from somewhere near Africa's Sudan had taken the world by storm and was literally loved to death. To this day, there are still circuses travelling the earth, exploiting the good nature of elephants, drawing in thousands of people curious to see these huge beings who demonstrate such intelligence and grace.

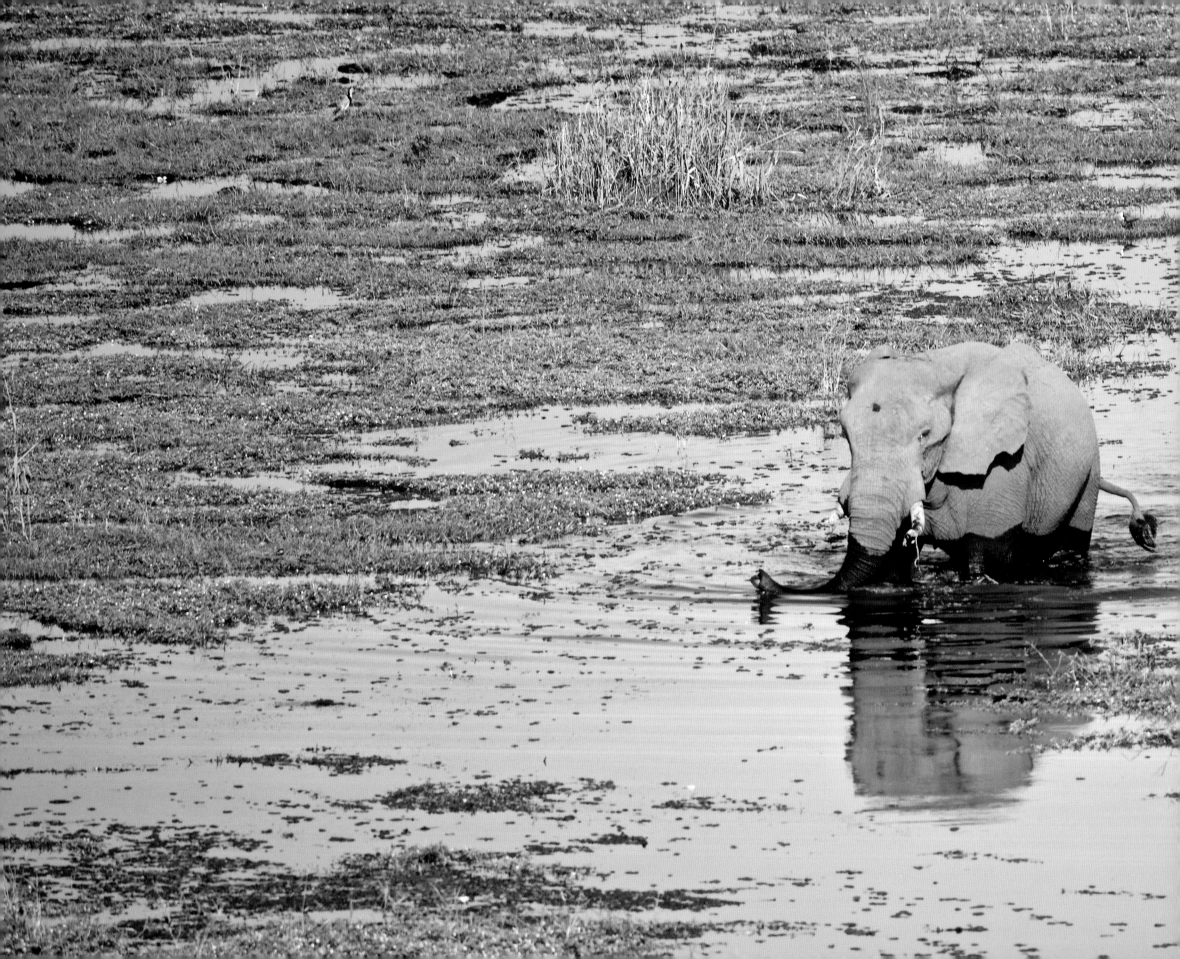

Botswana. With a population estimated at 130,000, this nation is recognized as being home to the largest population of elephants in all of Africa. But the actual number of elephants here fluctuates widely as those found at any one time are actually members of a greater population of 216,000, nearly half of all savanna elephants, that moves in and out of five neighboring nations: Botswana, Angola, Namibia, Zambia and Zimbabwe, depending on food, water and human threats.

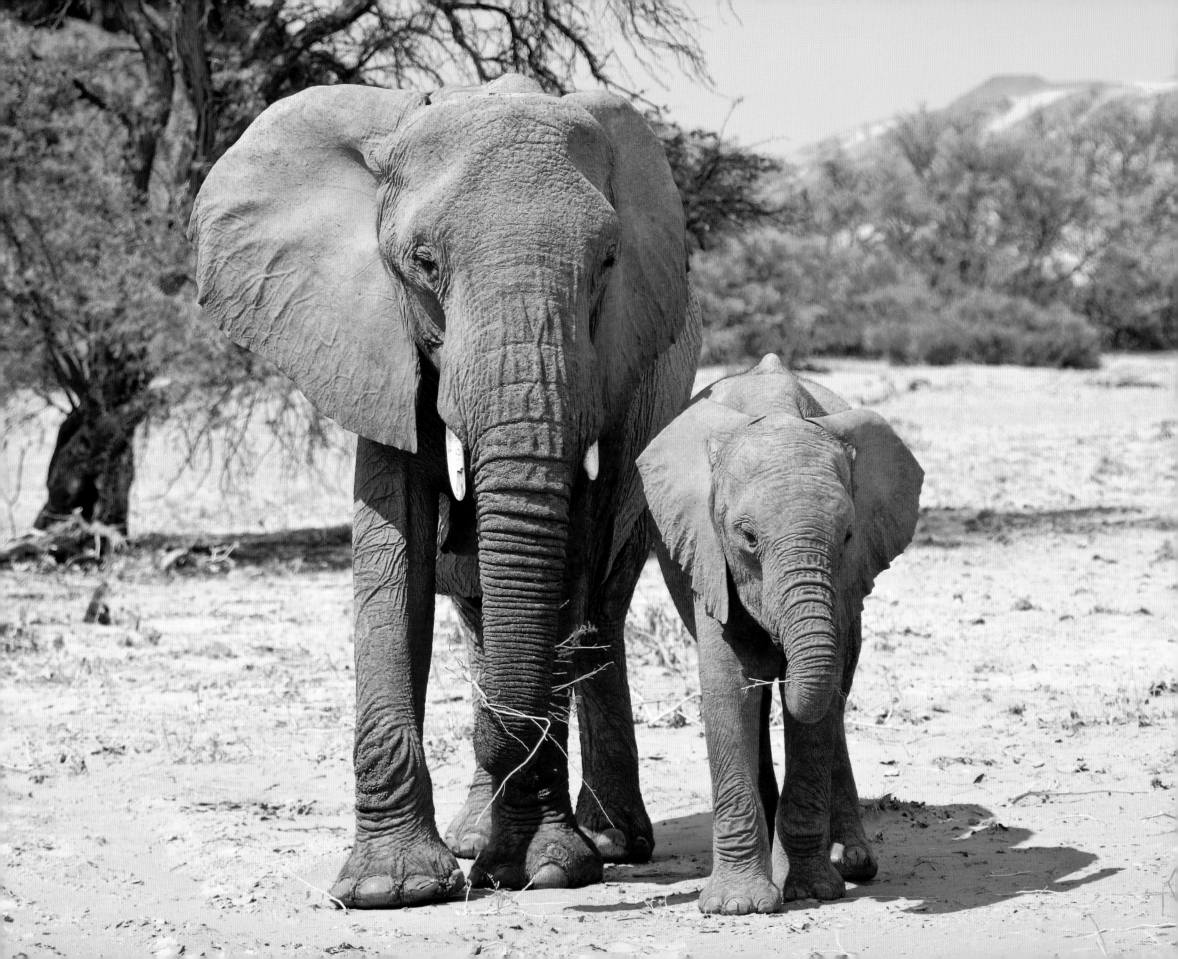

SATAO

Once a common sight across the African landscape, there have been uncommon elephants who carry the gene for unusually large tusks. At some point in modern history, hunters in the ivory trade took notice of these impressive souls who carried tusks that either touched the ground or weighed over 100 pounds apiece. The name bestowed upon these elephants was Tusker.

As science has always taken a back seat to commercial exploitation in Africa, the best record of tuskers across the continent has been kept by hunters, professional and illegal alike. This should come as no surprise as tusker-bearing elephants yielded the highest payday for white hunters of ivory and these hunters proudly documented their conquests in photographs and writing.

By the time Theodore Roosevelt made his epic expedition early in the 20th century, most of the giant tuskers had already been killed off to feed the insatiable appetite of the global ivory market. As rapid and thorough as the killing was, it was only just over ten years prior to the appearance of Roosevelt that the elephant with the largest tusks on record was killed. The great bull, ironically, was shot and killed by the African slave of an Arab ivory trader, not by a white hunter as most had been. The location was Tanzania, in the foothills of Mount Kilimanjaro, and tusks each over 10 feet long weighed in at over 210 pounds apiece. While the magnificent elephant was deprived of true respect during his life, his tusks have long been on display at The Natural History Museum in London.

Throughout the past two centuries, the overwhelming majority of tuskers have been sighted in the lands of East Africa. Here, Kenya has far and away been the homeland of the tusker population. Even today, with only a few dozen left alive on the continent, Kenya has been home to several of the most famous. Among those was the bull known as Satao.

Satao was born in 1968 and grew to be one of the largest elephants alive in the world at the time. His tusks measured 6.5 feet long and frequently touched the ground as he walked. So valuable were his tusks to the illegal ivory market that the Kenya Wildlife Service and the conservation group Tsavo Trust had Satao under constant watch. For most of the time, it was easy to keep an eye on him as the giant bull tended to spend his days in a small area of the park he inhabited, seemingly in hiding as if he knew the danger that surrounded him. By the early days of 2014, however, he'd resumed roaming and was venturing into areas of the park that were thick with vegetation, threatening his security. In March 2014, he was sighted with two seeping wounds, caused by poisoned arrows shot into him by native African poachers. A veterinarian from the David Sheldrick Wildlife Trust was rushed in, the Kenya Wildlife Service sized him up, and miraculously he was given a new lease on life. In mid-May he was seen again, appearing well and good, having fully recovered from his wounds.

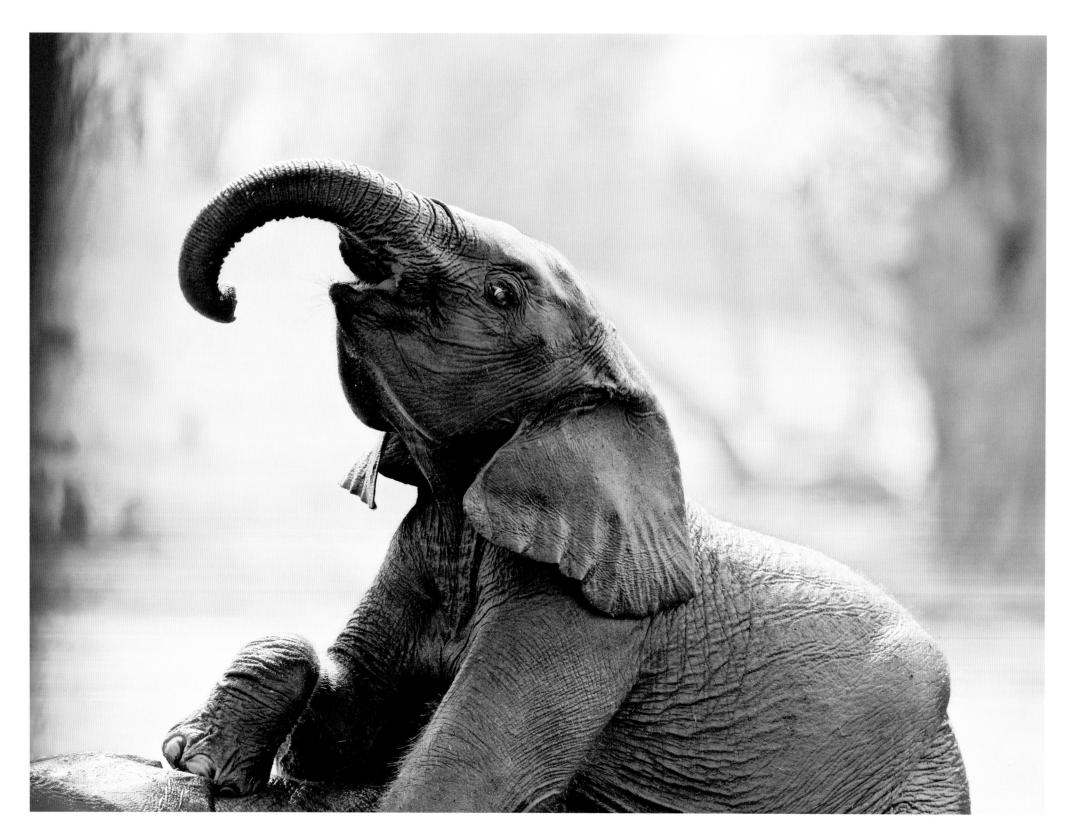

Zimbabwe. In November 2016, an anti-poaching team run by Air Shepherd was scouting the terrain in Hwange National Park when they discovered a young elephant, alone, upside down and trapped in a cement water trough. All that was visible above the surface of the water were four legs and the tip of a trunk. Death was inevitable. However, with the help of park workers and a tractor, the team got the elephant right side up and eventually freed. Air Shepherd utilizes a fleet of state-of-the-art drone aircraft equipped with cameras to locate poachers.

On 13 June 2014, though, Satao, the giant tusker joined the ranks of the unfortunate as he was found near the park border, laying on his side, another poisoned arrow in him, his tusks nowhere to be seen. In the end, ten days after the great Satao was killed, Kenya Wildlife Service rangers arrested three suspects, but their whereabouts are today unknown.

So beloved was the tusker Satao that another tusker who had emerged in the same area was named Satao II. For several years, Satao II captivated tourists and conservationists alike as he roamed the same park. But then in early 2017, during a routine aerial patrol by the Tsavo Trust, his body was discovered, a poisoned arrow ending his life too. Two weeks after Satao II was killed, authorities arrested two suspects, one in possession of an AK-47, 12 poisoned arrows and three bows.

Today, in defiance, there is yet another tusker carrying the name Satao in the same park. He is Crooked Satao, his name reflecting his one crooked tusk. As with the two treasured bulls who came before him, Crooked Satao is often accompanied by askaris, a Swahili word for soldier or bodyguard. These bodyguards are younger bulls who've bonded with Crooked Satao, in a form of apprenticeship, where lessons of life such as navigating the land and the locations of food and water are passed from one generation to the next. For savanna elephants in particular, this unique form of bull grouping, around a tusker, is a touching sight to behold. After all, in the bigger scheme of life in Africa, no other elephants have been more targeted by poachers than those who carry big tusks, making their survival through every single day a matter of miracle.

So if you make it over to Africa in time, you may be fortunate to see the reigning greatest tusker who like his predecessors has become quite an attraction. He goes by the gentle name of Tim. And as the son of Trista, one of the females studied by Cynthia Moss, a good bit of his life has been recorded. Five years after his birth in 1969, his family numbered 23, but the horrific poaching of the 1970s and 80s caught up with them too. Initially, three of Tim's relatives including his family matriarch were killed. Next, in 1977, while Tim was only eight years old, the killers found his mother, Trista, and ended her life with a spear. Over the ensuing years, more family members were killed, including Tim's sister Tallulah who in 2003 was also speared to death. Tim himself has survived three spear attacks to date. It's likely that without the medical response following these attacks initiated by Big Life rangers and the Kenya Wildlife Service, Tim might have already gone to the great beyond to join the long list of named and unnamed giant tuskers who by their ivory-toting majesty were among the most unique living beings ever to walk our earth.

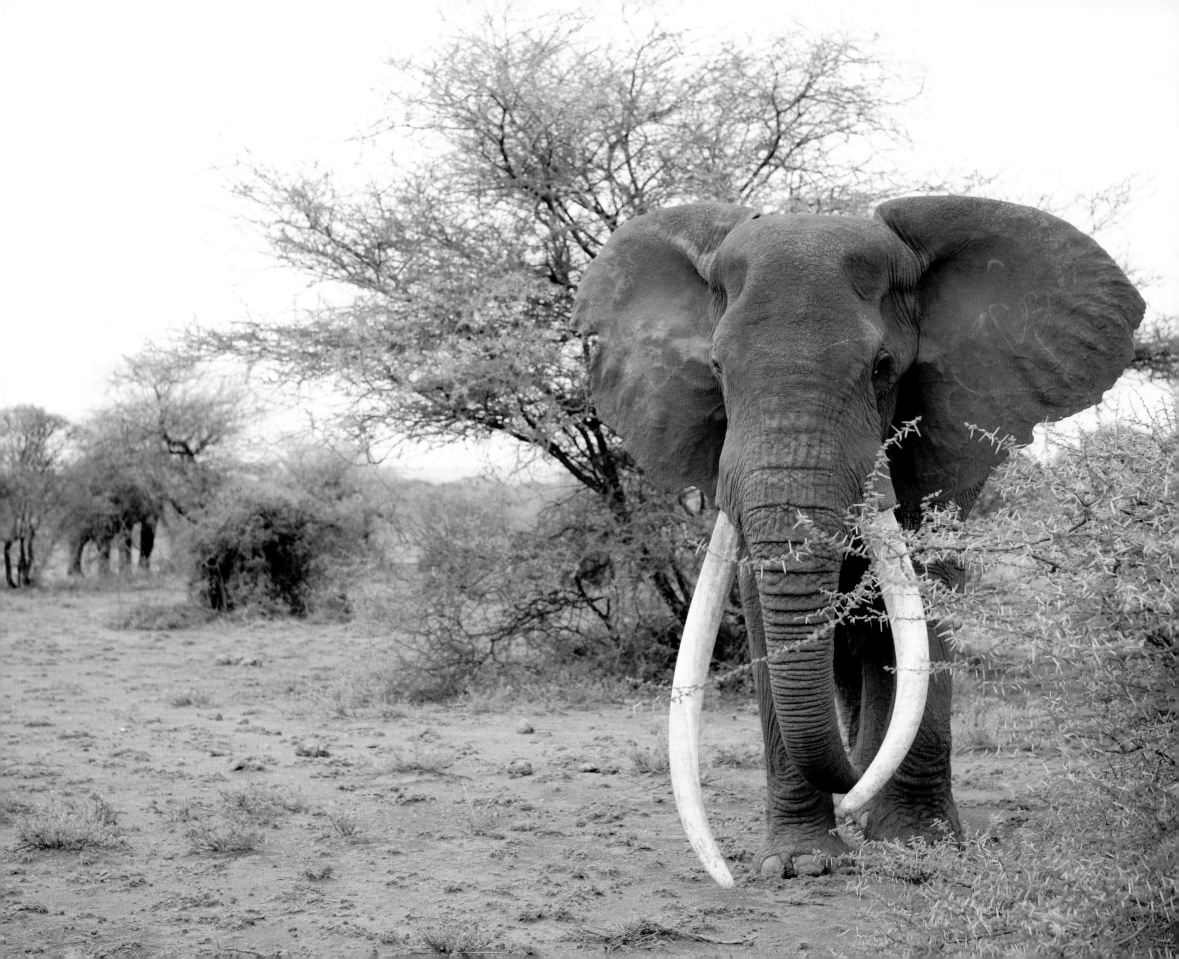

THE GUARDIANS

The age of the white hunter from Europe, and later the United States, brought the scale of elephant killing to a level where even the hunters themselves wondered if the species would survive. It was during this period that native Africans took notice of the potential for financial gain from ivory as they witnessed and played supporting roles in the widespread killing. As a result, once independence came to African nations and was followed by China's economic spring, native Africans became the exclusive suppliers of an unprecedented demand for ivory throughout Asia. With elephant populations across the continent already reduced to staggering lows, the poaching of elephants to meet this new demand was having dire results and soon an outcry went up from the caring around the world that the elephant could become extinct.

In January 1990, an international ban on the trade of ivory went into effect. The organization that declared the ban, the Convention on International Trade in Endangered Species of Wild Fauna and Flora (CITES), is administered through the United Nations. Initially, the CITES ivory ban brought a significant positive effect. But, by nature of the voluntary commitment of each member nation and the varying importance assigned to the lives of elephants by each country's greed and corruption, the effectiveness of the CITES ban on the trade of ivory diminished. Worse yet, CITES subsequently twice permitted the legal one-time sell-off of confiscated ivory; this triggered horrific periods of catastrophic elephant poaching each time.

From the arrival of the colonists through national independence and to this day, all of Africa's wildlife, particularly the elephants, have been vulnerable and consequently exploited. As far back as the late 19th century, there have been individuals around the world that have been sensitive to the immense pressure that mankind has been putting on wildlife. During the early 1900s, interest in zoology and biology blossomed in the Western world. Funding for the study and conservation of wildlife in the field became available and by mid-century the pioneers of today's conservation efforts were setting up tents. Today, addressing the complexities involved in protecting Africa's elephants has required a variety of approaches and has attracted a variety of different organizational styles. These styles include specialized grassroots efforts, legal advocates, anti-poachers, scientists, park managers and giant global concerns.

Richard Moller ran a sport-fishing business on the Kenyan coast and led camel safaris in Kenya's northlands before finding his calling in wildlife conservation. Following 11 years at Kenya's respected Lewa Wildlife Conservancy and four years of experience elsewhere, Moller co-founded the Tsavo Trust in 2013. With a team of 11 and the periodic assistance of other conservation organizations, Moller is actively protecting Kenya's largest elephant population and other wildlife by air and ground patrols

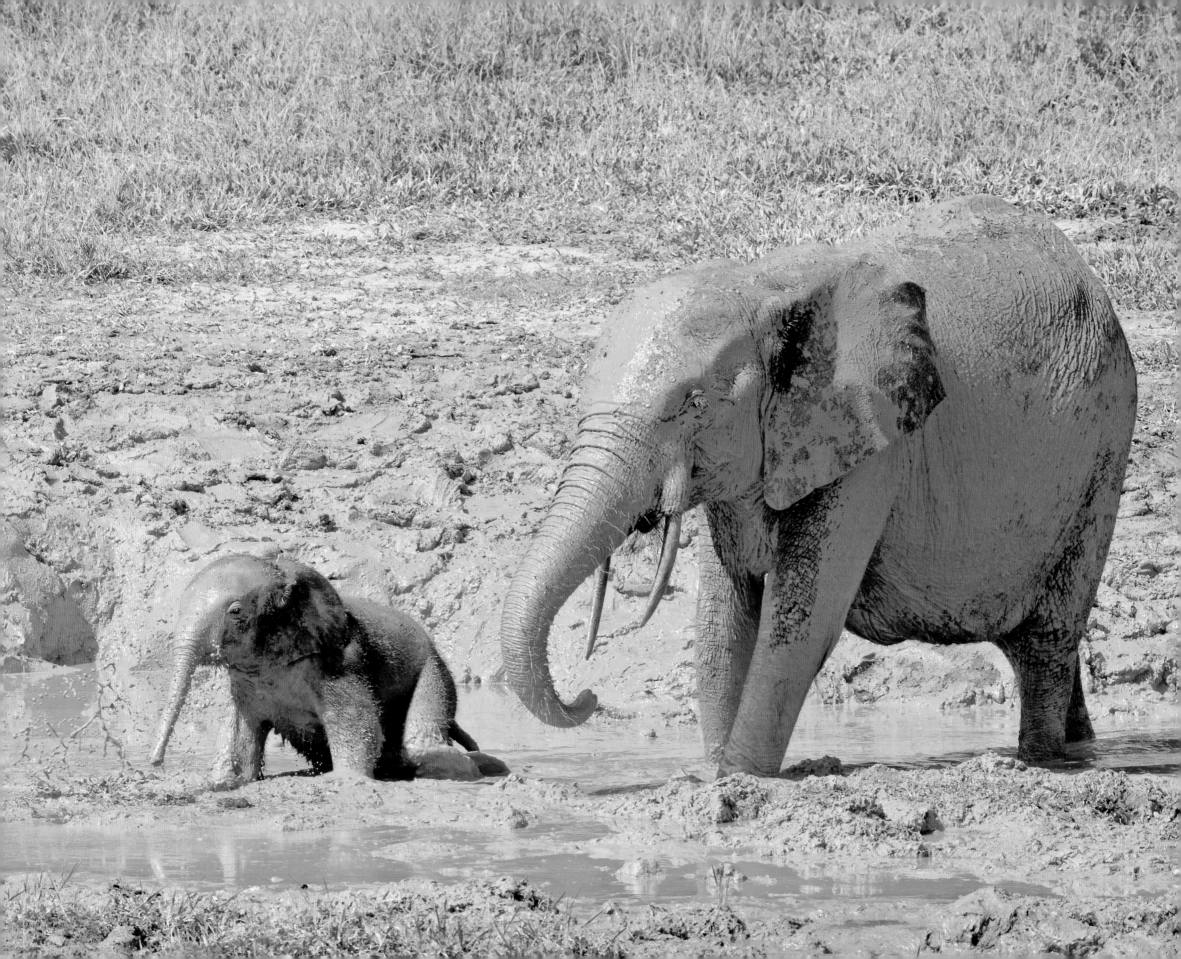

In 1980, Virunga National Park in the D.R. Congo was home to 8,000 elephants. Today, less than 400 remain. Virunga is widely known as a haven for rare mountain gorillas but it is also known for the men and women who protect the remaining elephants and gorillas.

in and around Kenya's largest national park. During the first three years of operation alone, the Tsavo Trust was involved in the arrest of 142 poachers, located 18 poacher camps and recovered 62 elephant tusks. Moller's efforts also include engaging with local communities, monitoring the movements and locations of elephant groups by radio collar, and the preservation of Africa's largest population of surviving tuskers. Given the huge expanse of his territory, 10 million acres, Moller's abilities as a bush pilot make the impossible possible.

In 2008, American Naftali Honig had taken a couple of years off before attending medical school to see the world. His backpacking adventure eventually took him to the Republic of Congo. Within a short time, he witnessed the arrest of a commercial bush meat trader but realized the poacher would soon be walking free, another example of Africa's often corrupt and failed wildlife protection efforts. So, with other activists he'd encountered along the way, he

co-founded EAGLE, Eco Activists for Governance and Law Enforcement and its supportive group PALF, Project for the Application of Law for Fauna. Honig and his team began investigating wildlife crimes, assisting in securing arrests, following criminals through the justice system and lobbying media and government officials to create a tougher climate. This effort then expanded into the training and deployment of sniffer dogs to track criminals and detect hidden ivory, bush meat, weapons and wildlife parts. By becoming involved with criminal cases at the crime scene, Honig could then be involved from the beginning of each case, ensuring that poachers were prosecuted to the full extent of the law, averting the opportunity for corruption.

Nick Brandt was directing music videos for big names in the American music industry when he went to Africa for the first time. Captivated by the wild world he found there, he shifted his life to photography to record what he was seeing. Heartbroken by the widespread

killing of wildlife, Brandt vowed to do all that was possible to stop it. Meanwhile, Kenyan Richard Bonham was leading safaris into nearby Tanzania, working as a bush pilot and managing a wildlife conservation program with the financial support of American Tom Hill. In 2010, Brandt contacted Bonham and, together with Tom Hill, they founded the Big Life Foundation. Today, Big Life efforts span an ecosystem covering two million acres in Kenya and Tanzania, utilizing more than 40 outposts, employing over 300 men, 15 vehicles, tracking dogs and aerial surveillance. Over 1,000 poaching arrests have been secured with more than 3,000 weapons confiscated. And, in an effort to attack the poaching problem from all angles possible, Big Life has expanded its operations from anti-poaching to include local community education, and the mitigation of human-wildlife conflict that includes an extensive fence-building program to prevent elephants from entering dangerous areas.

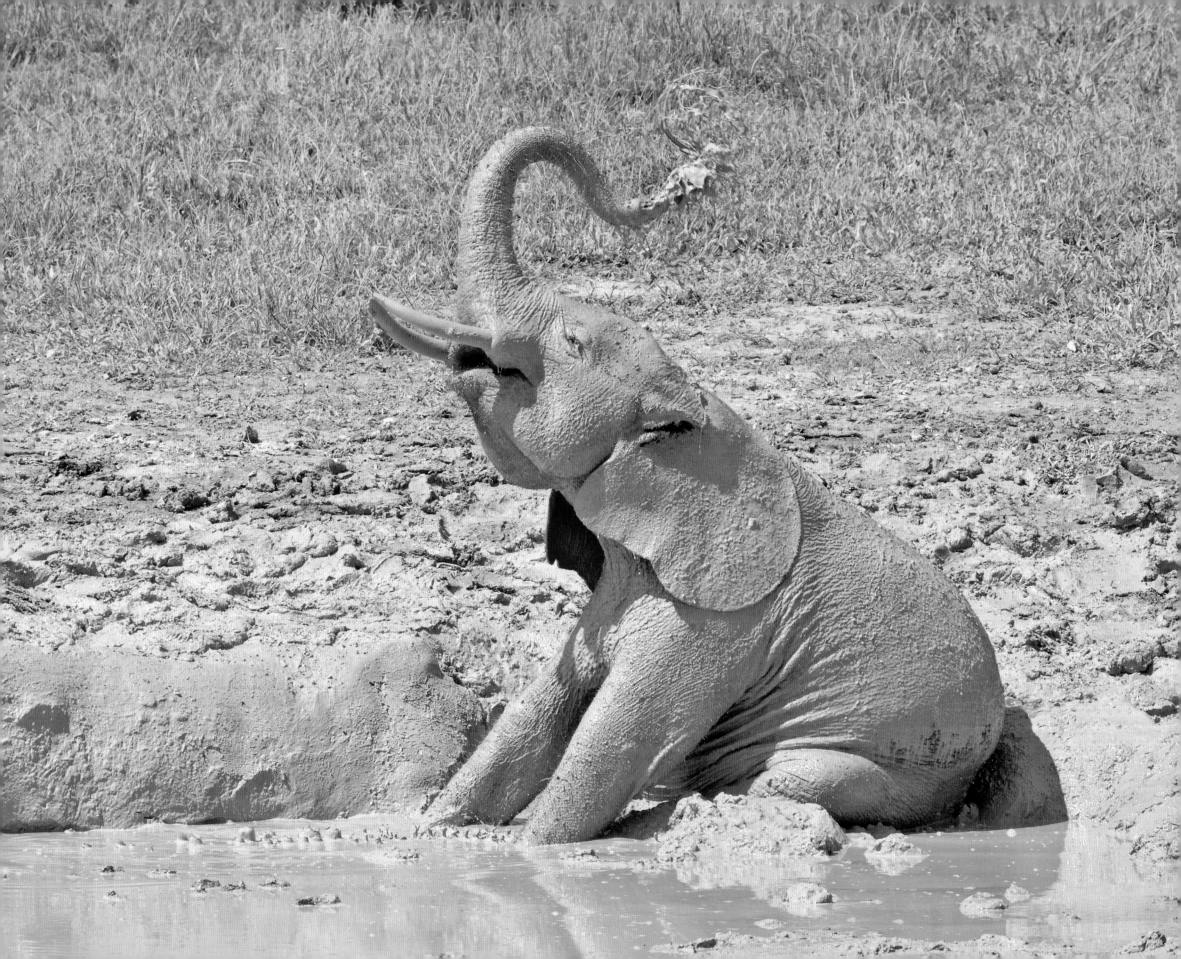

> *"The hardest part of my job is having to bury the men that have been entrusted to me. Since I started at Virunga in 2008, 39 rangers have died. Since the war started in 1996, about 160 rangers have died. Even though it is probably the most dangerous job on the planet, not a single ranger has left the corp."*

EMMANUEL DE MERODE
DIRECTOR, VIRUNGA NATIONAL PARK, D.R. CONGO

Iain Douglas-Hamilton was 23 years old and wanted to study lions. It was his first job in the field following his undergraduate studies in zoology on the path to a doctorate in England. Instead, he was assigned the study of elephants and since 1965 he has dedicated his life to their welfare. From the 1970s onward, Douglas-Hamilton's studies of elephant behaviour have led to his conservation efforts in 34 nations, pioneering aerial surveys and population studies. From his statistics, he was the first scientist to sound the alarm of potential elephant extinction. During the 1980s, Douglas-Hamilton worked as an advisor to Uganda's national parks authority, developing anti-poaching patrols by air and ground. And in 1993, he founded Save the Elephants (STE). The group continues to base its efforts on Douglas-Hamilton's science by utilizing data secured from the air and from widespread use of radio tracking collars on selected elephants carried out in Kenya and 28 other nations.

Douglas-Hamilton has been a tireless ambassador for Africa's elephants, speaking before countless governmental and private events in the United States and Europe. He co-authored two books and has been featured in numerous documentary film projects on conservation. His two daughters have since joined him in the effort and are now widely respected in their own right.

African Parks was the brainchild of European conservationist and businessman Paul Fentener van Vlissingen following a meeting he had with Nelson Mandela in South Africa in 1998. In 2000, van Vlissingen was joined by Michael Eustace, Anthony Hal-Martin, Manuso Msinang and Peter Fearnhead, all elevated and successful individuals, to officially form the organization now headquartered in South Africa. The motto of their carefully crafted enterprise, 'A business approach to conservation', was aptly chosen as many national parks and protected areas throughout Africa

have suffered from a lack of funding and mismanagement. The African Parks model relies on the organization taking over complete, long-term responsibility for the rehabilitation and management of derelict parks while remaining accountable to the government of the nation involved which retains ownership. This approach has come to be known as a Public-Private Partnership (PPP) and was pioneered by African Parks. To date, African Parks manages 15 national parks and protected areas in nine African nations. Employing more than 1,000 rangers, African Parks has the largest anti-poaching force on the continent. Along with the protection of wildlife, the organization manages every aspect vital to the parks' success, including training additional rangers, promoting tourism, fundraising, developing infrastructure and supporting local residents. An example of its effectiveness, African Parks took over Malawi's Majete Wildlife Reserve in 2003.

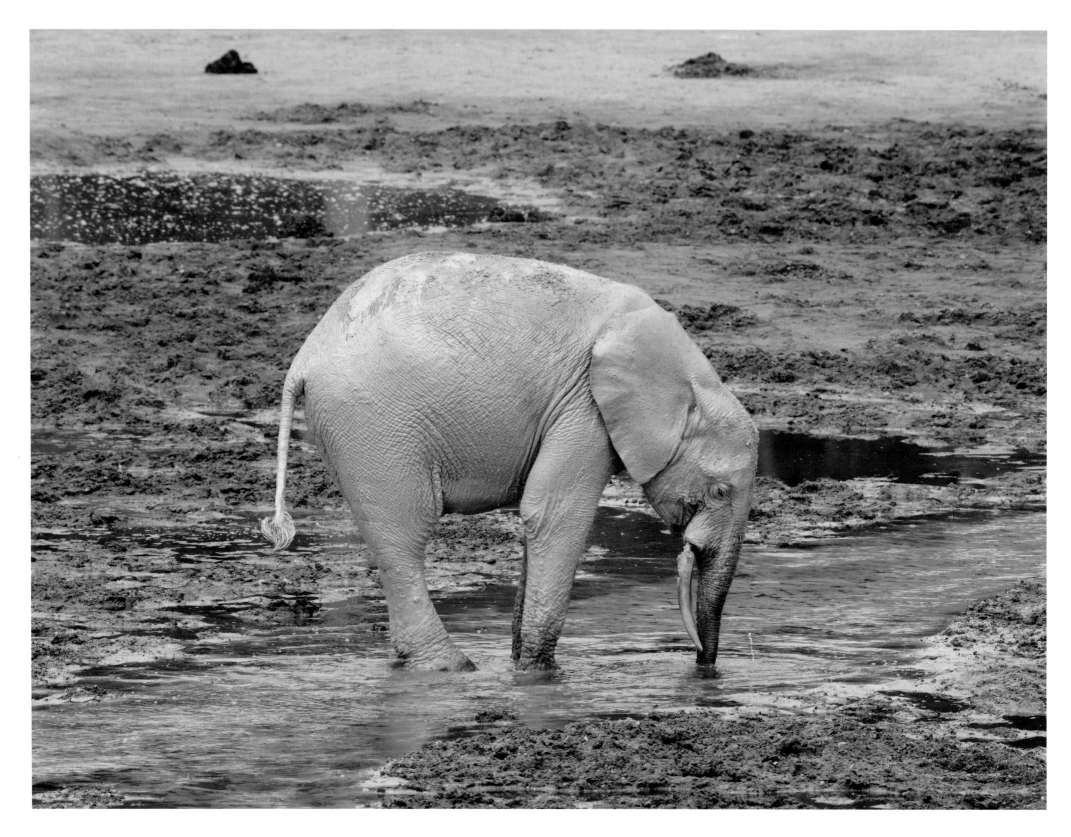

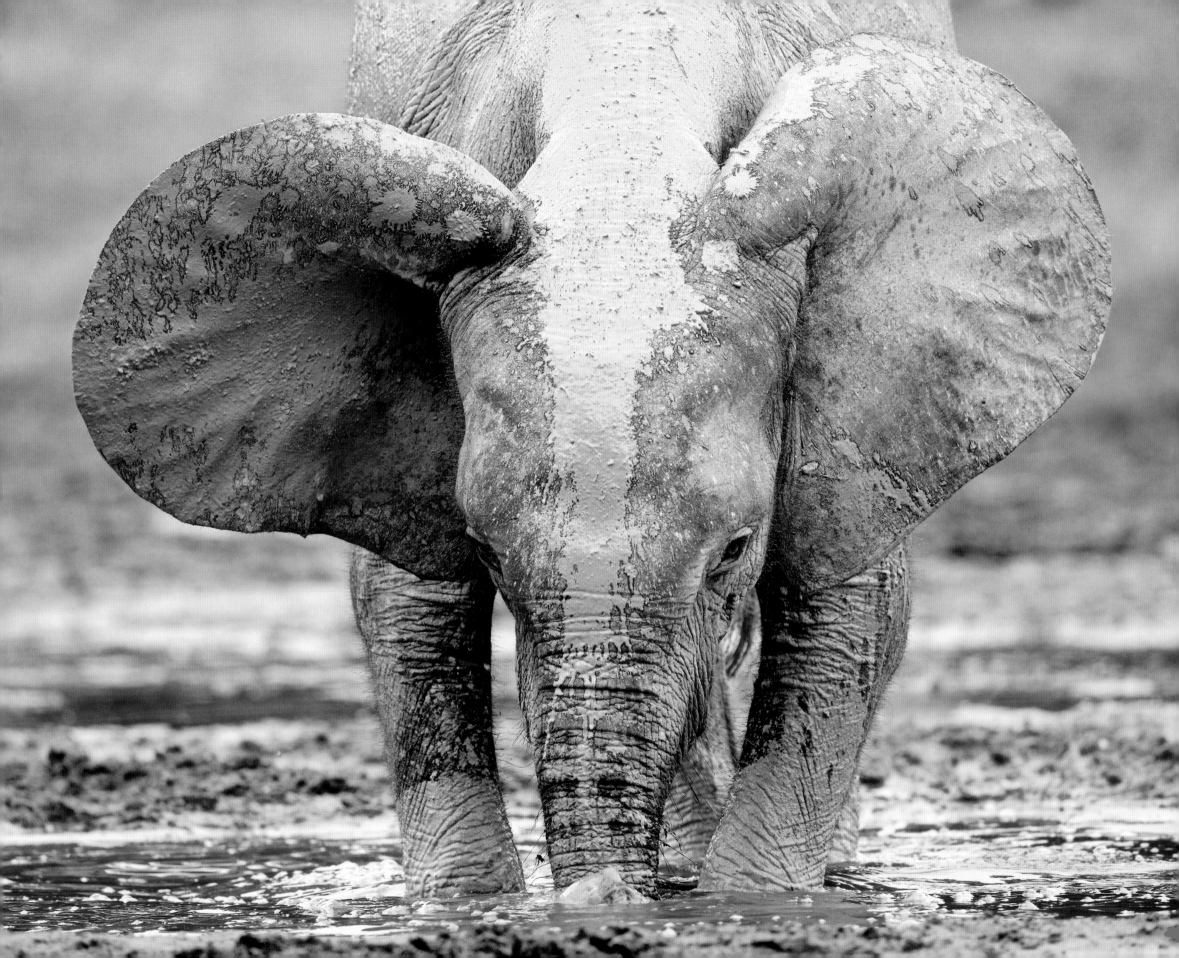

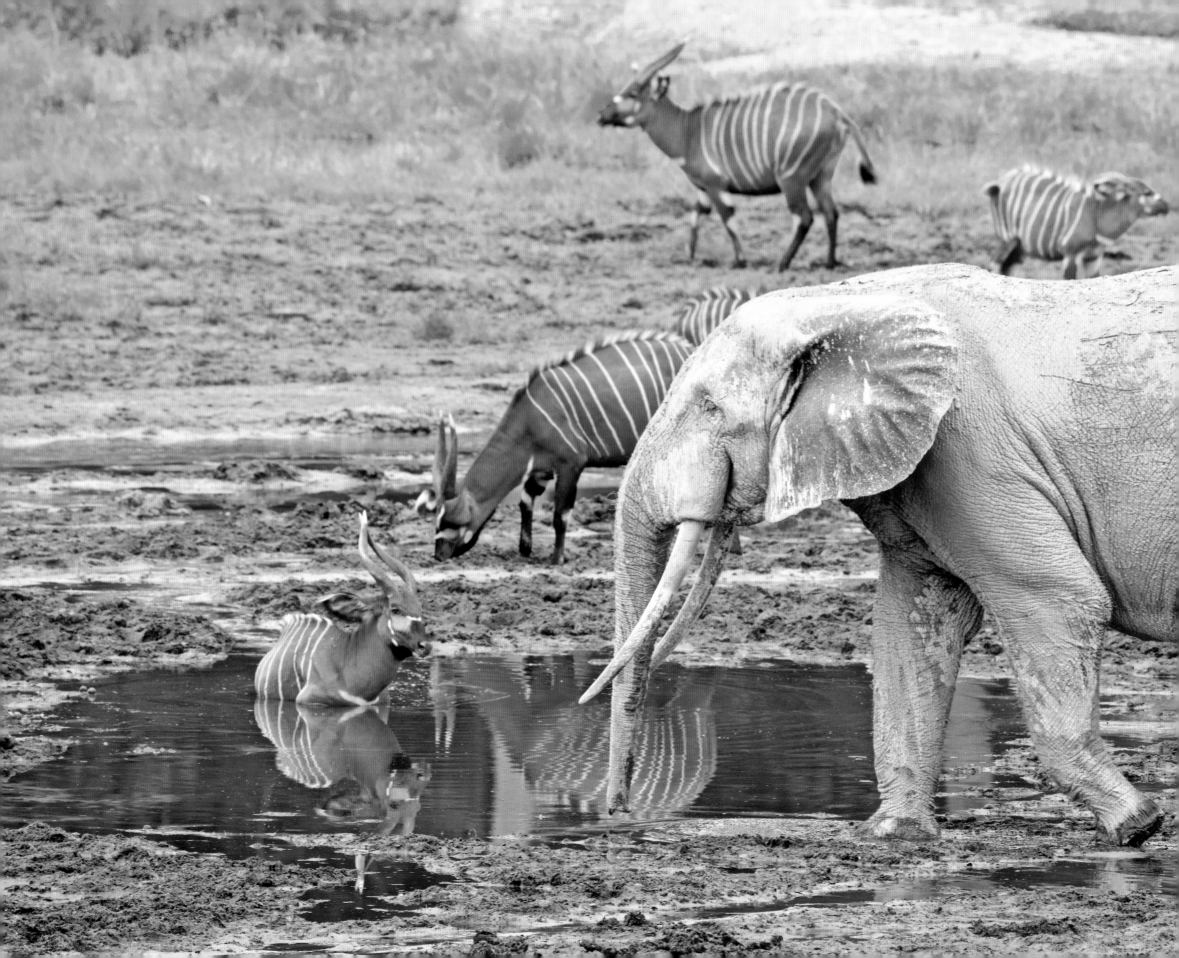

"They who have suffered so much at the hands of humans, never lose the ability to forgive, even though, being elephants, they will never be able to forget."

DAME DAPHNE SHELDRICK
2012

At the time, the park was almost void of wildlife, had no employees and no income. Today, Majete has not lost a single elephant to poaching since 2006, employs 180 people, receives over 8,000 tourists annually and takes in nearly one and a half million dollars in revenue each year.

And finally, there are the giant, global conservation organizations at work in Africa, led by the Wildlife Conservation Society (WCS). Back in 1895, a number of conservation-minded Americans, including Henry Fairfield Osborn, curator of the American Museum of Natural History, and George Bird Grinnell, founder of the Audubon Society, created the New York Zoological Society at the urging of the rising Theodore Roosevelt. Initially, the purpose was to advance wildlife conservation, promote the study of zoology and create a zoological park. During the late 1950s, the organization began a series of surveys and programs in five African countries. In 1993, the Society changed its name to the Wildlife Conservation Society with continued promotion to the American public made through its flagship, the Bronx Zoo. Today, the WCS is at work in more than 60 nations around the world on 500 projects, employing over 200 PhD scientists. In Africa, the WCS has the largest field program of all the conservation groups and is the longest standing, with a presence in 15 countries, accounting for 28% of the forest elephant range and 14% of the savanna elephant range. WCS scientists and staff work with governments and with conservation partners to protect elephants by training rangers, monitoring elephant movements, developing intelligence networks, working with local communities to accommodate the presence of elephants and working with judiciaries to ensure criminal prosecutions. With a presence in Uganda since 1957, the WCS has developed an extensive elephant management program that has included digging trenches and planting thorny bushes to steer elephants away from dangerous crop raids.

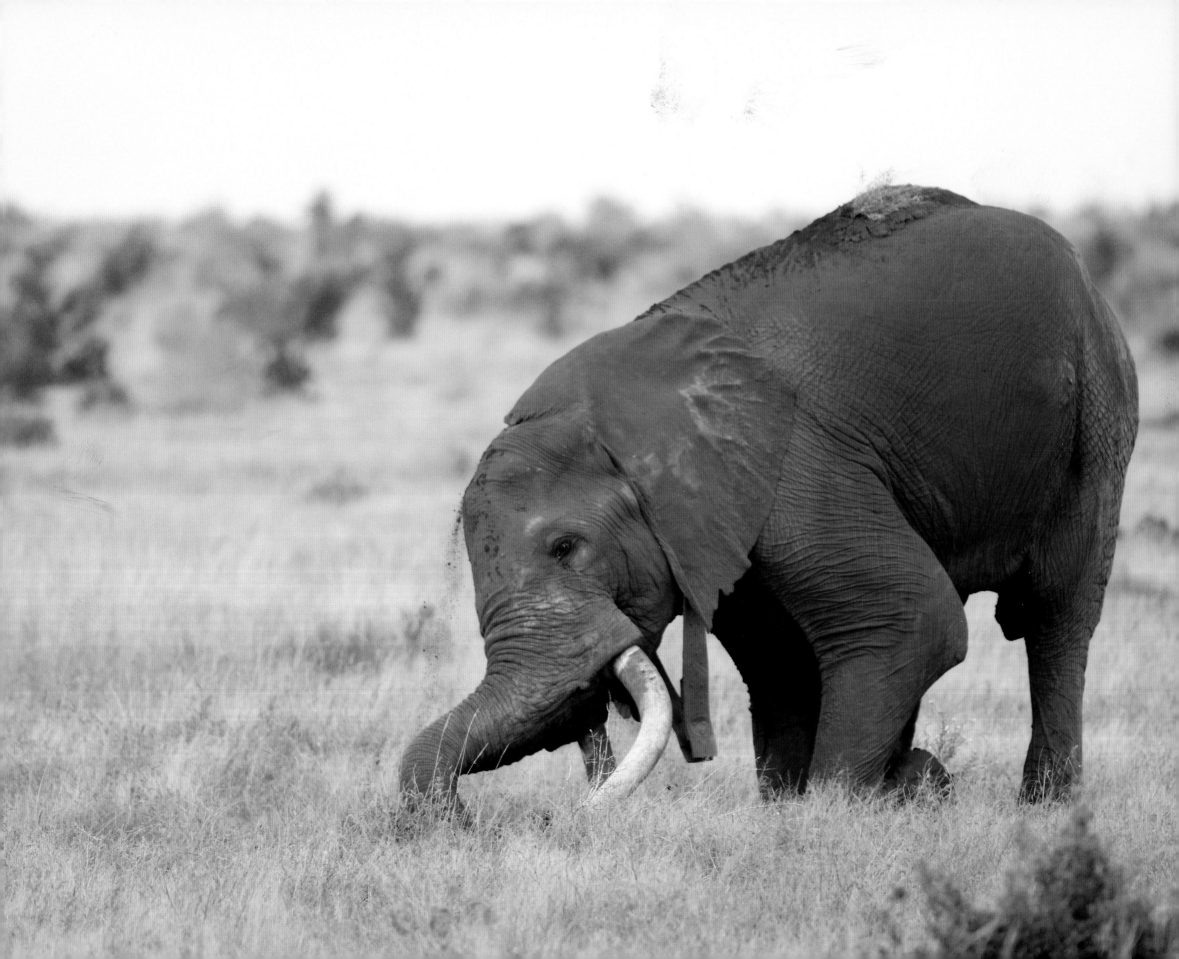

Mark and Delia Owens met in graduate school in the United States. Both shared a dream of saving a part of Africa's disappearing wilderness. Their conservation efforts are legendary and are chronicled in three books. In one valley of study, 16,000 of 17,000 elephants had been killed and the poaching was ongoing. Despite the situation, one brave bull was determined to trust Mark and Delia. For weeks each year, the elephant they named Survivor would feed in and around their camp, and their paths would cross at other moments. In time, the presence of Survivor became their inspiration. At a low point, they believed they had witnessed his death by poachers, but examination of the carcass proved otherwise and Survivor lived on.

Back in the United States, the 96 Elephants campaign was launched in 2013 to raise American public awareness of the ivory trade. And way back in 1967, it was the WCS supported Iain Douglas-Hamilton with his first elephant survey.

While it has taken the engineering and wealth of a global effort to make the progress that's been made so far, the sweat and dedication of native Africans has been a success story of equal magnitude. From various corners of the continent, caring individuals have stepped forward to do all they can to save the animals they grew up with and cherish. The ranks of the scientific studies, the elephant orphan sanctuaries, the anti-poaching efforts, the park rangers, the park staffs, the safari guides, the camp managers and staff, the veterinarians and numerous other contributing institutions are all filled with these good people, from communities large and small, who have risen to the occasion.

It has long been apparent to the guardians of elephants that they are facing a complicated and violent world. Over the course of the past few decades, thousands of park rangers and other anti-poaching personnel have been killed in the line of duty. With the use of automatic weapons in the hands of poachers becoming common since the 1980s, the wilderness of Africa has frequently become a war zone when poachers have been challenged by authorities. In South Africa alone, in 2015, 70 firefights were recorded. Also in the same year, just a few months before my time in the Democratic Republic of the Congo, poachers killed three park rangers and an army officer as the authorities had tracked the signal of an elephant's transmitter to a poacher's camp. And then just a couple of months following my departure, one of the rangers I'd met was also killed.

While it has been reported that elephant poaching rates have been declining for several years now, it's clear that this is due in large part to the fact that there are fewer elephants left alive to poach.

Local extinctions have become the norm. Meanwhile, the pressure on surviving elephants has increased. At the 2016 CITES summit of member nations, Professor Lee White, the Director of the Nation of Gabon's National Parks and a CITES delegate, reported that poachers in his parks no longer drop their weapons when confronted by law enforcement but instead routinely shoot at his rangers on sight, a story repeated across Africa. And another crisis has been developing for a while now, that of increasing conflicts between hungry elephants and hungry farmers of the exploding human population. Spear attacks on crop-raiding elephants are now commonplace and many of these elephants are not surviving. The guardians of elephants have their work cut out for them but thankfully their passion to save elephants, combined with strong intellect, is finally winning over the human beings who previously had no appreciation for the lives of elephants whatsoever.

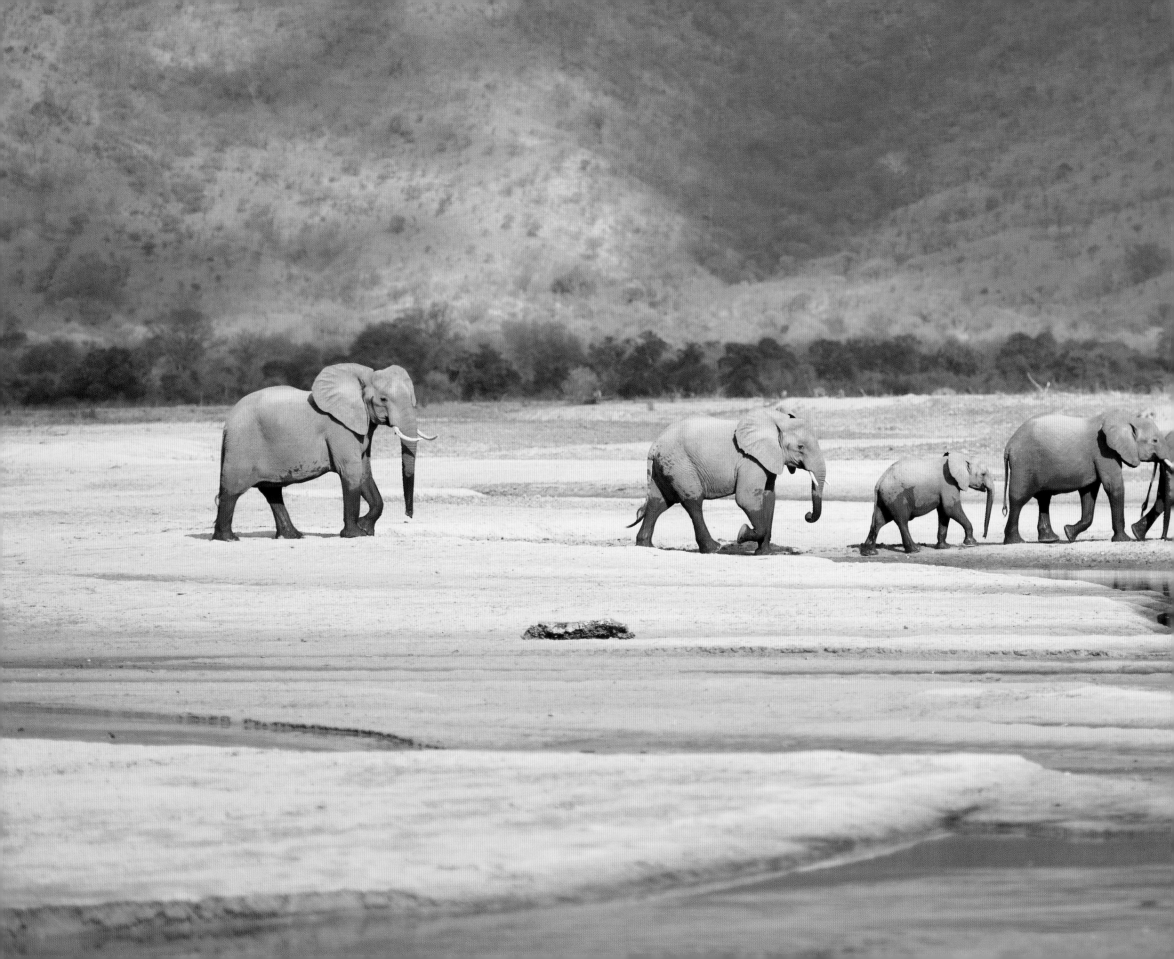

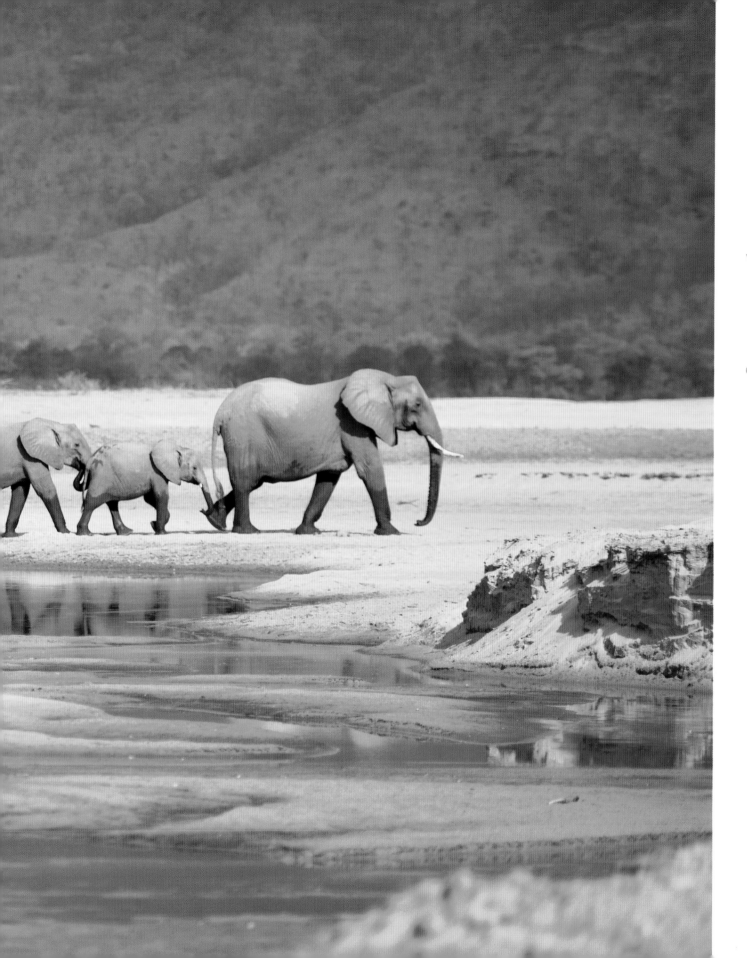

Kenya. Daphne Sheldrick grew up taking walks into the forest with her parents, siblings, dogs, Bob the impala, Daisy the waterbuck and Rikki-Tikki-Tavi the mongoose. She went on to be one of the most accomplished conservationists in history. Early in her career, an elephant named Eleanor entered her life. Four years prior, Eleanor had been found standing alone, two years old, not far from the body of her dead mother. At her new home with Daphne, Eleanor immediately took responsibility for two other elephant orphans. As the worst drought on record continued and more orphans were brought in, Eleanor adopted the care of each one and also brought home stray orphans she discovered. With time, Eleanor's family of elephant orphans were joined by orphaned rhinos, buffaloes, ostriches and a zebra.

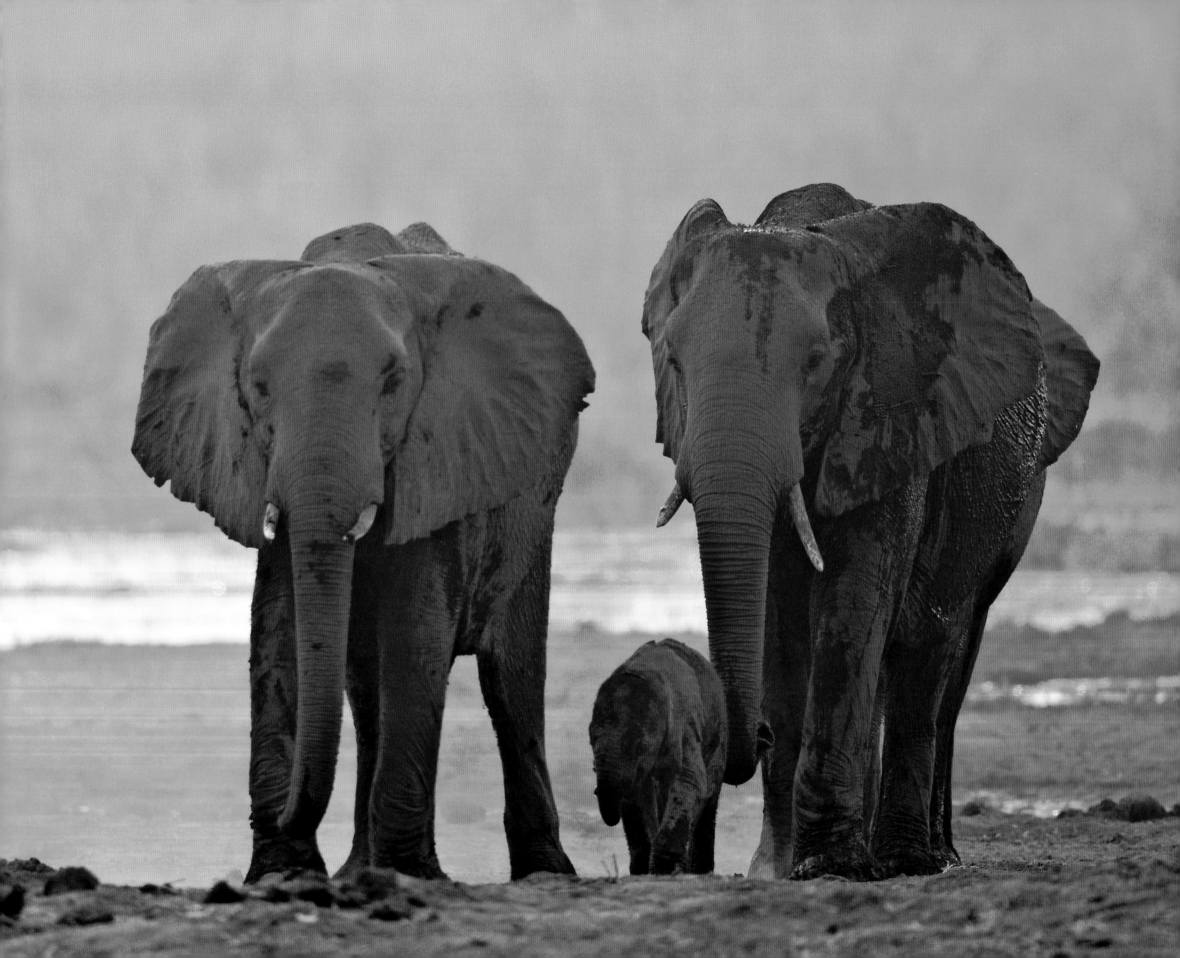

DOZER

One night, while drifting off to sleep in my tent in Botswana, I was awakened by the sounds of branches breaking and leaves rustling in the shrubs and trees just outside. Curious to see what was going on, I made my way in the darkness to one of the windows of the tent. Under the light of the moon I made out the shape of an elephant and, behind that one, more elephants. Then another big branch snapped off in another direction. I made my way over to a window on that side of the tent and saw still more elephants. In all, I counted over 20 elephants surrounding my tent and having their way with every sizable tree and shrub in sight. It was a feeding frenzy. Crash! Another young tree toppled over and then came the sound of leaves being stripped off its spindly little branches. I watched in awe for a good half an hour at the voracious eating and the thorough destruction that was going on. In the morning light, the area around my tent looked much like images on television I'd seen of the path left behind by a killer tornado.

While studying a group of bulls one day in Zimbabwe, my eyes were drawn to the exploits of one fellow in particular. While all had chosen to look for food in a heavily vegetated area where few other wildlife could venture, over the course of about an hour, the most active bull had first knocked over one sizable tree by placing his shoulder into it, and then went on to fell three other sizable trees nearby. The demonstration of strength and determination was awe-inspiring. What had one moment ago been a tree became an upended exhibit of roots and freshly tilled soil. For his exhibition of power, I named this fellow Dozer, short for bulldozer.

Prior to these events, I'd been aware from reading several African habitat studies of the role that elephants play in the ancient balance between animals and vegetation across the continent. In short, elephants have been a key factor in Africa's biodiversity. From their tree and bush thinning exploits, areas of safety and food supply are opened up for smaller

animals. Plant nutrients are spread to barren areas by their dung. Seeds of edible plants and their fruits are similarly dispersed. And, in general, the regeneration of Africa's landscape as we know it has been encouraged through the ages as a result of the presence of elephants. The elephant, by simply walking over the land and possessing such an appetite could easily and rightfully be credited with being Africa's most skilled gardener.

But gardeners, in the human scheme of things, are often held in the somewhat lowly status of maintenance, alongside the likes of janitors and house cleaners. Consider Britain's great Groundnut Scheme. Started just after World War II as a stimulant to Africa's and Great Britain's sagging economies, the plan called for the clearing of five million acres in what is today Tanzania. On this land, vast quantities of peanuts would be planted and harvested. The first step of this grand project was the disposal of the hundreds of thousands of animals that lived there, including elephants.

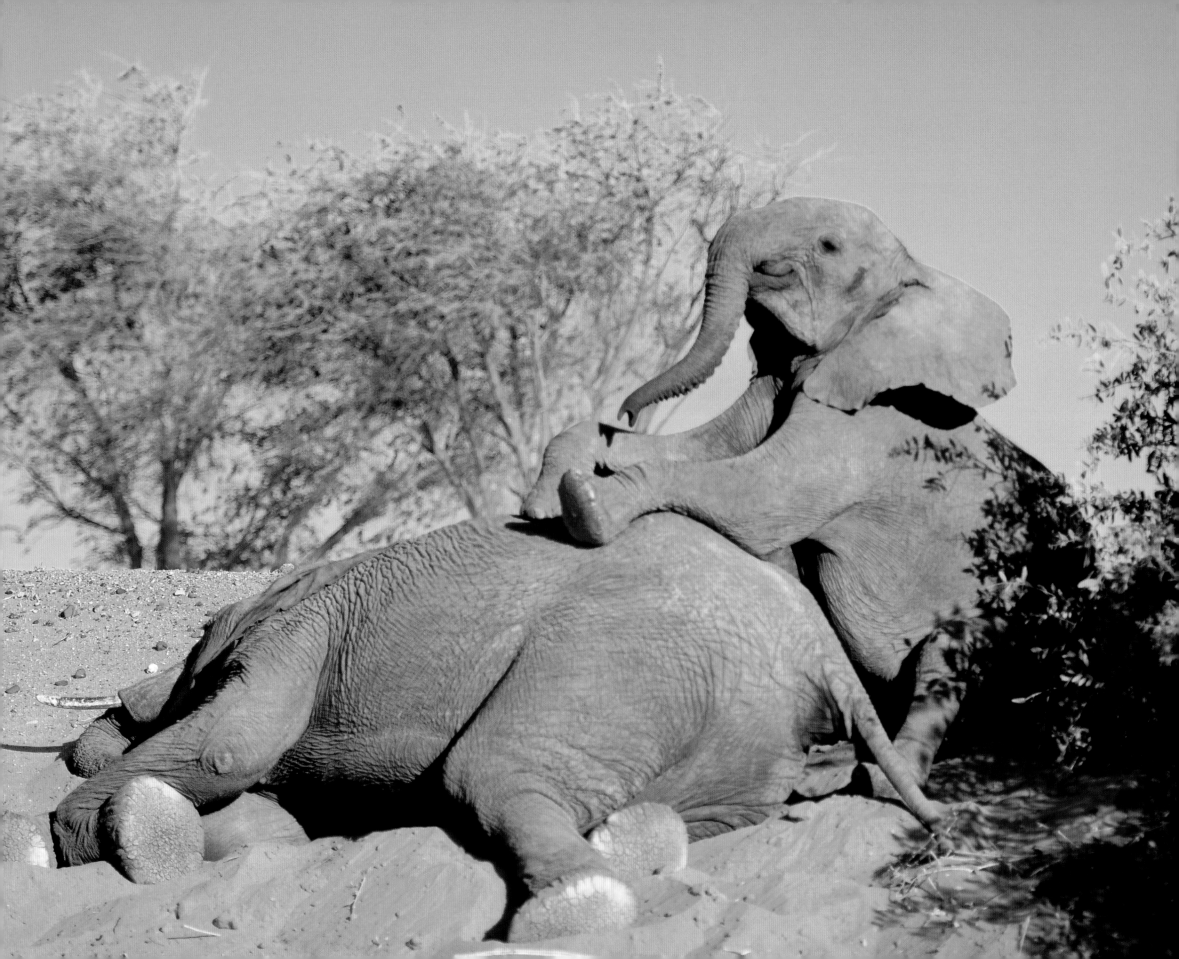

Namibia. A scientific study completed in 2015 of Namibia's Etosha-based savanna elephants confirmed that Africa's elephants incredibly and consistently know the closest source of water to their current location, no matter how remote. And, they will travel the most direct route to get to that water over a distance of at least 30 miles.

Hunters were brought in and made it so. The slaughter was so vast that I can find no records anywhere of the numbers of each species wiped out. It was clear that there was a new gardener in town and in the end, it was proven that he wasn't very good. After over four years of intense effort, it was concluded that the soil was poor, no suitable supply of water existed and the few plants they'd managed to establish provided poor yields. The scheme was declared a failure and the area became a dust bowl.

Also competing for the great grey gardener's land were the ranchers who came in. While raising livestock had been going on for quite a while among the native Africans, the colonists brought with them the notion of large-scale cattle ranching. Like the requirements of large-scale agricultural projects, ranching implied the total human control of sizeable pieces of land. Fencing on an unearthly scale was created. All predators, especially lions, had to be exterminated. Then all other grazers who would compete for the grasses the cattle would need also had to be eliminated. And finally, these artificial habitats never took into account age-old migration routes. As a result, many a mile of fence was routinely trampled by elephants on their way to necessary food and water and, in turn, many an elephant was destroyed in revenge.

The long-term success of both farming and ranching operations in the wild lands of colonies necessitated the creation of a new career, the creation of an official government post: Game Control Warden. The more intrusive colonial man became in Africa, the more conflicts arose between the settlers and the wildlife. In order to bring more land under control, more extermination had to be undertaken and the size of the animal was of little consequence. In fact, the bigger the animal, the bigger were the problems they created. The slaughter by white hunters was astounding. As one hunter became tired of executing his job, another was hired to take his place.

Warden R.J.D. Salmon (1888-1952) of Uganda killed over 4,000 elephants. Warden C.R.S. Pitman (1890-1975) also of Uganda shot nearly 4,000. J.A. Hunter (1887-1963) of Kenya shot over 1,000 rhinos and countless elephants. And the list goes on.

Yes, it became evident early on. Once the European adopted Africa as his own and influenced the native Africans in the process, there was really no more need for the services of the grand old gardener that had plied his trade throughout most of Africa for longer than mankind can remember. Sure, you can still see him at work here and there, but even his days in many of these places seem numbered. It's my contention that if there is at some point only one elephant left alive, that elephant will be following in the footsteps of Dozer, knocking over trees to find just the right roots to eat and, in the process, opening up the tangled undergrowth of thickets for the benefit of countless other wild animals to benefit from.

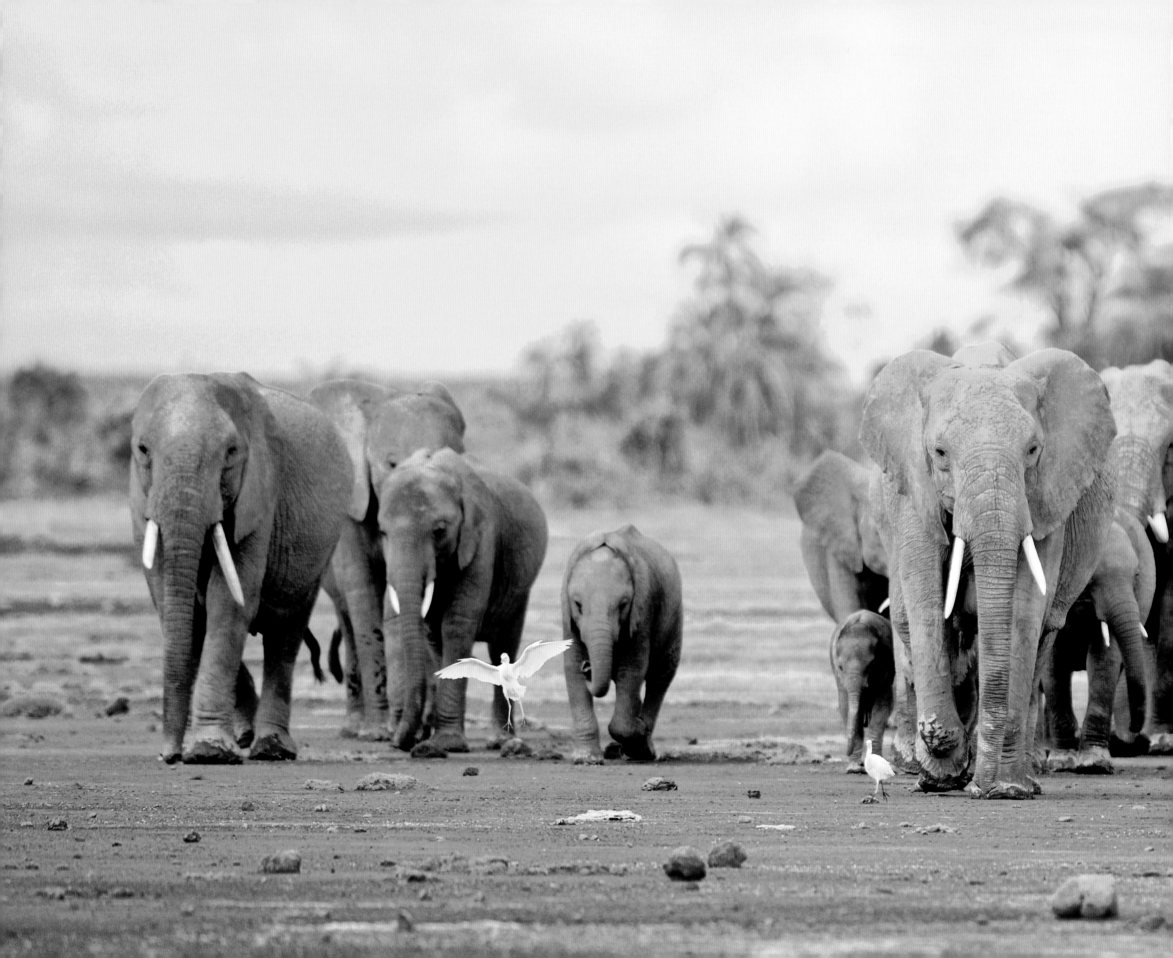

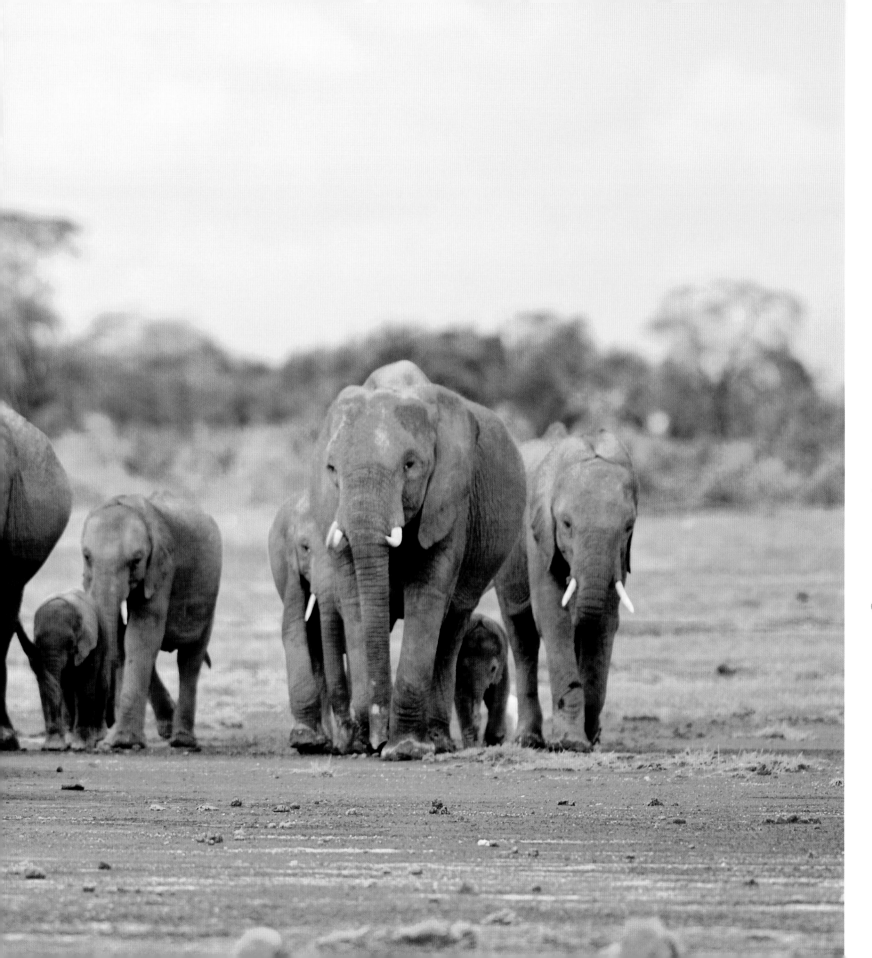

Kenya. In Samburu, a children's movement to protect elephants and other wildlife is gaining momentum. "There will be no poaching in my area," said James Ntopai, 25, a Samburu warrior and project coordinator for Kenyan Kids on Safari. "The community now understands the importance of conserving elephants and other wildlife." Founder Todd Cromwell, like a growing number of others, realizes that the future of all wildlife in Africa is in the hands of today's children and these children must be well prepared to take on their future responsibility.

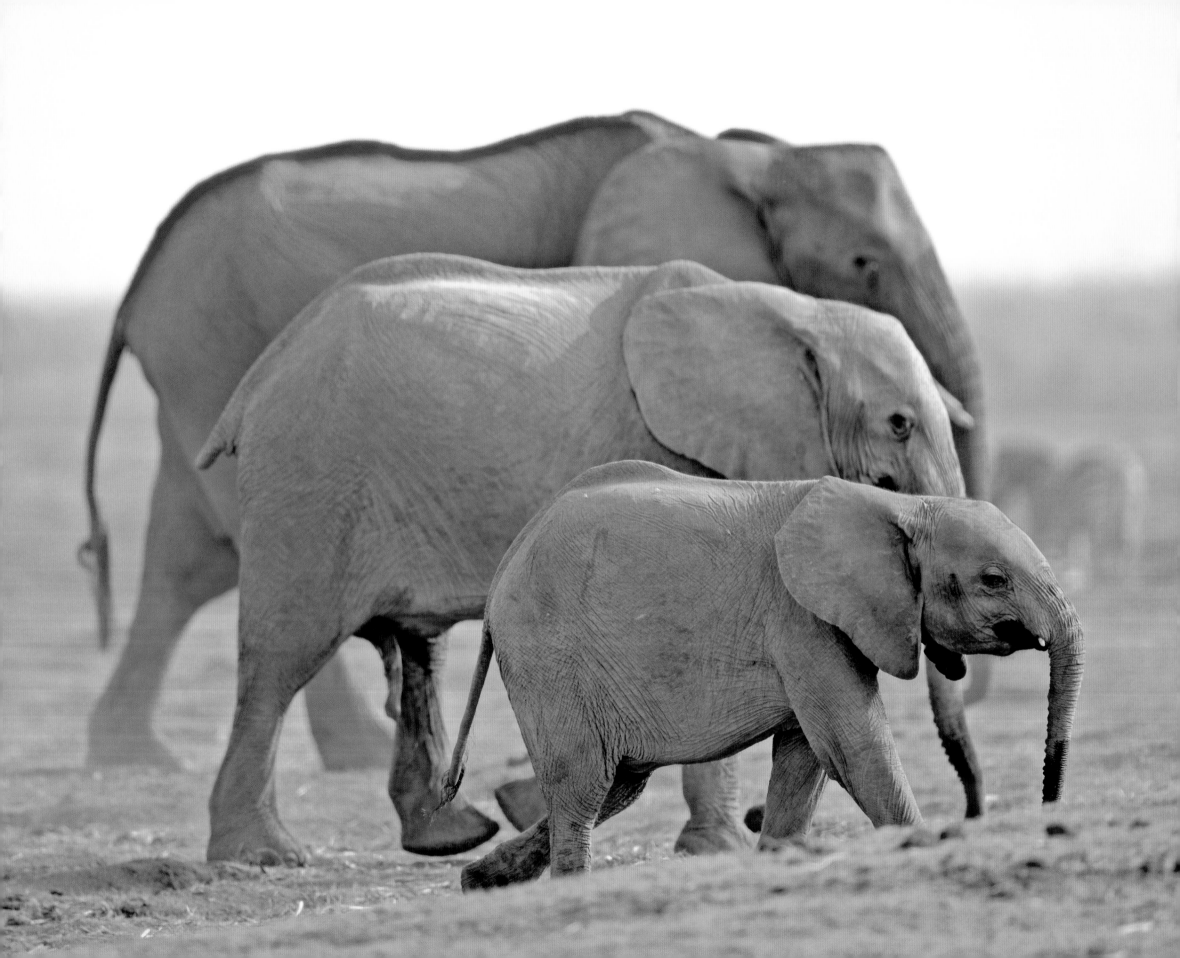

PAPER PARKS

The notion of setting aside areas of wild land as preserves for the enjoyment of future generations of mankind stretches around the world. Even the poorest countries have tiny corners of their territory where the land is left untouched for the most part and wildlife is somewhat free to roam. Parks, like zoos, have come to represent places where the common man can get a glimpse of the world as it once was and see animals that once dominated the landscape before man's conquest. While often a last-ditch attempt to hang onto what once was, the creation of parks and reserves in Africa has been a noble effort, on paper. Sadly, most nations of Africa have failed to allocate the resources necessary to maintain the parks they created or never had the financial ability to do so in the first place. Critical in this history has been the inability to protect the wildlife that was intended to be kept safe. Three parks and reserves have left us with lessons too troubling to ever forget.

SELOUS

During my time in Tanzania, I would occasionally ask locals about Selous; the Selous Game Reserve in the southeastern part of the country. Selous is one of the largest and most diverse animal reserves in the world, a UNESCO World Heritage Site. The land, according to all reports, is much the same as it was thousands of years ago as no permanent human structures or habitation have been allowed. All the iconic animals of Africa can still be found here and traditionally in larger numbers than anywhere else in Africa.

Ironically, the Selous Game Reserve is named in honour of one of the greatest elephant hunters of all time, Sir Frederick Selous. As a renowned turn of the 20th century explorer, big-game hunter and guide, Selous took the lives of thousands of wild animals with many of them later put on display in museum and natural history collections around the world. While the government of Tanzania is to be applauded for setting aside the land, most of the Selous Game Reserve is tragically leased to private hunting concessions. It is under this veil of legalized killing that one of humanity's greatest crimes against nature has taken place.

During the 1970s, the Selous Game Reserve was home to over 100,000 elephants, the largest concentration of elephants at that time in the world. But, as the price of ivory rose in the following years, so too did the poaching of elephants. By 2010, two out of every three elephants who had once called Selous home had been killed and today only a few, just over 10,000 souls, survive. So, in getting back to the response to the inquiry I made about paying Selous a visit, without exception I was confronted by silence, fleeting looks off into space and the words "don't bother". So consequently, I didn't. Sadly, I didn't visit Selous Game Reserve in Tanzania and from that time until now, I think of Selous often, thinking of it as it must have been, a thriving haven for countless elephant families not all that long ago.

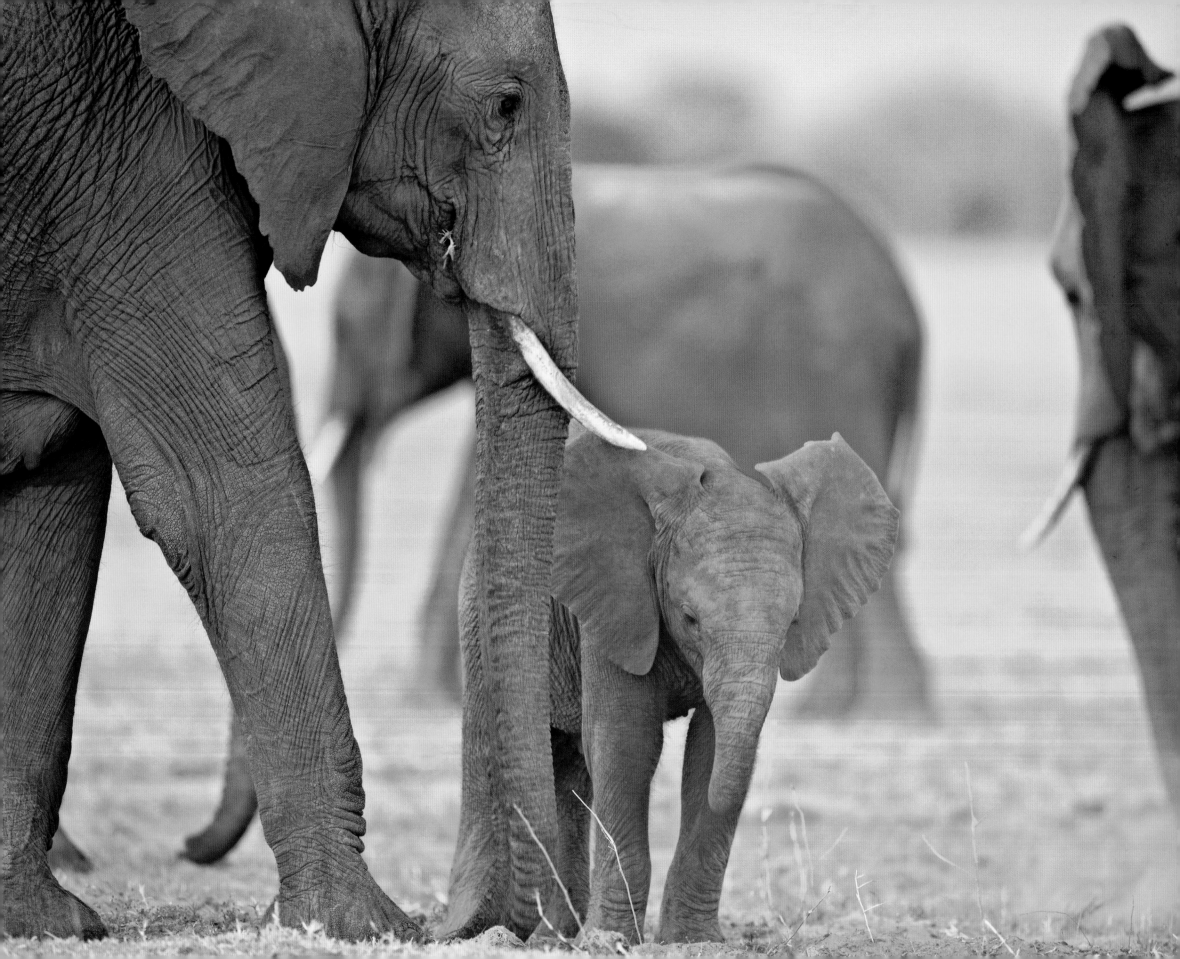

Lawrence Anthony was a highly respected international conservationist and author. In 1998, he purchased a former hunting property in South Africa, turning it into a wildlife sanctuary. He rescued numerous elephants from dire situations, developing a close bond with several of them. On March 2, 2012, Lawrence Anthony died of a heart attack. By the second day following his death, the elephants he had rescued, who had not been to the home in a year and a half, had traveled 12 hours from their location to stand vigil outside of his home. For two straight days, they lingered before moving back into the bush. Exactly one year later, on the same day, at the same time, the elephants returned again to stand vigil. And, exactly one year after that, on the same day, at the same time, they returned yet again.

MINKÉBÉ

As I was planning a trip to Africa to photograph forest elephants, I set my sights on the nation of Gabon. At the time, I believed that of Africa's remaining 100,000 forest elephants, this country held the largest surviving population and more than half of those were still alive. Within this country, I knew that the remote Minkébé National Park along the border with Cameroon was, by nature of its remoteness, a pristine sanctuary for elephants. From what I'd read, Minkébé National Park was a special place. Isolated from humanity and the centuries of killing by humans that had scarred the rest of Africa, the wildlife here had flourished. As recently as the year 2000, humans who'd had contact with wildlife here reported witnessing an innocence, a lack of fear in all animals from crocodiles to elephants.

But a lot can happen in Africa in five or six years. As I got up to speed on the current state of elephants in Minkébé, my heart sank. The park's asset of isolation had become its biggest liability. Very few roads of note existed within Gabon to get tourists to and from the park, let alone within the park. With limited access, law enforcement faced immense challenges to doing their job. To those across the border in Cameroon, who would stop at nothing to make money, the vast frontier stood as a tree, ripe with fruit for the picking. First into the park came an illegal gold mine, attracting nearly 7,000 humans of ill-repute, including poachers. Word must have spread like wildfire about the wildlife, innocent and docile, ready for the taking. Following the government's closure of the mine, elephant poachers

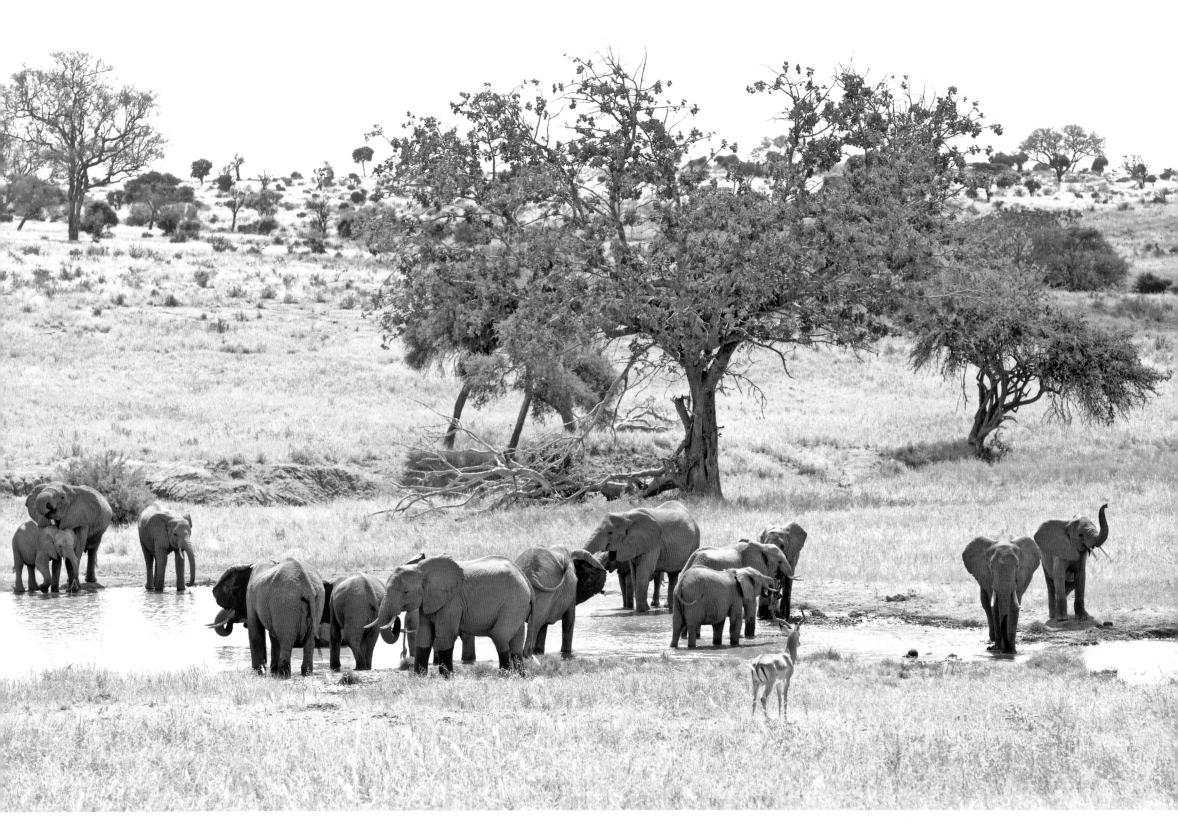

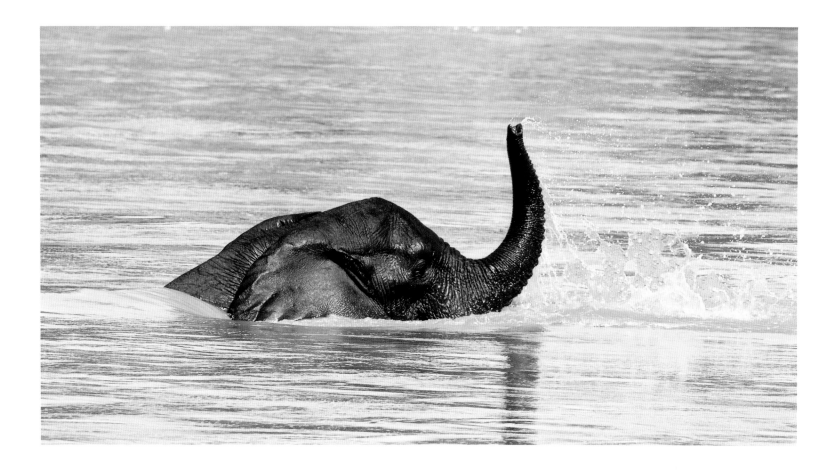

continued to run freely and by 2016, 80% of all elephants were dead, their tusks carted across the border to Cameroon.

Just before my visit to the Central African Republic to be with the forest elephants there, I communicated with renowned conservationist Dr Lee White who has been the backbone of the parks in Gabon. He asked me when was I coming to visit, and I replied that I had a lot more thinking to do. I've heard wonderful stories in the past few years about the elephants who roam the beaches of Gabon along the Atlantic Ocean and I know Gabon to be a beautiful country. But I will be thinking of the former paradise of Minkébé for the rest of my life. Minkébé, once one of the last surviving truly wild places on this earth, an Eden, laid bare and decimated by the slaughter of nearly 30,000 elephants in only a ten-year period.

LUIANA

Prior to dedicating my life to the welfare of elephants, I had little desire to visit the far-off continent of Africa, save maybe to gaze upon the pyramids of Egypt. But once I started making trips there, my fascination with elephants and more romantically with what must have been, what once was, continued to grow. At the root of this lament has been a nation that in recent history was once home to the largest population of elephants in all of Africa: Angola. During the early 1970s, Angola held an estimated 200,000 thriving elephants. Two hundred thousand! In this country, the current and historic home of elephants has been the Luiana Partial Reserve in the south of the country. I frequently entertained the notion of visiting this nation, this reserve, to see for myself just how many elephants lived there and by my presence be a voice for an interested Western world and promote the benefits to all of wildlife tourism.

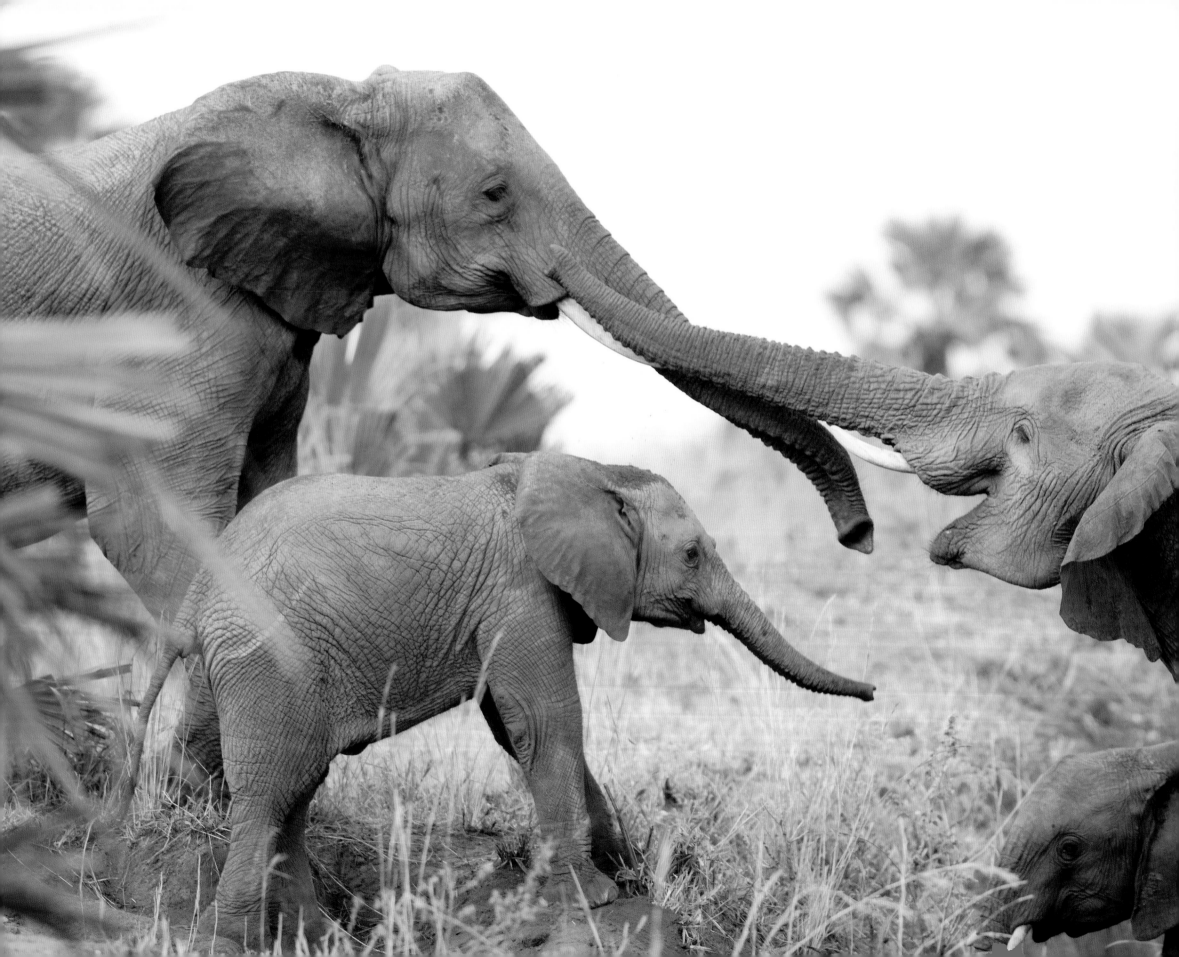

> *"We have lived in the best of times and seen the wonders of wildlife ... and belong to a brotherhood the members of which have memories that cannot be matched ... we have lived on into a new world which I do not pretend to understand."*

SIR ALFRED PEASE
Member of Parliament, White hunter

To date, I have yet to enter Angola. I want to go, but what momentum I'd managed was snuffed out by the results found by conservationist Mike Chase during the Great Elephant Census. Today, there are roughly 3,400 scared and traumatized elephants left. Just 3,400 of a population that just 40-odd years ago numbered 200,000! What's more, each year, Angola has been losing 10% of its remaining elephants, the fastest rate of decline in all of Africa. Further, in Angola, Mike Chase saw the largest known herd of elephants in recent history, a gathering of some 550 souls. A pathetic observation as the only reason that so many elephants gather together in this day and age is for protection, the result of prolonged trauma.

Angola is a land of trauma for both elephant and man. In 1975, Angola won its independence from Portugal and like so many other African countries following independence descended into ongoing, brutal civil war. To add fuel to the fire, those of us alive in those past days will recall how the Cold War came to remote Angola with the United States and the Soviet Union supporting opposing sides in the civil conflict. The entire country was a war zone and soon factions were funding their war efforts with money raised from the sale of ivory, the death of elephants. By the 1980s, 100,000 elephants had died and the killing continued.

One day, I will visit Angola. I will visit to encourage locals to look at elephants differently and to affirm the government's efforts to protect them. After all, Angola by nature of its sparse human population is capable of giving elephants the greatest amount of room of all African nations, an invaluable commodity given the mounting loss of habitat taking place in all other nations every single day.

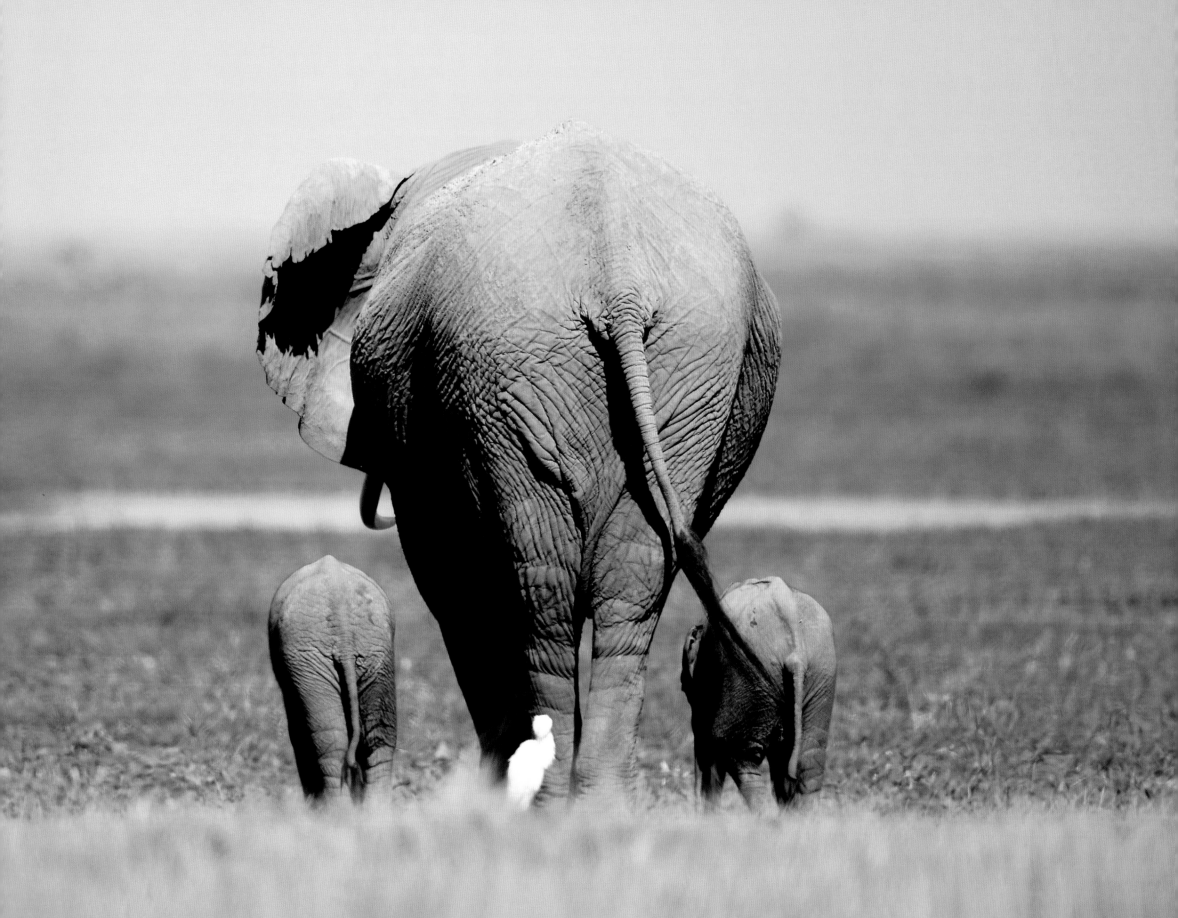

WONKY TUSK

I was on my way to Lower Zambezi before heading up to South Luangwa during my days observing Zambia's elephants. I'd stopped over in the nation's capital of Lusaka to transfer to a small plane. In the shadow of the new multi-story international terminal, under construction by a Chinese contractor, a sizeable group of colorful traditional dancers and other well-dressed individuals gyrated in anticipation of a celebrated departure. A lengthy red carpet laid in waiting up to the door of a golden-colored private jet. Then he appeared. It was President Edgar Chagwa Lungu. Walking with appropriate stature, he made his way along the carpet. And in a matter of drum beats, I watched as the President went airborne and flew out of sight.

<< Kenya. Elephants rarely give birth to twins, with the event taking place less than once in every 1192 births. In 2018, two sets of twins in Africa came into the world, one set in Tanzania and these, Norah and Katito, in Kenya. Kenya's last recorded elephant twins were born 38 years prior.

While Lungu had been rising to power, 350 miles to the east, a female elephant in the Zambian bush was rising to matriarch status. Her left tusk rising up, her right tusk awkwardly pointing down, Wonky Tusk was the leader of a family of five that included her sister, a daughter, a teenage son and a younger son known as Wellington.

In 1998, a well-appointed tourist lodge was built smack dab on the path that Wonky Tusk, her ancestors and countless other elephants had been using for decades to reach a cherished giant mango tree. While most elephants who had visited the tree turned elsewhere or found a way over a retaining wall, Wonky Tusk boldly marched her little family right up the lodge steps, through the lobby and out to a courtyard where the giant beloved mango tree stood. This procession then became a near daily event and then an annual event each fruiting season that endeared Wonky Tusk and her family to tourists from around the world.

As life goes, Wonky Tusk passed away a few years ago but her sister, in taking over the family, continues the commute straight through the lobby at Mfuwe Lodge with young Wellington in the lineup. While I didn't time my stay to coincide with the mango season, one morning, a lone elephant appeared in the driveway outside the entrance, looking intently at the inviting lodge steps, no doubt wondering, hoping that mango season was just around the corner.

With my time at South Luangwa complete with a stay at the fine Mfuwe Lodge, I travelled back to the Mfuwe village airport. As I walked out along the tarmac to board my plane, I caught sight of a familiar aircraft. There, parked a few yards away, was President Lungu's shiny golden jet. And as I flew off, I sent the President a little prayer, a prayer that encouraged him to look after the welfare of his nation's elephants, especially Wellington, and to do it in a fashion that was as passionate as his own rise to power.

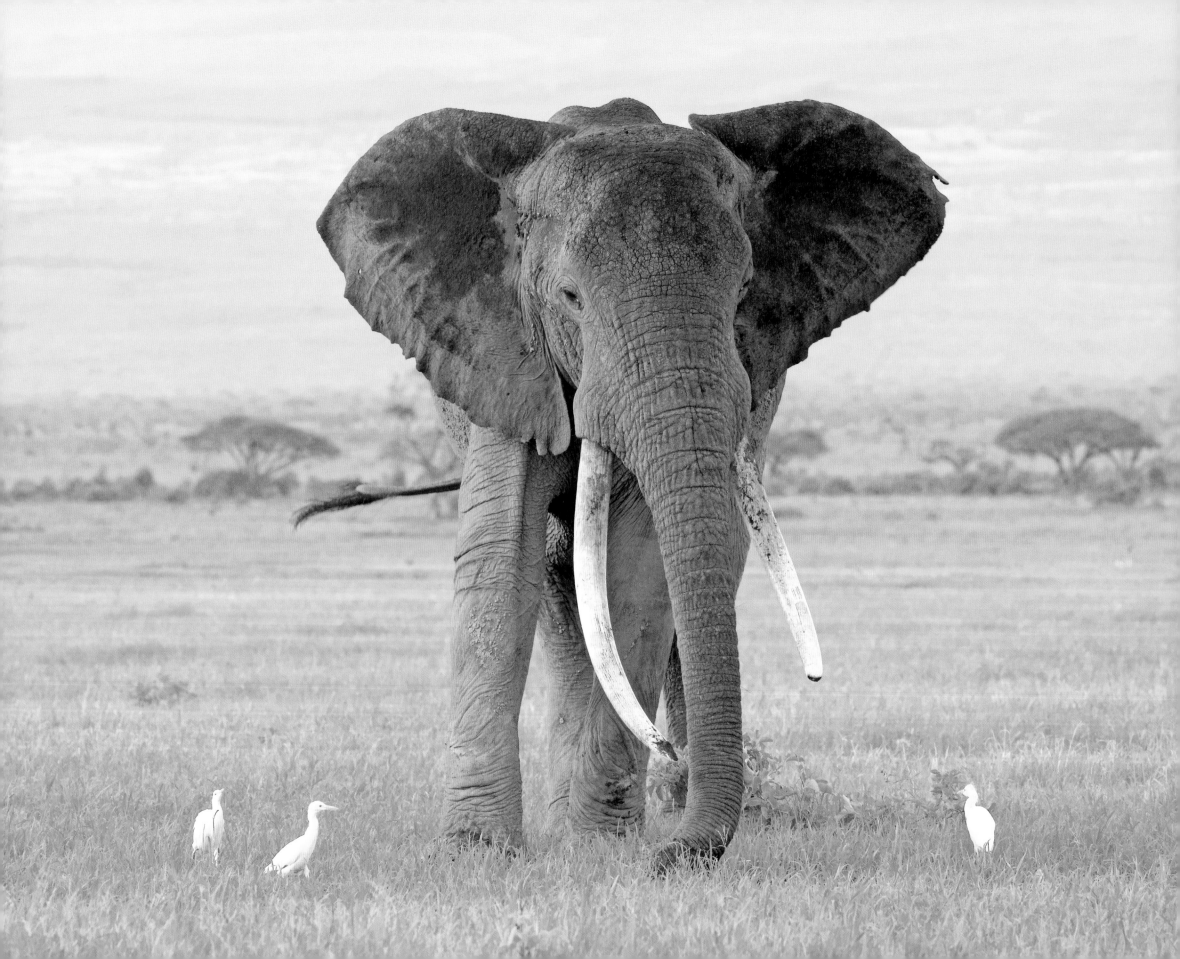

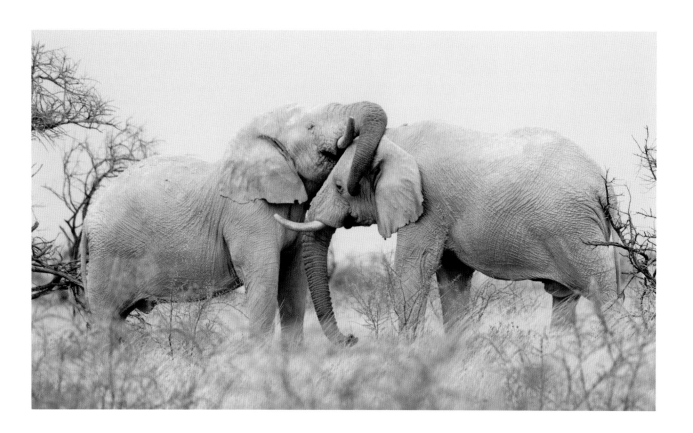

<< Esau, nephew of Echo, the world renowned elephant matriarch.

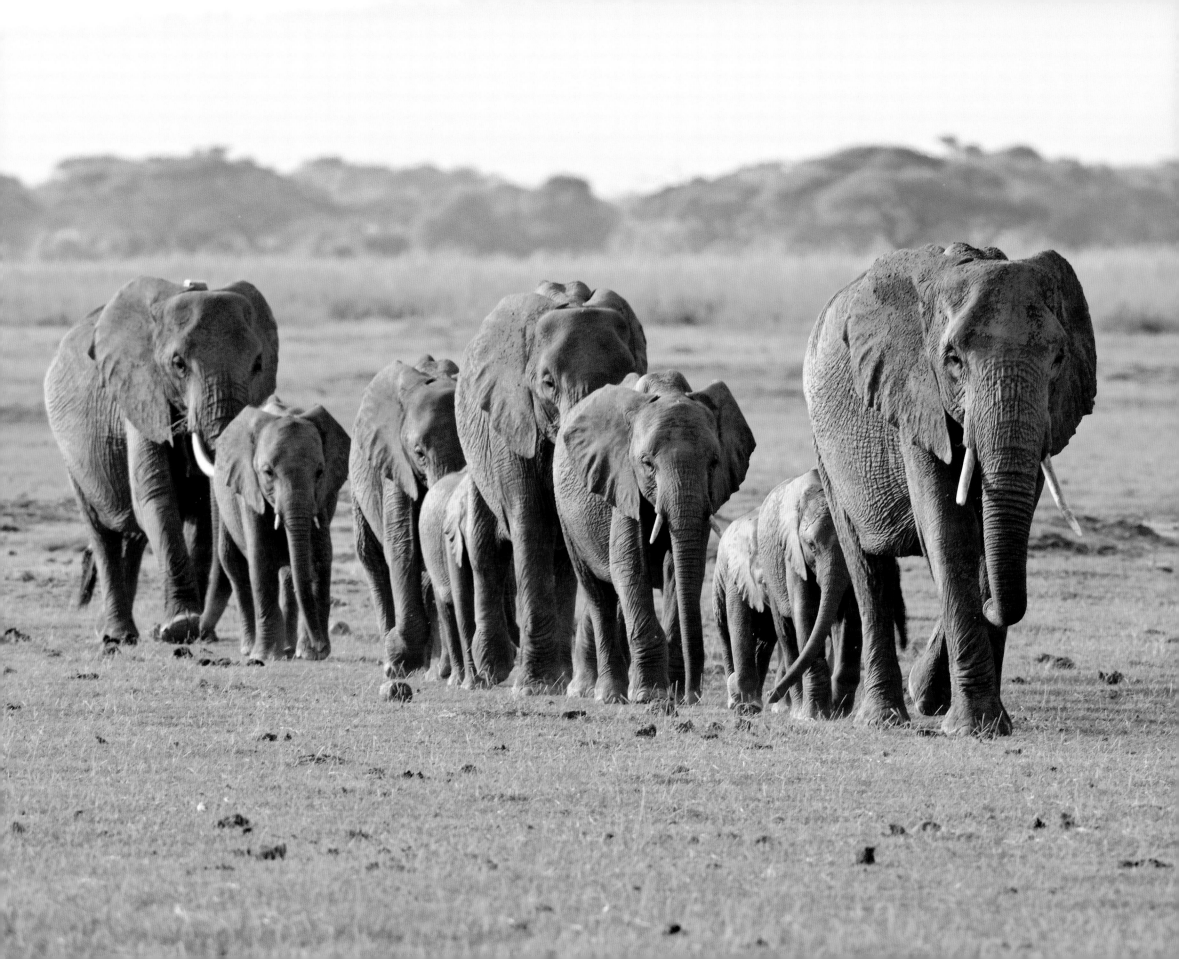

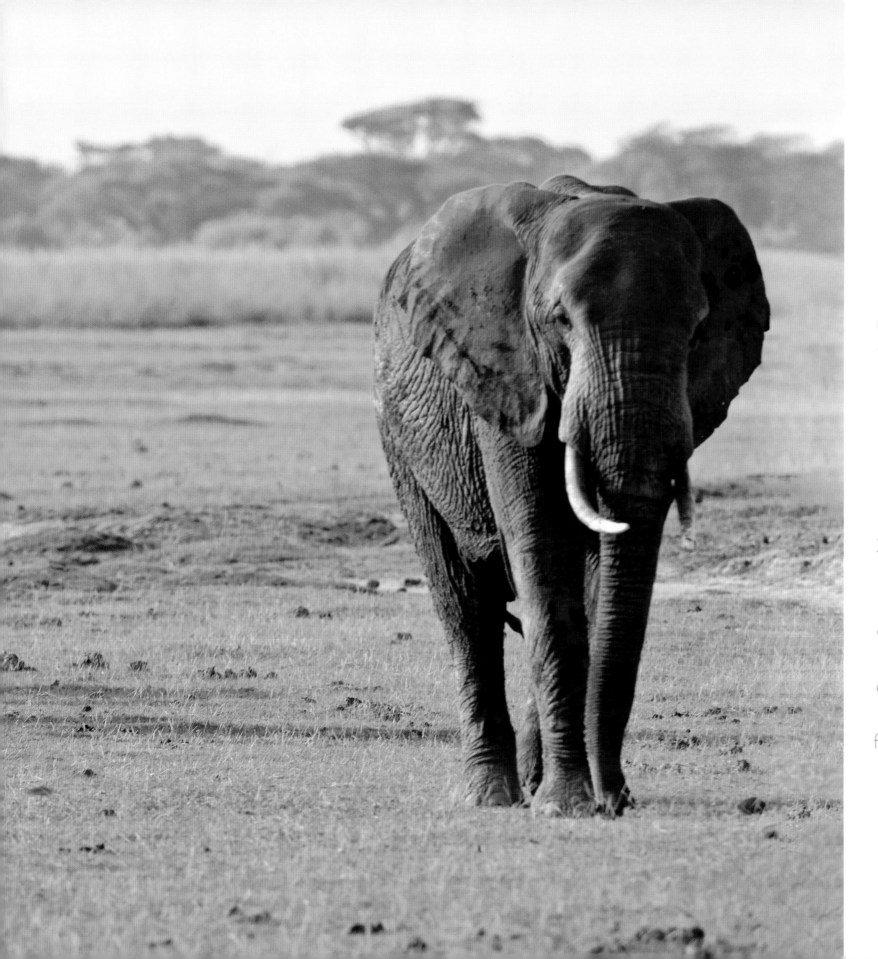

Cynthia Moss grew up in a town outside New York City, riding horses and appreciating the outdoors. She left a budding career as a reporter for *Newsweek* magazine to study elephants with Iain Douglas-Hamilton. Four years later, she co-founded the Amboseli Elephant Research Project with an elephant named Echo as her first subject. Echo was studied for over 30 years and with her family significantly increased humanity's understanding of elephants. Along the way, Echo gave birth to at least eight babies, was the subject of numerous documentary films and books, and became the most celebrated wild elephant in world history.

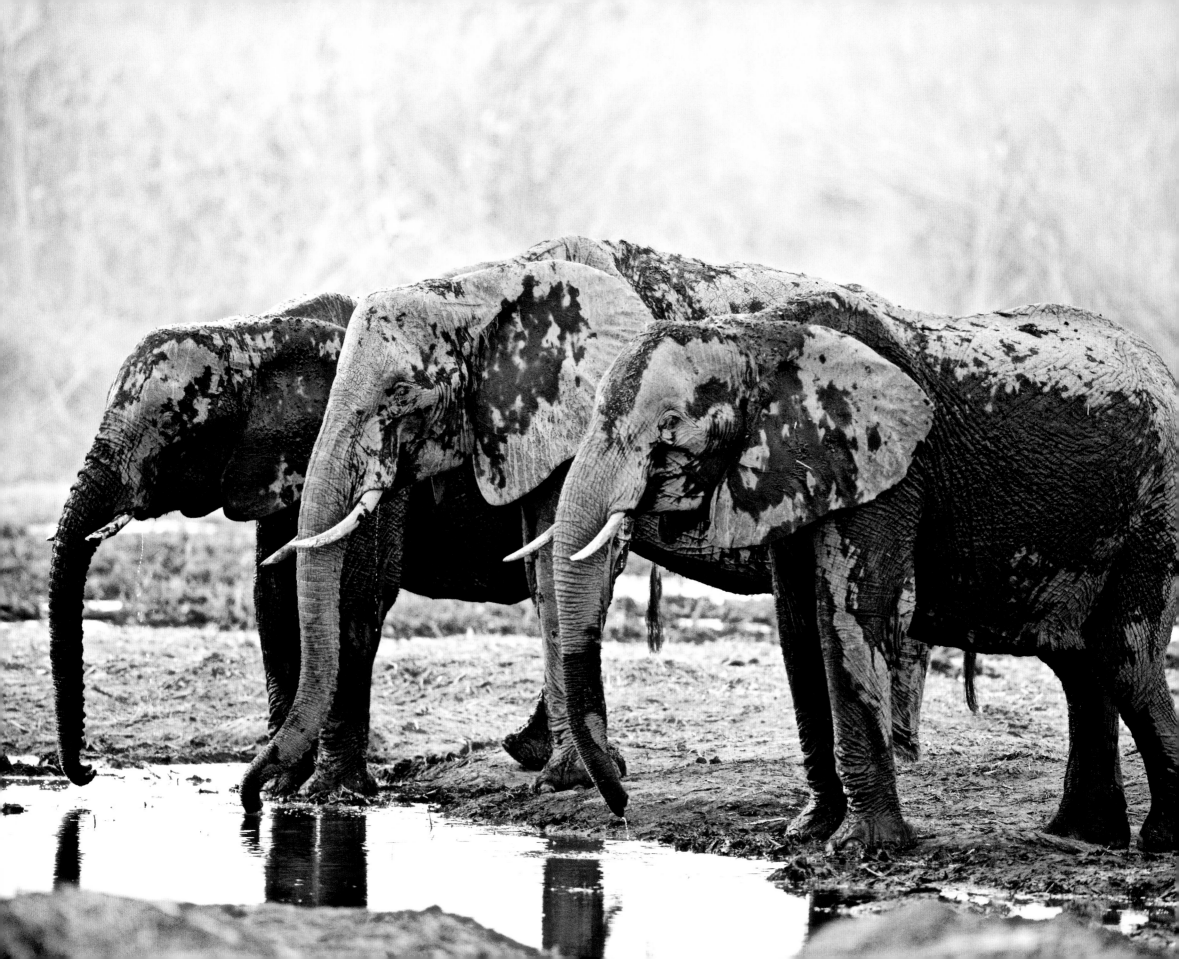

VOORTREKKER

While I was in Namibia with the desert-adapted elephants, word went around one day about the sighting of a dead bull elephant. My mind went immediately to Voortrekker. After all, there are only a small handful of adult bull elephants in the entire population of desert-adapted elephants. On the way out to see the carcass, it was revealed that the bull had died of wounds sustained in fighting with another elephant. Then, upon seeing the remains of the dead bull, it was clearly on the smaller side and certainly not Voortrekker. I was relieved. And as I mulled over this dead elephant, I realized that word would have gone out far and wide had this carcass actually meant the end of the legendary elephant known as Voortrekker.

In the muddled and muddied human history of Africa, descendants of the early Dutch settlers of today's South Africa ran into a series of troubles with the British who had moved in to dominate the southern region. To escape the influences of the British, over 10,000 of the Dutch population packed up and migrated northward during the period 1835-1840. The exodus became known in history as The Great Trek. Those pioneers who undertook this challenging migration became known as Voortrekkers.

Westward across southern Africa and forward to 150 years later, by the 1980s the settlers of today's Namibia had all but wiped out the elephants who had once lived there. But in 1998, from an isolated outpost of survival in the north, an intrepid bull emerged to make an exploration south into the region once hit hardest by hunting. He was given the name Voortrekker. For weeks, it is told, Voortrekker surveyed the area and then abruptly left to return north. Weeks passed and then Voortrekker appeared again, this time with a matriarch and roughly 20 elephants in tow. These pioneers were the survivors of the original elephant inhabitants and some, including Voortrekker, can still be seen today.

Like their ancestors before them, they once again came under threat from human beings. In 2008, the government of Namibia inexplicably issued six permits to hunt them. One of the permits was designated for Voortrekker.

Alarmed, a small band of conservationists launched an appeal to stop the hunt. In the end, five elephants were hunted and shot to death but a group of ten passionate women from the United Kingdom, the United States and Canada raised US$12,000 by walking 87 miles through the desert and bought the hunting permit designated for Voortrekker, thus saving him.

During my days in Namibia, the government issued three more permits to hunt desert-adapted elephants. Despite the small number of these elephants who have managed to survive, the misguided government of Namibia continues to see fit to kill them off. Even with the significant amount of open space that exists in the remote landscape where the elephants live, the only solution deemed

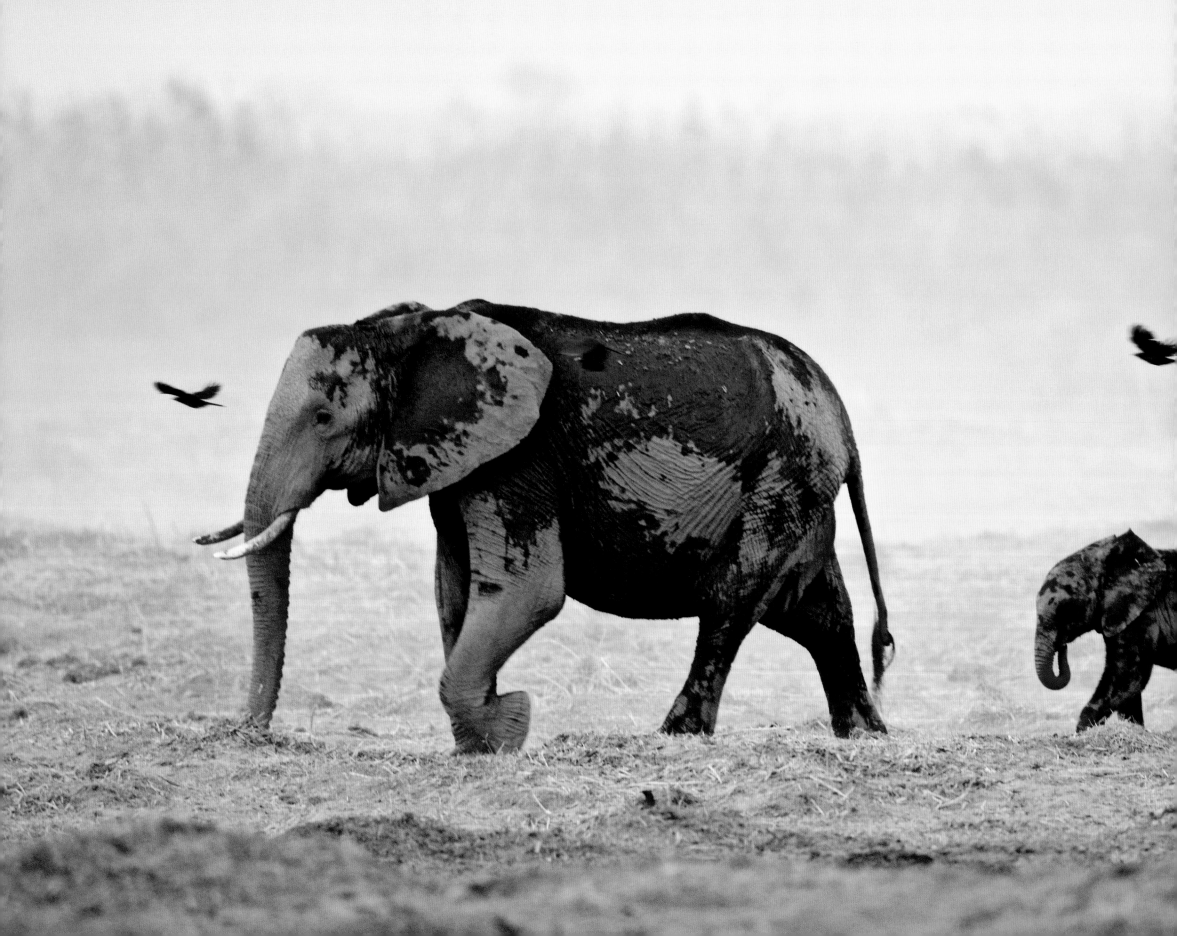

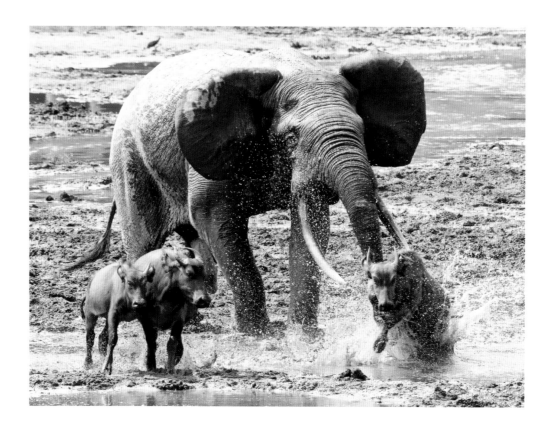

suitable by the government for bothersome elephants is death. In looking into this further, there is an incentive for the area's poverty-stricken human population to look down on elephants and to look up to the government. A significant portion of each hunting fee collected is keenly distributed amongst the remote human population; an appeasement for their little troubles with the elephants and an incentive to complain until the funds and the elephants both disappear.

Were Voortrekker a human being and not an elephant, his exploits of resettling to a land where all of his kind had been exterminated would be celebrated as was the landing of man on the moon. Today, at last report, Voortrekker is still alive, and so are hopes that the desert-adapted elephants of Namibia, as well as those clinging to life in the nation of Mali to the north, will be saved and permitted by mankind to live their challenging lives in a very challenging environment, as a cherished part of a very challenging world.

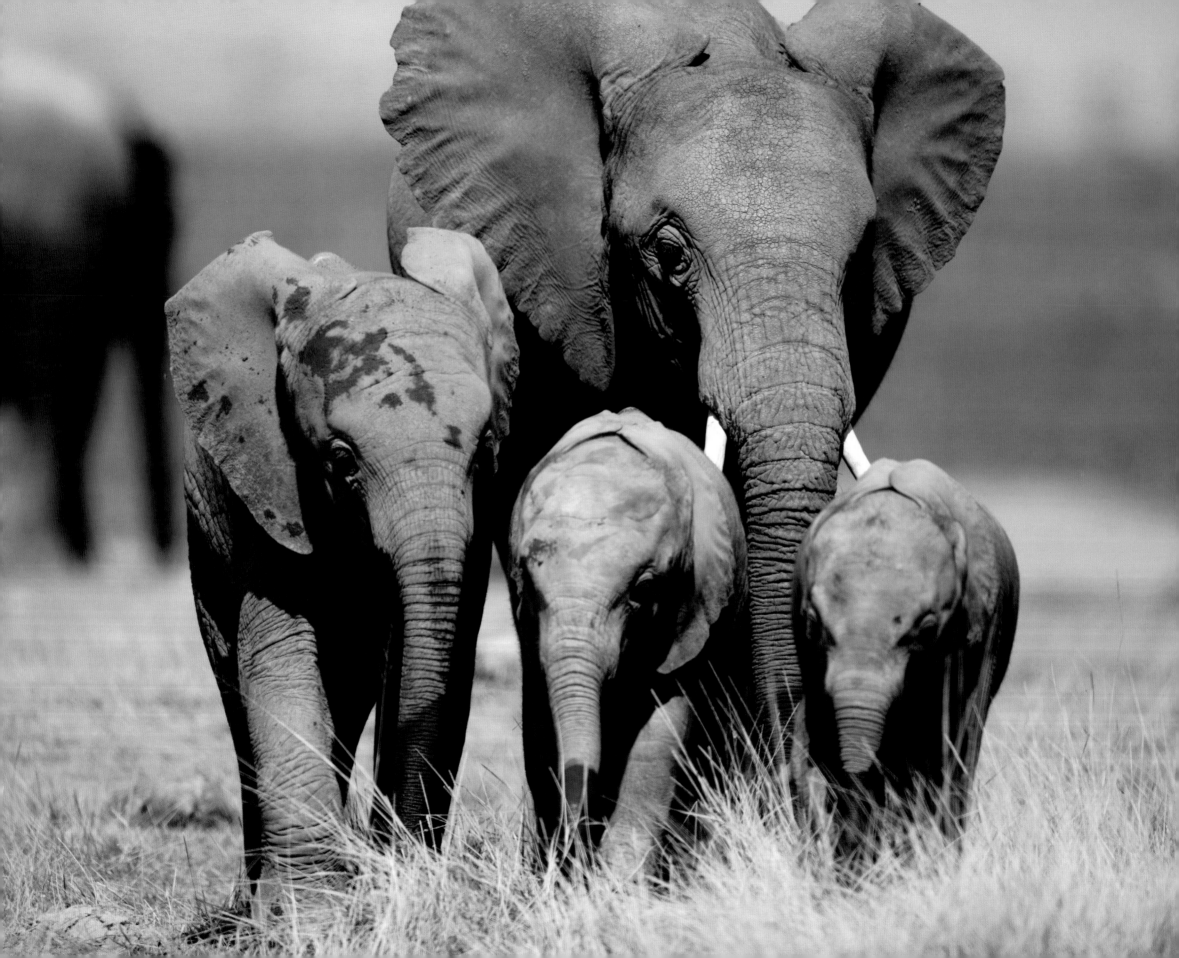

NOSEY

Zimbabwe is one of those places that when seen through a broad lens, represents both triumph and tragedy. Here, Mother Nature has put together one of her most glorious presentations. In the east are the mountainous and rugged Eastern Highlands. The impressive Victoria Falls decorates the northwest. The Chinhoyi Caves, Mana Pools, Gonarezhou and Hwange areas sparkle as national parks. Forests and wildlife once dominated most of the landscape. And from the rich soil, the British colonial settlers and their descendants farmed so effectively that, not so long ago, the nation was known as the Bread Basket of Africa.

But tragedy struck in the latter half of the 20th century as the country's majority pushed out colonial rule. The tragedy came in the form of a man who rose to power during the revolution and went on to assume the role of supreme leader: Robert Mugabe. As a school teacher for over a decade and as a student in higher education who eventually earned seven college degrees, he led a respectable yet harmless life. But by 1960, his political activism had taken root as one by one the nations of Africa ousted the rule of the colonial powers. By 1980, with Zimbabwe's independence from Britain, he had secured the highest seat in government and in 1987 the national constitution was revised to give Mugabe dictatorial powers.

Under Mugabe's rule of nearly 50 years, tyranny and corruption defined government. As a result, most of the country's skilled workers left. With the seizure of farmland and agricultural operations from most of the colonials, they too left the country. Unemployment nationwide increased to 80%. Education collapsed to the point where only 20% of children attended school. Life expectancy plummeted from 60 years to 35 years. In short, while those in Mugabe's favour enjoyed lavish lives of excess, the majority of the country lived in some of the world's worst poverty.

In the wake of Mugabe's rule, over half of all animals in Zimbabwe are now dead – dead from mismanagement, dead from poaching, dead from habitat loss.

While Mugabe was transitioning from education to politics, which included years of imprisonment, an American high school dropout and World War II veteran named Arthur Jones had moved his family to Zimbabwe, then known as Rhodesia, in search of adventure. Jones had interests in bodybuilding, flying and wildlife. He lived there for 12 years, making money as a control hunter and wildlife exporter. As a control hunter, he killed countless animals deemed by authorities as 'in the way'. And by his own account, over 600 elephants fell dead to his gun. As a wildlife exporter over an eventual 20-year period, he captured thousands of animals, from snakes to elephants, and sold them to foreign zoos, pet stores and researchers.

While in Africa, Jones became preoccupied with his interest in bodybuilding and particularly the way in

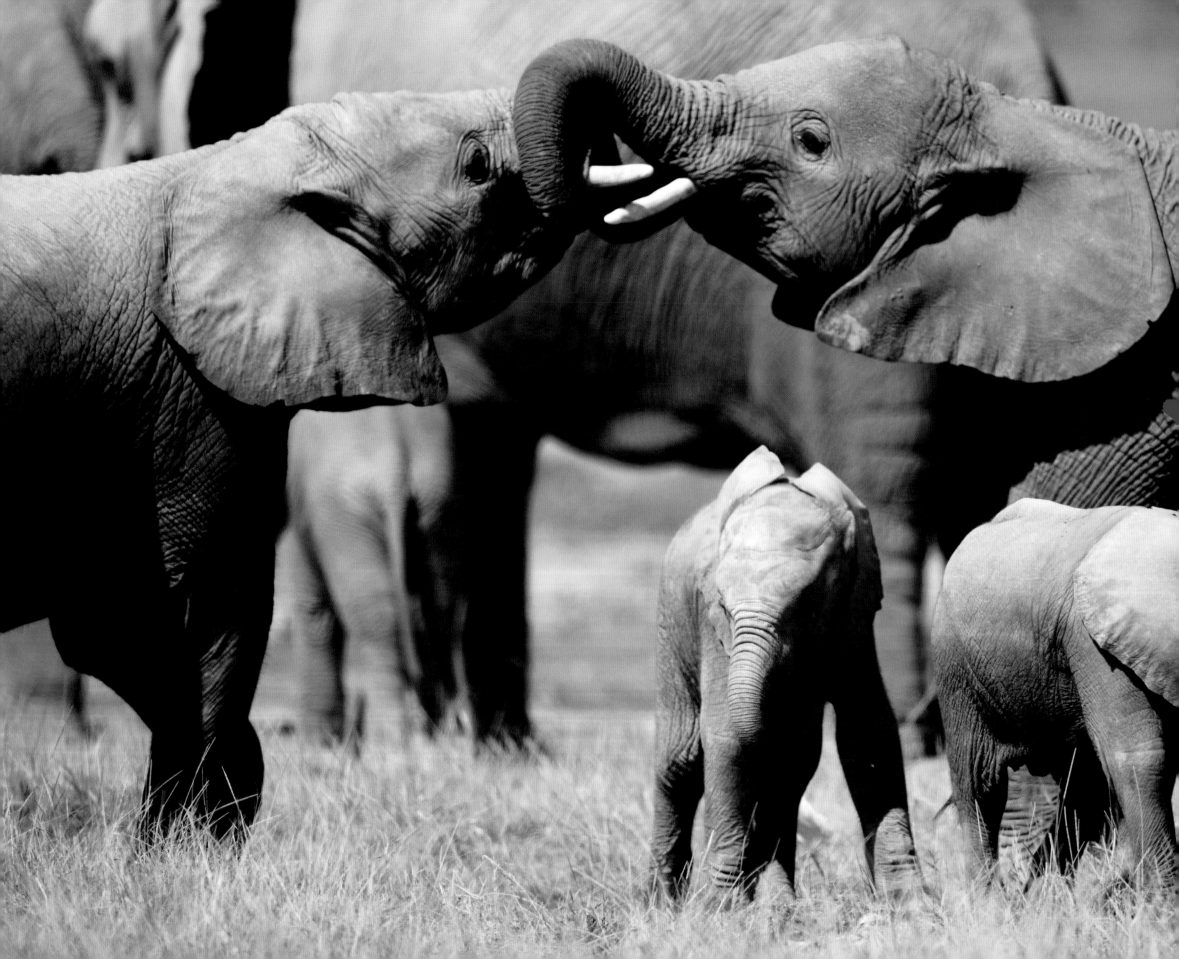

> *"It's not the ivory that will enrich us. We'll find far greater enchantment in the journey of life [the elephants] will lead us on. Whether they survive long enough for us to really get to know them depends entirely on what we can learn about the soul of the elephant."*

DERECK JOUBERT
Conservationist, award-winning filmmaker,
author and National Geographic Explorer

which athletes did their weight-training exclusively with metal plates on bars. An epiphany was in the making. Upon his return to the United States, he refined the design of training machines he'd invented, finally founding the iconic Nautilus Inc., and creating an exercise movement that revolutionized the fitness world.

As Jones was immersed in building his successful fitness empire during the 1970s, a young Hungarian living in East Germany quietly immigrated to the United States to escape the dark cloud of communism. In America, the young man set out to make a living the only way he knew how, by reviving the business that had been in his family for generations: a circus. His name was Hugo Tomi Liebel.

Meanwhile, by 1980 Jones had acquired the first parcel of land from a drug lord of what would become a 600-acre property in central Florida that he called Jumbolair. Here, the Nautilus empire grew to include a state-of-the-art television studio, the nation's longest private aircraft runway, a fleet of aircraft including three Boeing 707 jetliners and a collection of over 2,000 exotic animals that included hundreds of snakes, crocodiles, rhinos, a gorilla and 32 elephants.

In 1984, Jones learned of a massive government cull of elephants back in Zimbabwe and became determined to

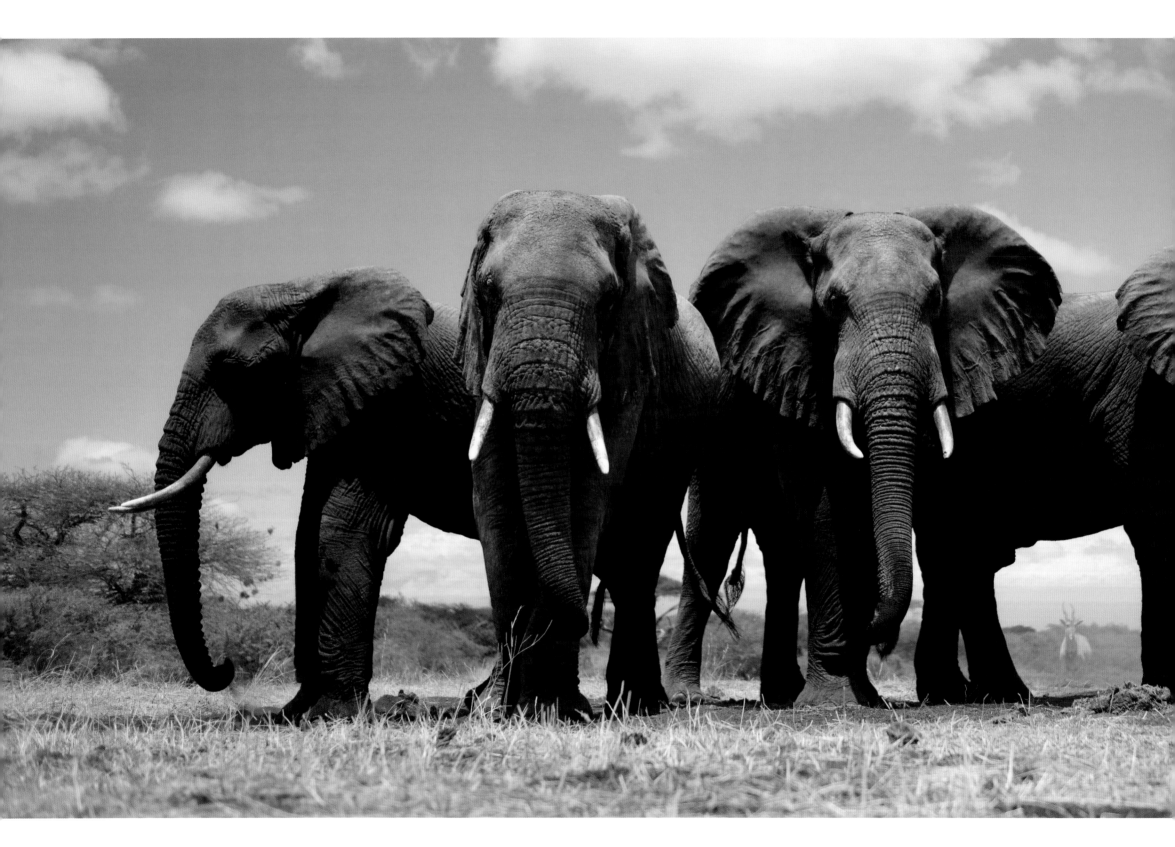

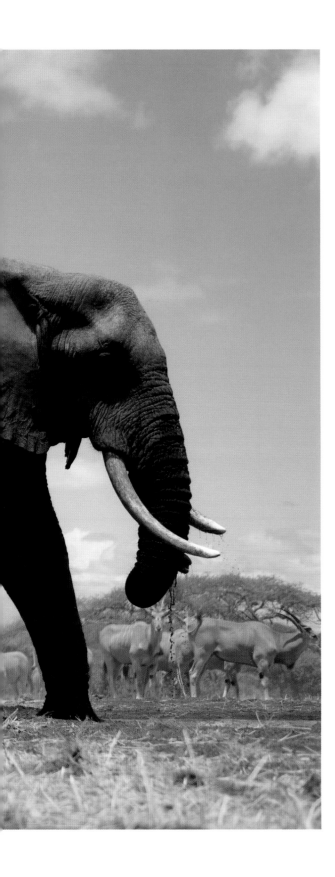

Kenya. In 2016, the largest stockpile to date of seized ivory tusks was ceremoniously burned in Nairobi National Park. Weighing 105 tons and representing the lives of at least 6,500 elephants, the burn was meant to be a clear message to the world, a message echoed by Kenyan President Uhuru Kenyatta: "For us, ivory is worthless unless it is on our elephants."

take in the orphaned babies. At the helm of one of his modified 707 jetliners, he flew over, collected 63 baby elephants and successfully flew the unusual cargo back home to Jumbolair. The entire event, entitled Operation Elephant, was a national television news event, covered by Hugh Downs and Barbara Walters as a segment on ABC's popular news show 20/20.

Within two years of Operation Elephant, Jones chose to sell Nautilus and put his focus on another fitness venture. At the same time, he began selling off the elephants of Jumbolair that he'd worked so hard to acquire. Within four years of Operation Elephant, Jones separated himself from Jumbolair. In the end, all of Jones' elephants had been sold or given away to the far corners of the United States, ending up in zoos, circuses or private displays.

Among the early elephants that Jones sold off was one of the Operation Elephant babies. This little elephant would later be known by several names, but to

those who cared most about her welfare she was known affectionately as Nosey. Following a short stay with another animal exhibitor, Nosey was bought in 1988 by the Hungarian immigrant Hugo Liebel. Nosey was bought in 1988 by the Hungarian immigrant Hugo Liebel who immediately began preparing the young elephant for a life in the circus. By 1993, Nosey was a veteran of the fair and circus circuits and Liebel had been cited for the first time by the USDA for a violation of the animal welfare act. Liebel has been cited in all over 200 times by USDA inspectors, many of these violations involving the care of Nosey. Among these violations were the alleged neglect of Nosey's filthy living conditions, failure to provide adequate living space, and contaminated food and water.

Liebel, his wife and five children were all involved in the family business. Nosey became the circus' dominant source of income leading Liebel to repeatedly announce that Nosey was

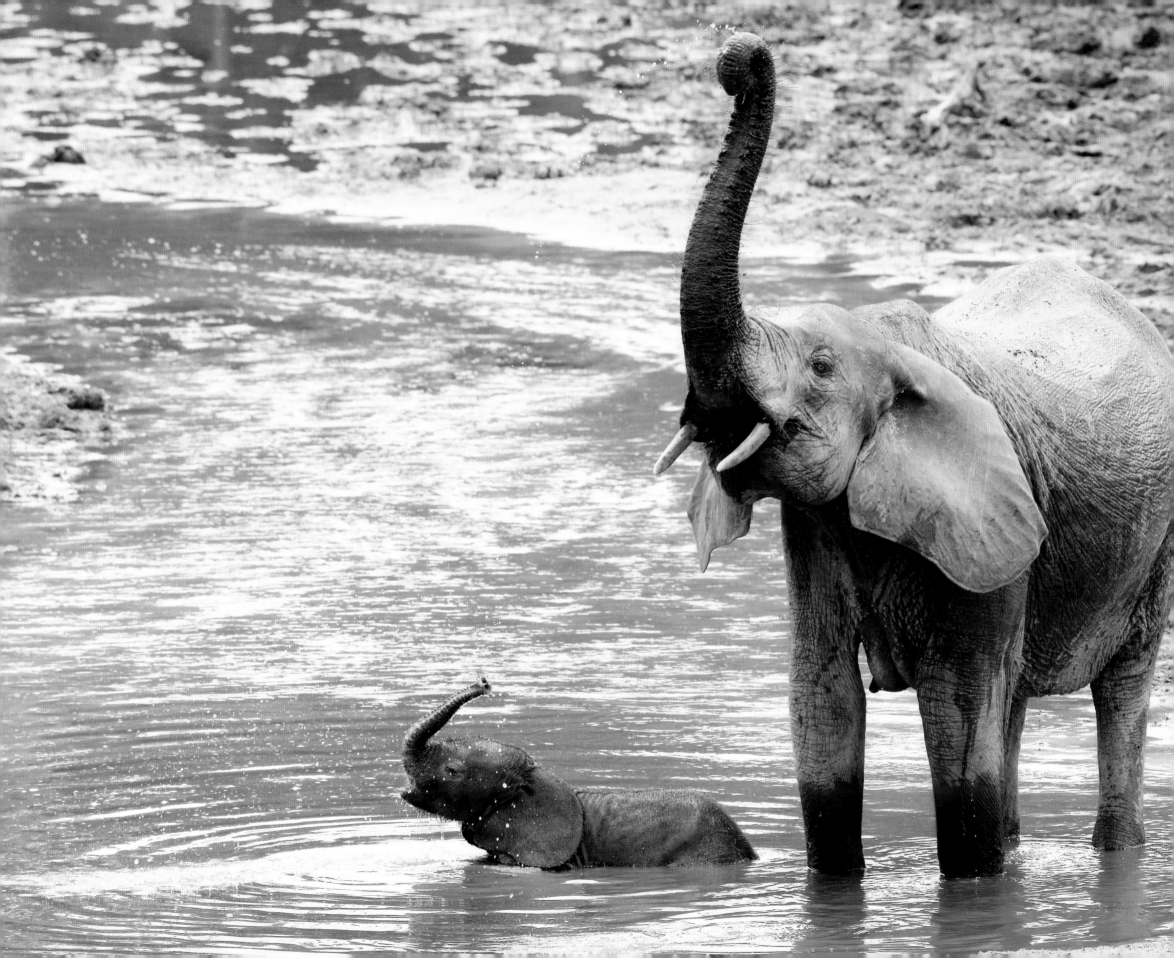

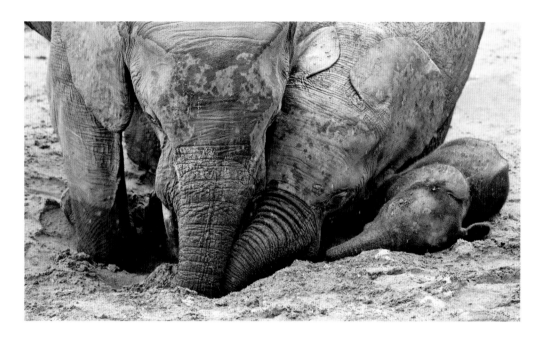

like family to him. Just the same, Nosey's physical condition deteriorated and at times arthritis forced her to have a severe limp during sessions in fairs carrying fairgoers on her back. Perhaps the worst aspect of Nosey's life in captivity was having to endure a life alone, without the company of other elephants. It's well known that elephants are among the most loving and social beings on the planet, needing interaction with their own kind in order to stay healthy.

While Liebel and his family denied mistreating Nosey, photos and videos secured by concerned individuals repeatedly showed the elephant limping during performances and confined under poor conditions. In time, over 400,000 people signed a petition urging her retirement to a sanctuary. Meanwhile, state and federal authorities continued to cite and fine Liebel for his ongoing animal welfare violations. Protests and vigils for Nosey continued. Finally, authorities were prompted to take action yet again, this time seizing custody of Nosey. A judge then made a ruling, and the elephant was sent to a sanctuary for elephants in the hills of Tennessee.

For decades now, Zimbabwe, the beautiful, has been the stage for countless tragedies for elephants, some of these dramas persisting to this day. With certainty, the human players eventually fade to dust, but the elephants who have lost their lives along the way, the elephant families that have been destroyed here, are not coming back, ever. And in the sings of the theatre, the chatter of selling the growing ivory stockpile, the sale of orphaned babies and the violent end of countless additional elephant lives drones on.

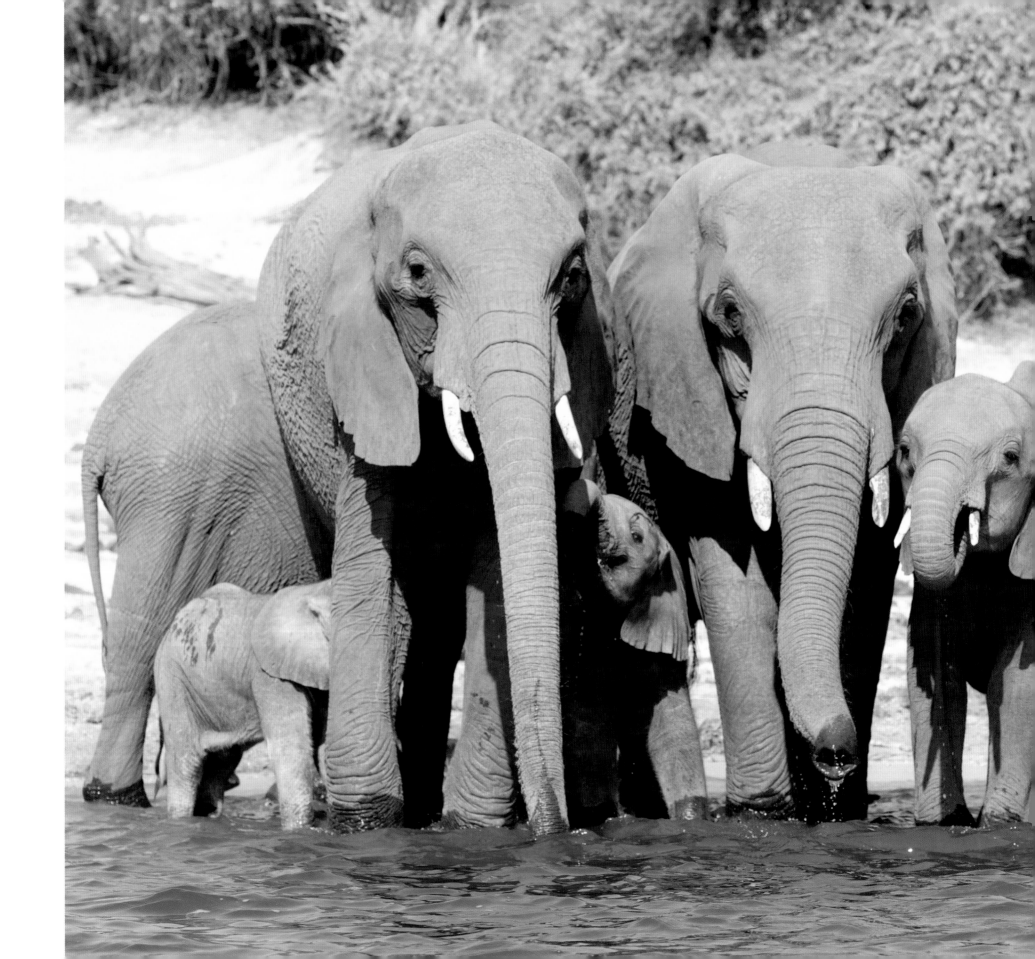

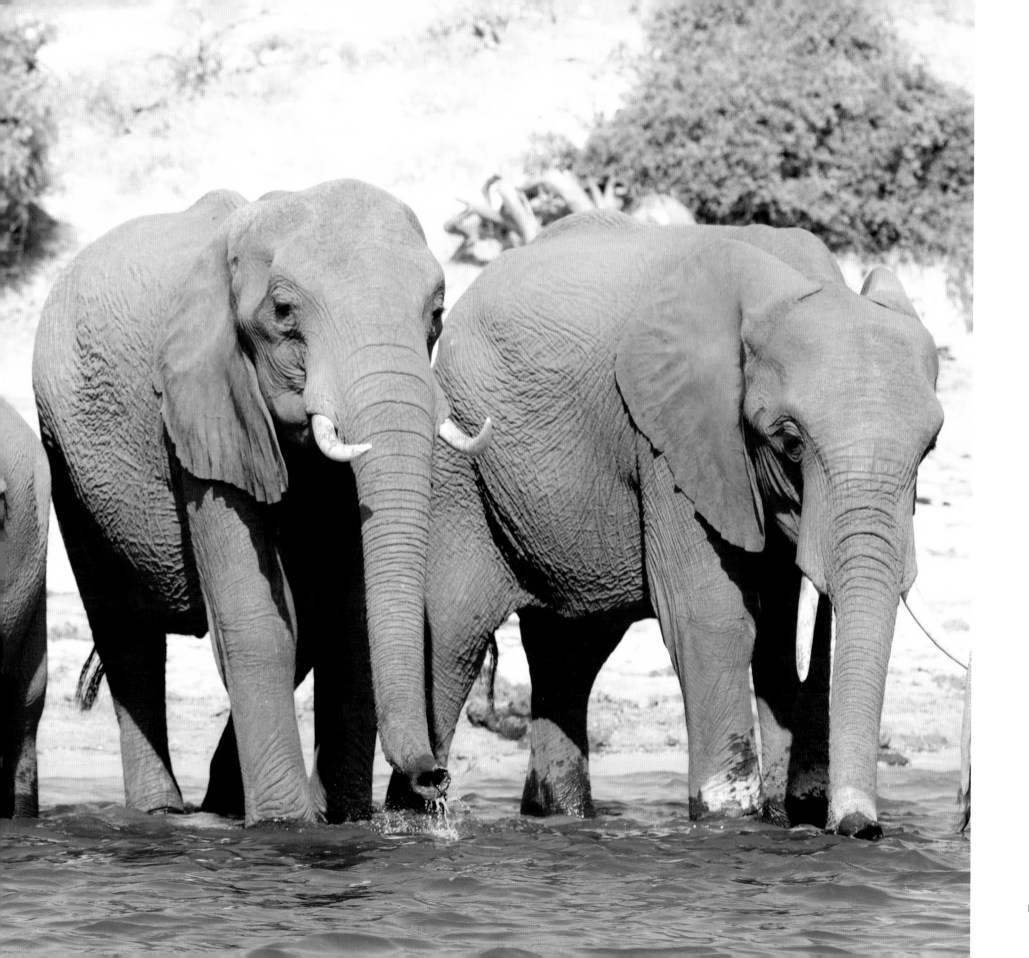

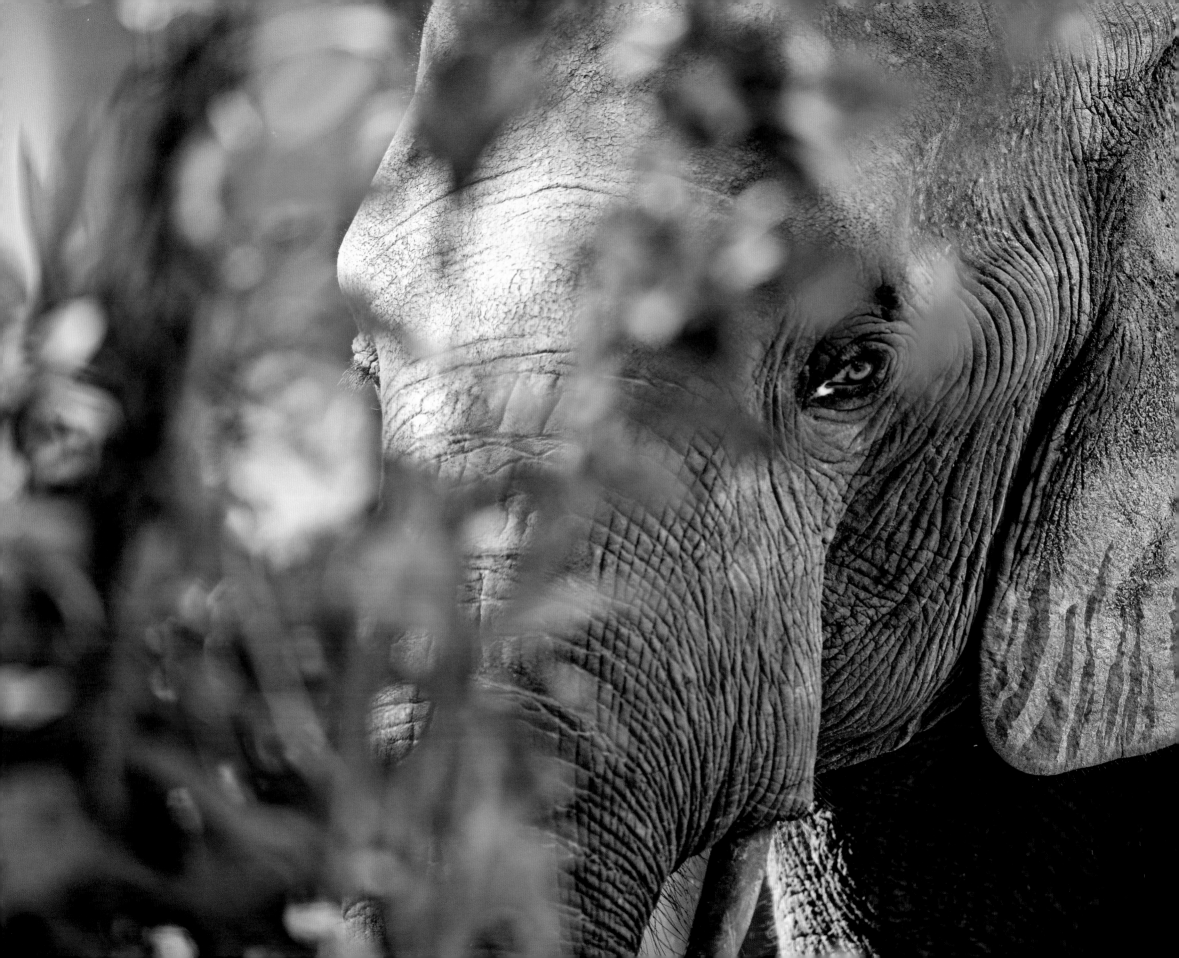

"When I opened my eyes again, you were asleep.
I suppose you had not seen me or had taken one
look at me and become overcome with boredom.
Anyway, you were standing there, your trunk
limp, your ears collapsed, your eyes closed,
and I remember that tears came to my eyes.
I was seized by an almost irresistible urge to
come close to you, to press your trunk against
me, to huddle against your hide, and there,
fully protected, to sleep peacefully forever."

ROMAIN GARY
"Dear Elephant, Sir," *LIFE magazine*, December 22, 1967

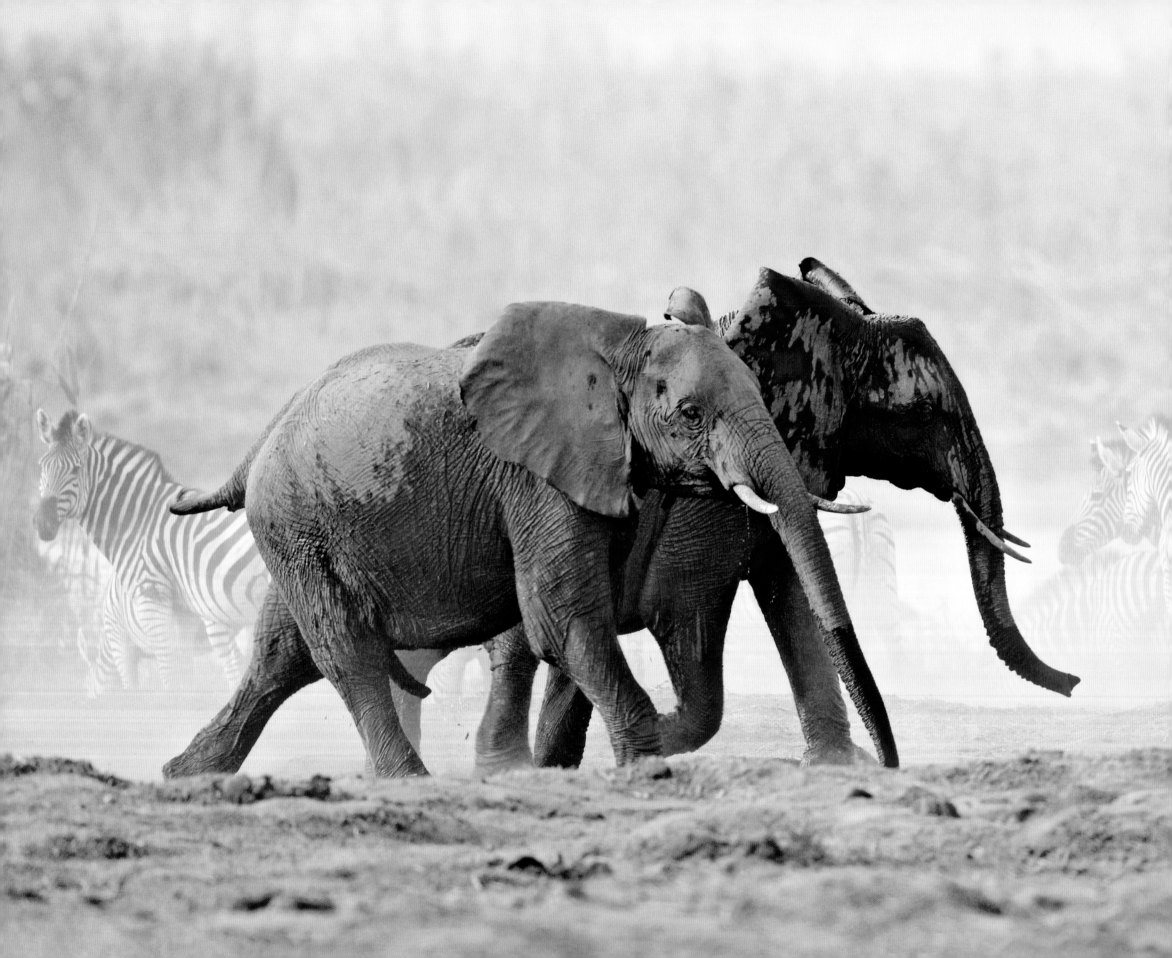

SAVANNA ELEPHANTS

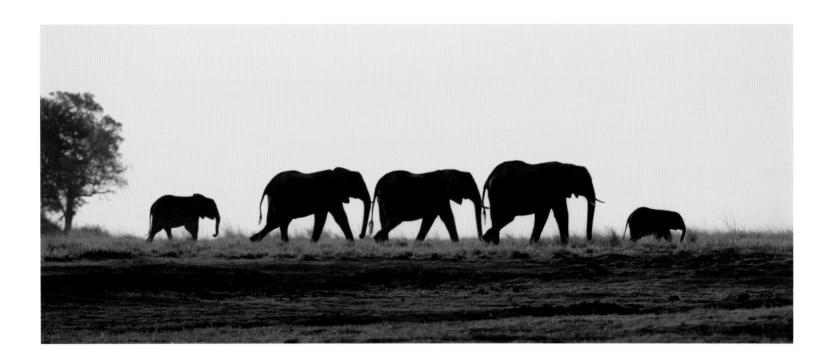

The savanna of eastern Africa epitomizes Africa's landscape in the minds of people around the world. Like a carpet, the golden grasslands stretch as far as the eye can see in many places; the occasional acacia tree or shrub bravely holding sway here and there. Savanna lands are found in 27 countries of Africa, and

so stalwart are their presence, scientists estimate most have stood where they are for two million years or more. All in all, over half of the continent is covered by savanna with the most well-known portion known simply as Serengeti.

The African savanna is home to 45 species of mammals, including the

savanna elephants. As a species, the savanna elephant is the largest elephant in size, not only in Africa but worldwide. While they prefer the vast expanse of the savanna itself, they can also be found in dense forests, mountain slopes, woodlands, deserts and even ocean beaches in a home range that includes most of

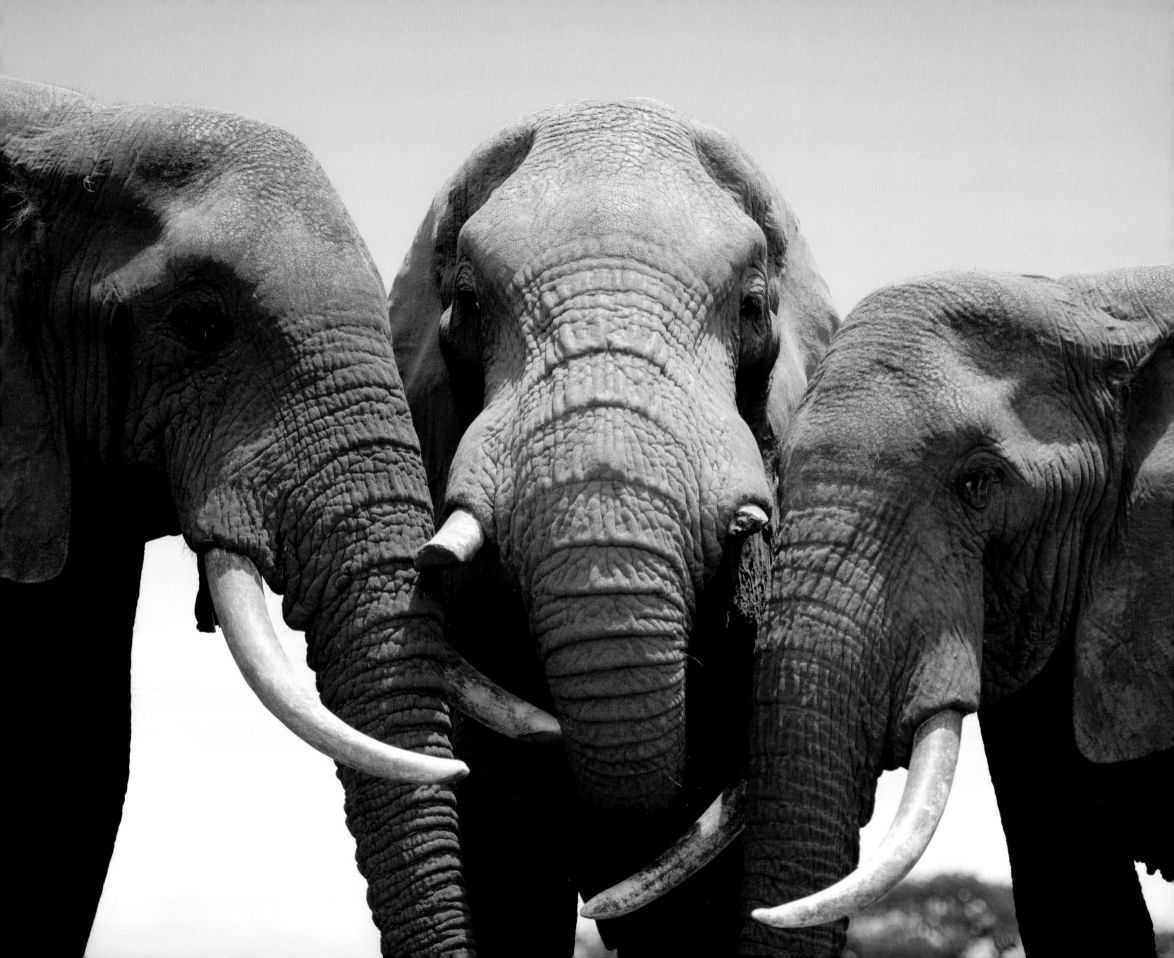

Kenya. A letter writing campaign by school children led the nation's first president,
Jomo Kenyatta, to declare the internationally famous elephant known as
Ahmed a living national monument in 1970. From that day forward, five armed
guards watched over Ahmed and his giant ivory tusks day and night until
he passed away peacefully four years later.

southern Africa, East Africa and across central Africa westward all the way to Senegal. Despite many local extinctions, savanna elephants today can be found in 18 countries.

The 2015 Great Elephant Census report revealed that of the millions of savanna elephants who once lived as recently as 200 years ago, a little more than 350,000 survive today. In the seven-year period prior to the census count, the species declined by 30% as killing for ivory once again reached maddening levels. In countries that once saw hundreds of thousands of savanna elephants, today only a handful remain. Angola, once home to nearly one million is today home to only about 3,000. Chad and Ethiopia are each home to a little more than 700. Cameroon, a lawless centre in the illegal ivory trade, has only 148.

In any discussion of elephants in Africa today, their only real predator, mankind, has to be acknowledged as every single aspect of elephant life has been affected by humanity's bad behaviour. For countless thousands of years, the savanna elephants lived in relative balance with native African people. As humanity spread from Africa up into Arabia and trade developed, among the items traded was savanna elephant ivory, a commodity the Arabs prized for their artful knife handles. Later, the Europeans explored Africa and with their colonies came a gluttonous appetite for ivory that turned the trade safaris into hunting safaris. Eventually, the savanna elephant populations lay decimated with local extinctions common, and even the hunters lamented the once plentiful elephant. With this romance of what once was came a new safari in the 20th century. Modern, all-terrain vehicles roamed the African landscape in increasing numbers, no longer containing men with guns but families armed with binoculars and cameras.

Meanwhile, the balance of life in the savanna between humans and elephants that had lasted for centuries had come to an end. The native African human populations in every corner of the continent grew to extreme numbers. Today, native Africans and savanna elephants compete for everything: for water, for food, for the space needed in which to simply exist. The savanna, once depended upon by generations of elephants for survival, has been carved up by fences, livestock monopolizing the water sources, and the land cleared and turned under to make way for agriculture. Desperate for food, conflicts between elephants and farmers now seem endless. As the 21st century continues to unfold, it is clear that the savanna elephant will never again dominate the golden carpets of grass that once commonly stretched as far as the eye could see. But there's no denying that the sight of elephant families on the savanna has won over the hearts of countless tourists from around the world, tourists who increasingly have been taking a stance on behalf of these iconic beings.

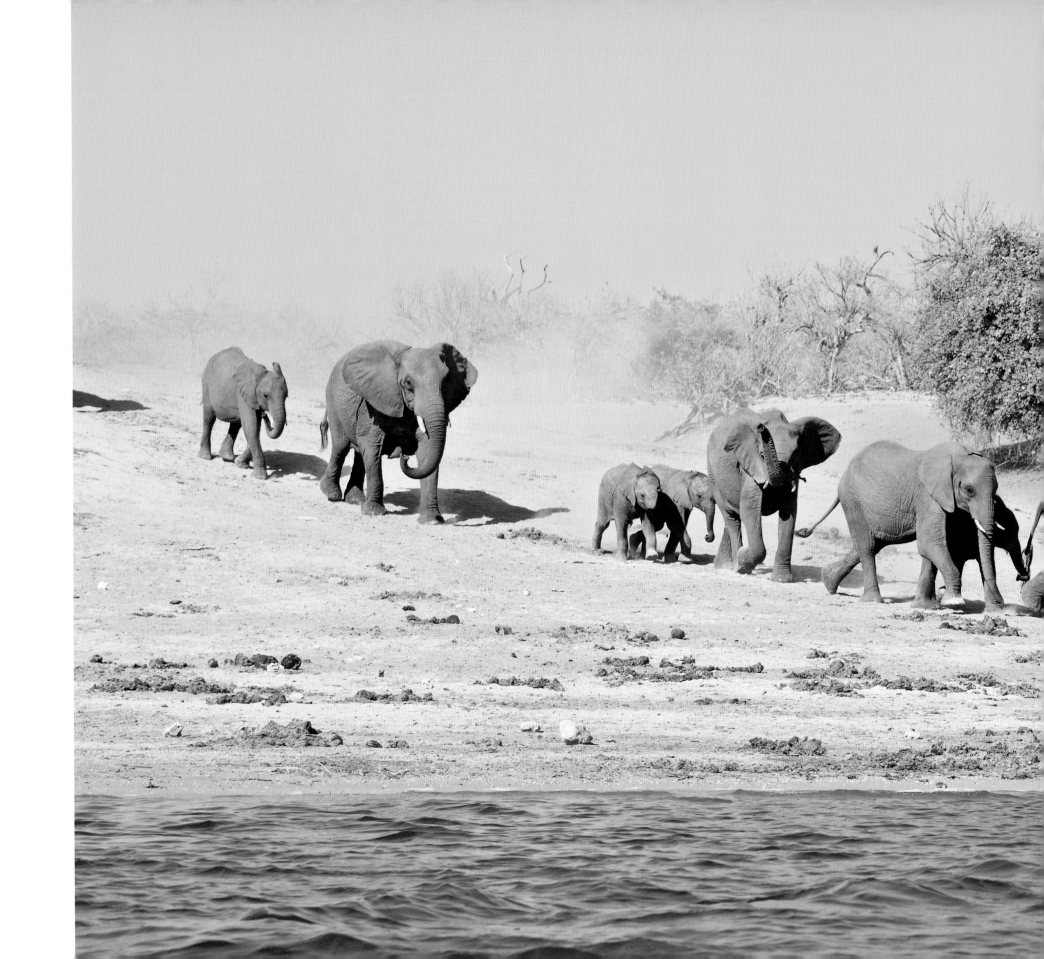

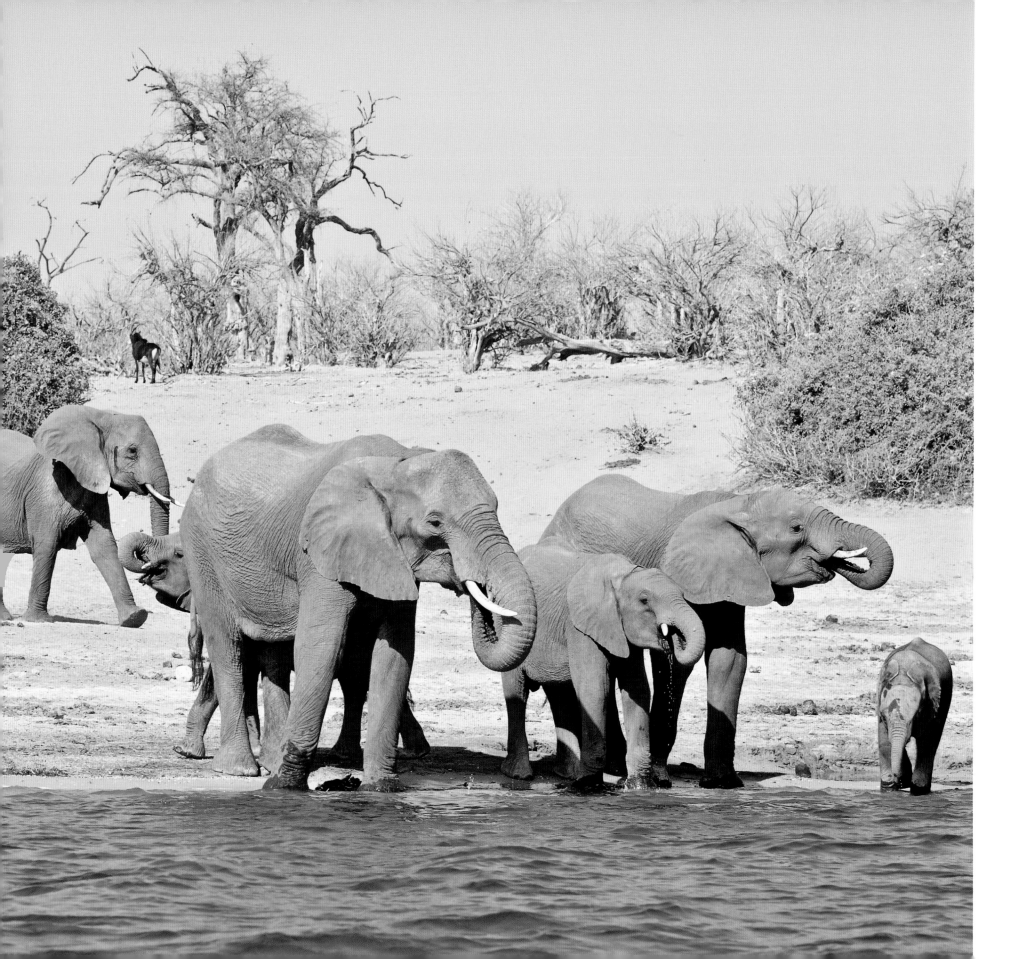

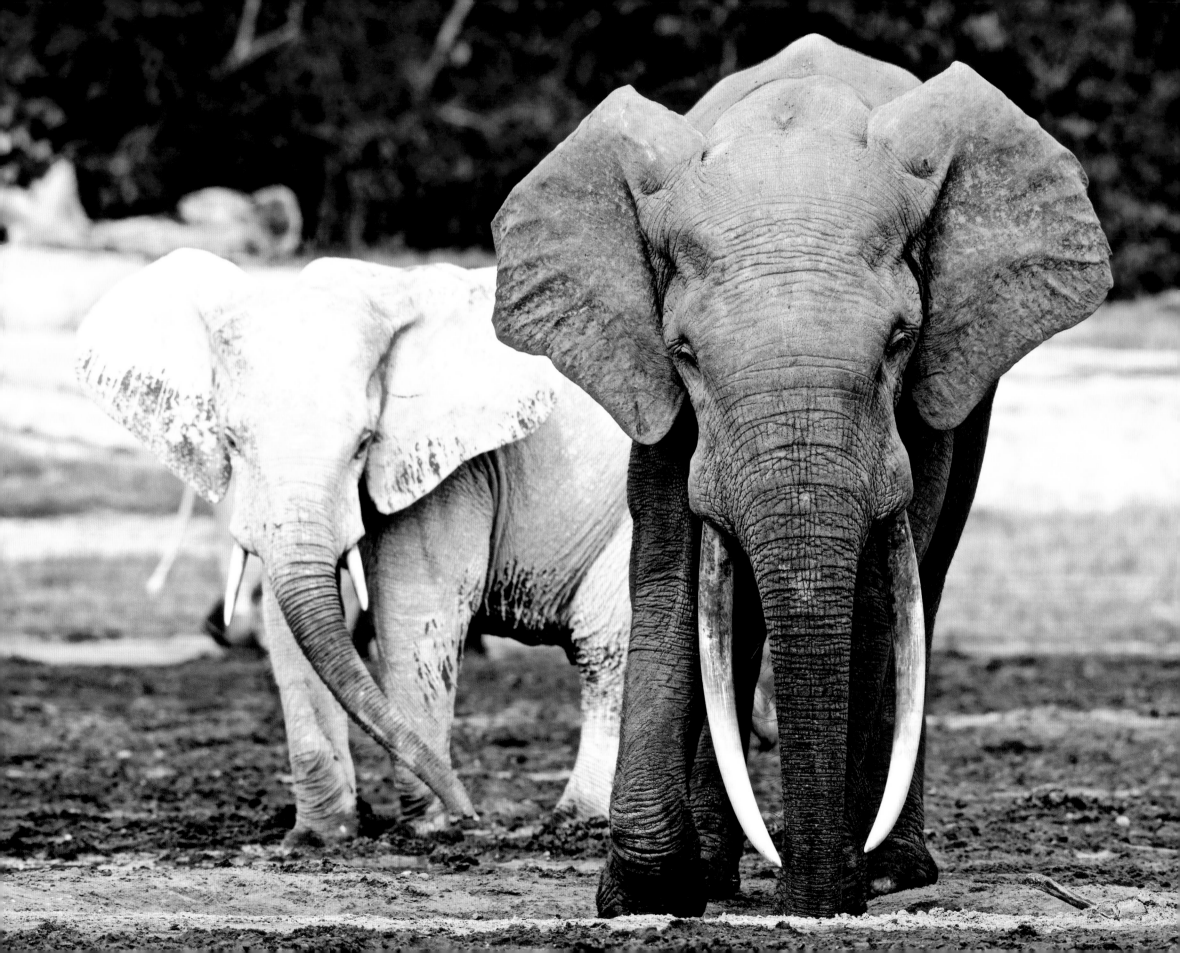

FOREST ELEPHANTS

In addition to the world's hottest, most well-known desert, Africa holds the world's second largest rainforest, the Congo rainforest. Almost identical in size to South America's Amazon rainforest, Africa's variation is the dominant feature of the Congo Basin, renowned simply as the Congo. Touching ten countries, the Congo is teeming with life. Approximately 10,000 species of plants, 1,000 species of birds, 700 species of fish, 300 species of reptiles and 400 species of mammals call this vast paradise home. The dominant mammal population though is man, in numbers exceeding 75 million. In far fewer numbers, and relegated to the deeper portions of the jungle, are the forest elephants.

As recently as 150 years ago, an estimated two million forest elephants lived in the Congo. Today, a little more than 100,000 individuals have survived the onslaught of humanity, living in a range that extends across the center of Africa from the Atlantic Ocean to the western environs of Uganda and Tanzania. Like desert elephants, forest elephants were originally thought to be closely related to savanna elephants. But in 2010, a genetic study found that forest elephants are so distinct that they were reclassified as a species in their own right. Scientists figured that the two species split from each other over two million years ago and that forest elephants are actually more similar to elephants that once lived in Europe than they are to savanna elephants.

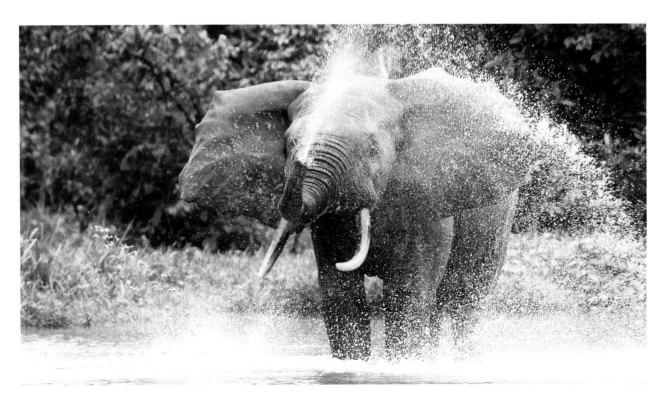

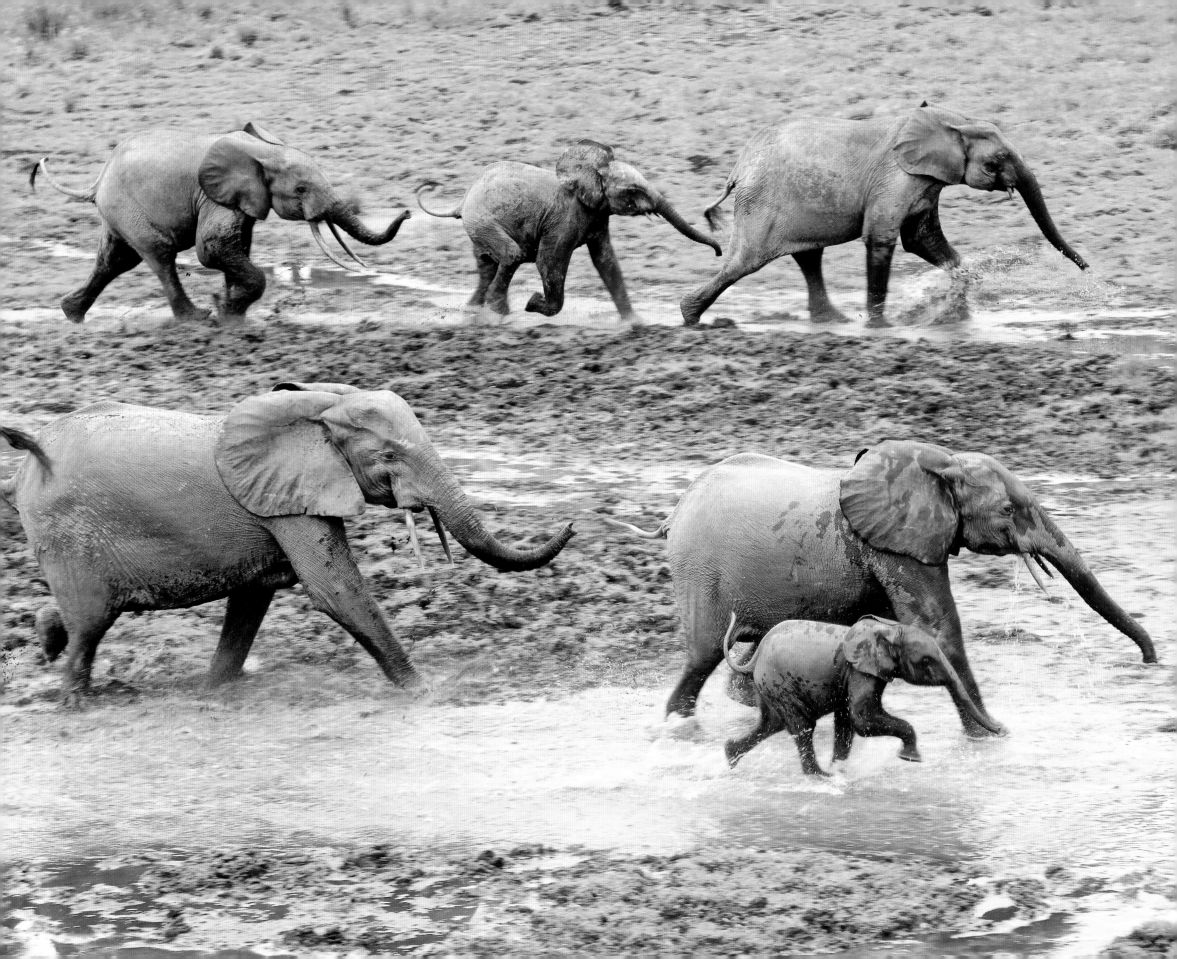

> *"If you talk to the animals they will talk with you and you will know each other. If you do not talk with them you will not know them and what you do not know, you will fear, what one fears, one destroys."*
>
> **CHIEF DAN GEORGE**
> Tsleil-Wantuth Nation

Many of the unique qualities of forest elephants are obvious to the human eye. In terms of size, they average two feet shorter in height and an average of two tonnes less in weight than savanna elephants. Their ears are significantly shorter and rounder in shape. Their tusks are harder, straighter and point downward compared with the savanna elephants' curled tusks that tend to point forward. They live in smaller family units of three to five individuals, similar to desert elephants and as a matter of family survival in a very challenging environment.

But it's the impact that all elephants, particularly forest elephants, have on their habitat that makes them invaluable to the greater scheme of life. They are an integral part of the centuries-old balance of nature. While mankind consumes and destroys in interaction with the environment, elephants give back. Nowhere else is this process more apparent than in a rainforest. As the largest beings in the forest, the way elephants feed and move about is beneficial to many other species. Many others are quick to take advantage of their paths of travel. The fallen trees and large shrubs are made available for food. But it's their dung, a plentiful commodity and nutrient rich owing to their poor digestive abilities, that is a key ingredient in the ongoing life of the jungle. From their waste, existing plants are fertilized, new plants are established as seeds are distributed and all the plant-eating beings who call the forest home benefit from a richer food supply.

And finally, the most magical aspect of forest elephants is that they're the species of elephant least understood by humans. Elephants, in general, are not known for having the most acute eyesight. There are places in the rainforest where vegetation is so thick that only 1% of sunlight reaches the ground. Forest elephants are just as active at night as they are by day. All in all, for much of their lives, forest elephants move about a habitat where eyesight is not enough. As scientists in recent years have discovered, forest elephants rely heavily on their senses of hearing and smell, along with their magical sense of vibrations, to make their way through the night and the thick jungle. Perhaps someday, if these elephants endure, mankind will better understand their superior use of senses and their uncanny ability to live in harmony with the natural world.

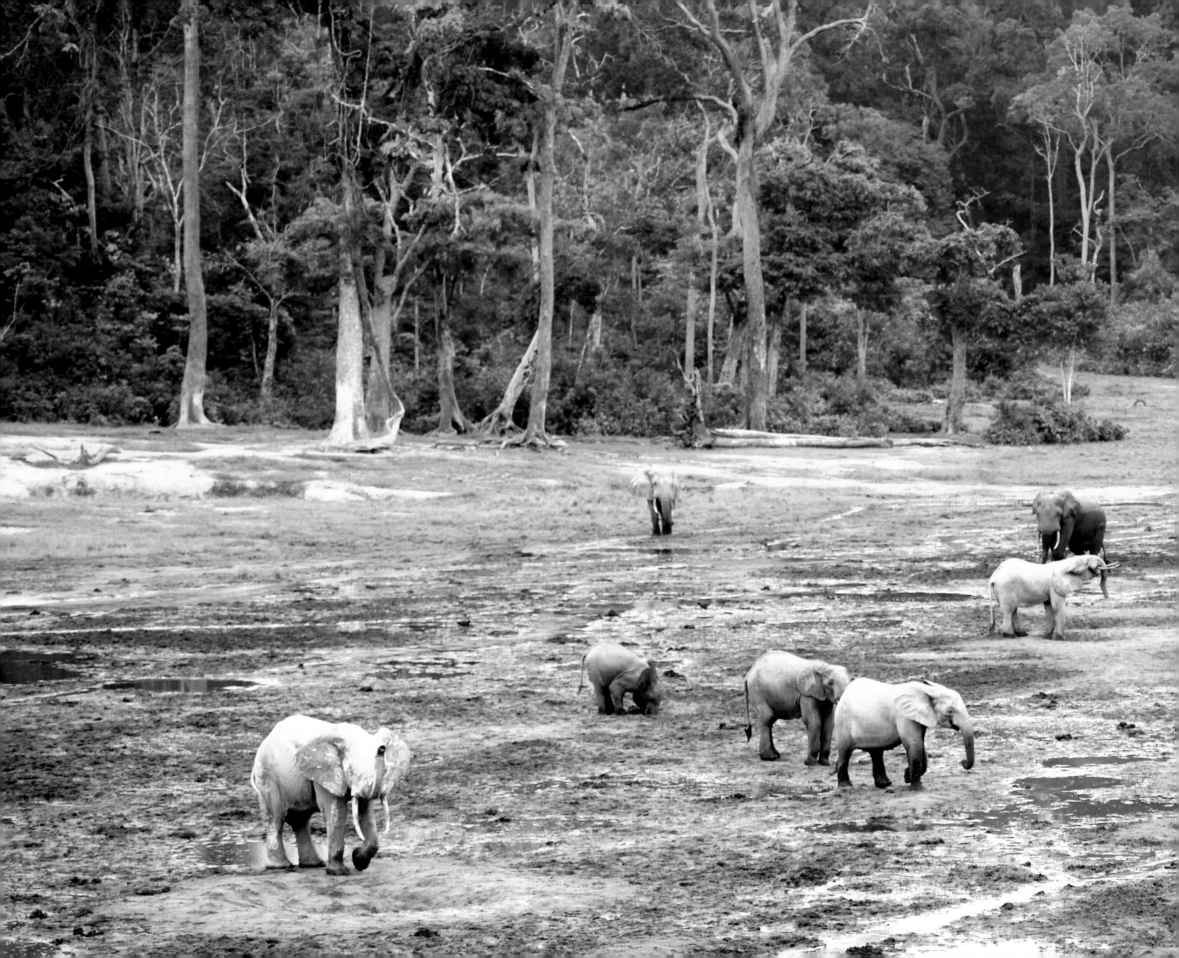

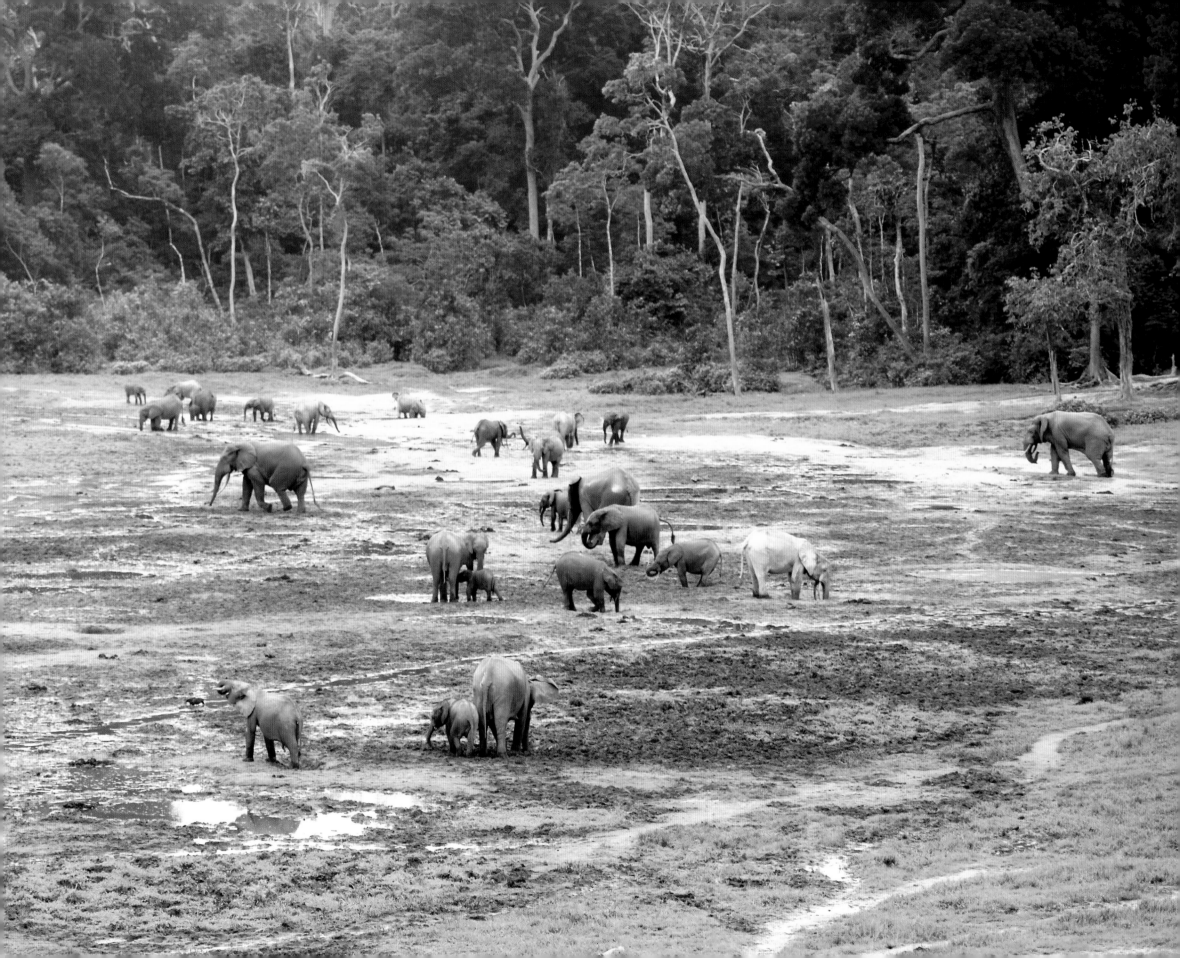

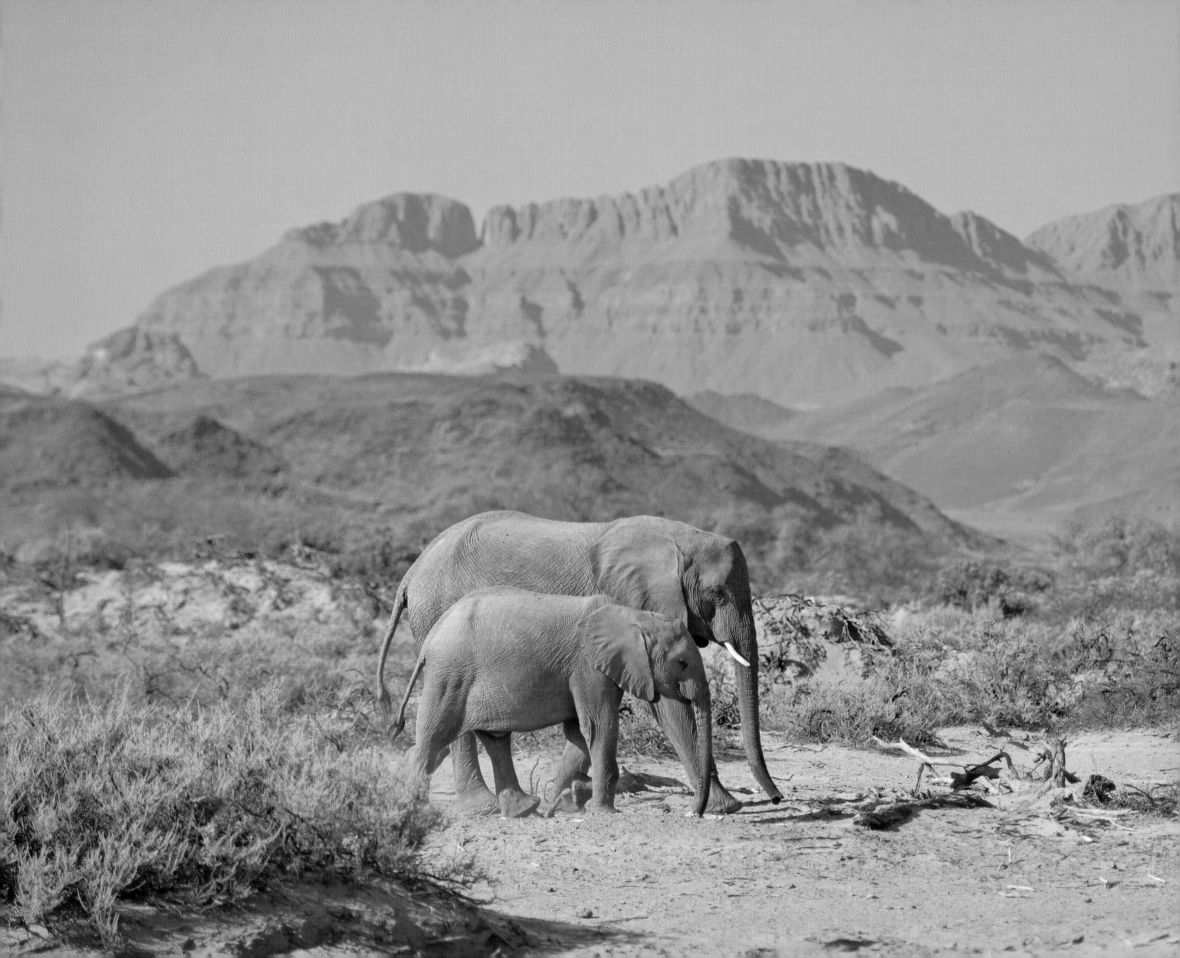

DESERT ELEPHANTS

The world's hottest and most iconic desert, the Sahara, accounts for nearly one third of Africa's landmass. Meanwhile, the world's oldest desert, the Namib, exists along the continent's southwest coast, running right up to the shores of the Atlantic Ocean. Average annual rainfall in the Namib is a little over one-third of an inch and temperatures easily reach 113°F. The Sahara exhibits equally extreme desert characteristics. Despite these deterrents to life, along with an incredible scarcity of food and water, tiny populations of elephants live in each desert. These are desert-adapted elephants, elephants who call the desert home all year long, as opposed to the savanna elephants who migrate to the desert from time to time. In the Sahara, primarily within the borders of the nation of Mali, a band of about 250 elephants survive. In the Namib, exclusively within the borders of Namibia, a stalwart population of roughly 600 live on.

In earlier days, both populations were significantly larger and desert-adapted elephants inhabited many of Africa's other deserts. Among these other groups was a sizeable population that once lived along the northern fringe of the Sahara drifting up towards the Mediterranean Sea, known as northern desert elephants. These elephants were among the first to feel the impact of mankind in the modern age and were killed during the days of the Roman Empire until they became extinct.

In general, desert-adapted elephants deserve increased distinction and sensitivity in their conservation. They are unique. They've adapted their bodies and their lifestyles to improve the odds of surviving in an arid environment. The adaptations include broader feet, longer legs and smaller bodies. Additionally, they can live without water for a longer period and commonly exist together in smaller family sizes of half a dozen or so compared with their savanna relatives who average about 15 members per family.

In the quest for food and water, desert-adapted elephants have claimed the largest home ranges of all elephants and are prone to epic migrations. During an average day, they will travel 16 miles with up to 43 miles traveled in a day not uncommon. To date, one group was witnessed traveling 120 miles in one day. In Mali, they make a remarkable 300-mile annual migration, moving from water hole to water hole, munching on any trees and shrubs they find along the way. In Namibia, most of their lives are spent along dry riverbeds where underground water supports moisture-rich trees and shrubs. One population in the south of the country annually undertook an amazing migration of several hundred miles deep into Angola and back but sadly all were erased from the surface of the earth by heartless humans.

A glimpse at how precarious life is for desert-adapted elephants can be seen in the observations made by American scientists Laura Brown and Rob Ramey who have studied several subpopulations in Namibia for over ten years. One such population was comprised of

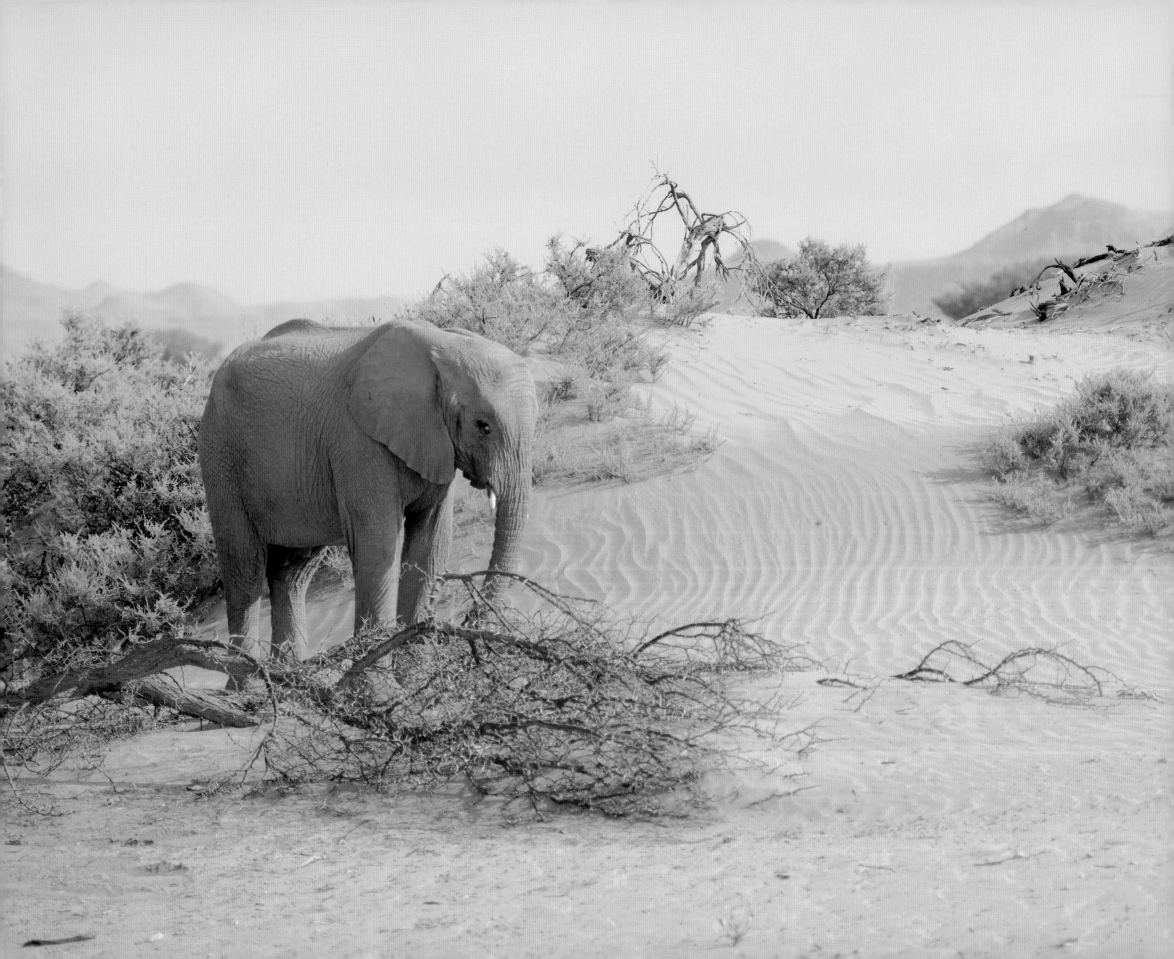

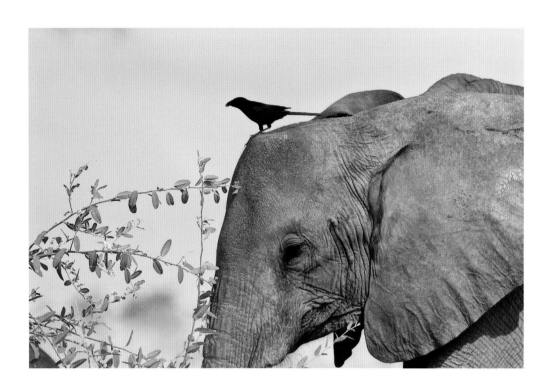

63 individuals when the study began. At the tally point, there had been 32 known losses that took place as follows: 14 died of human causes, including nine shot illegally, four shot by government officials for having been deemed 'problem elephants', and one died from complications brought about by a scientist's tracking collar; 11 died of natural or unknown causes; and seven disappeared with their fates unknown. The study also noted the fact that elephants in challenging environments reproduce at significantly reduced rates, a characteristic compounded by the fact that many babies fail to live past three months of age.

In the bigger picture of wildlife worldwide, the future of desert-adapted elephants is as tenuous as that for any animal alive today. Mali's population is currently being kept alive in a war-torn country by the actions of a newly formed ranger group trained by conservationist Rory Young, part of a greater effort to increase community involvement. Namibia's population receives little favour from the government and garners a lack of appreciation from the local native Africans. With only 800-900 individuals alive in the two locations, this rare being is apparently living on borrowed time.

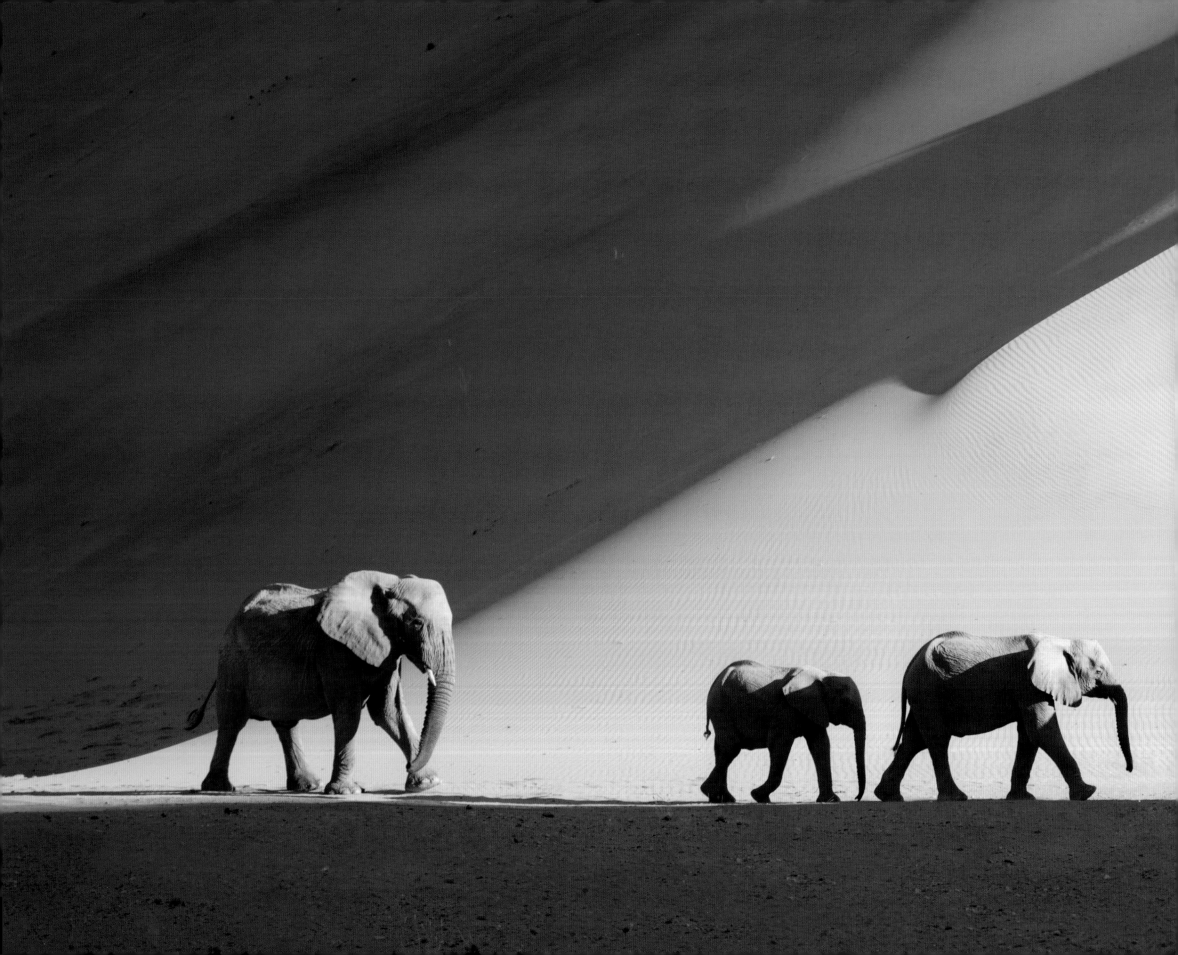

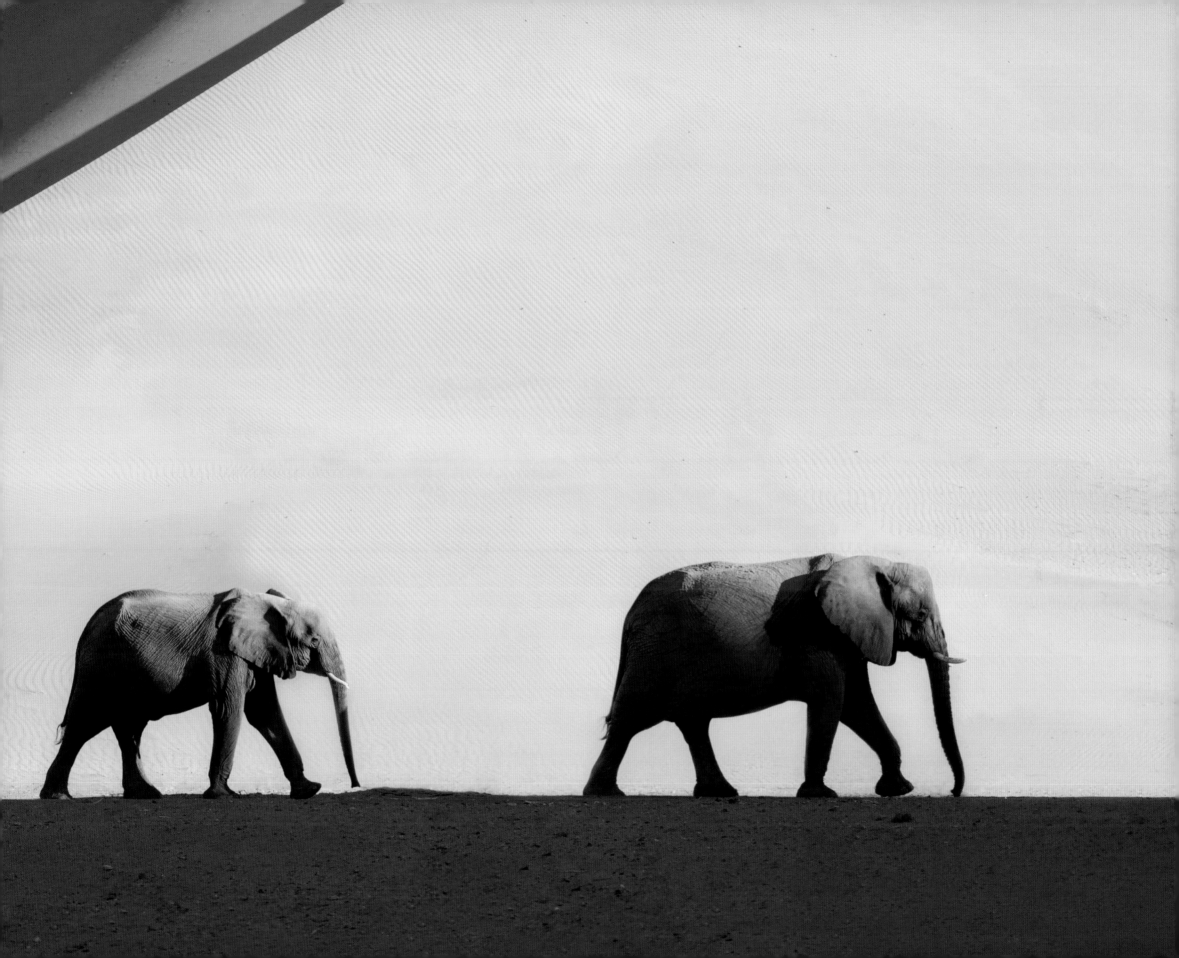

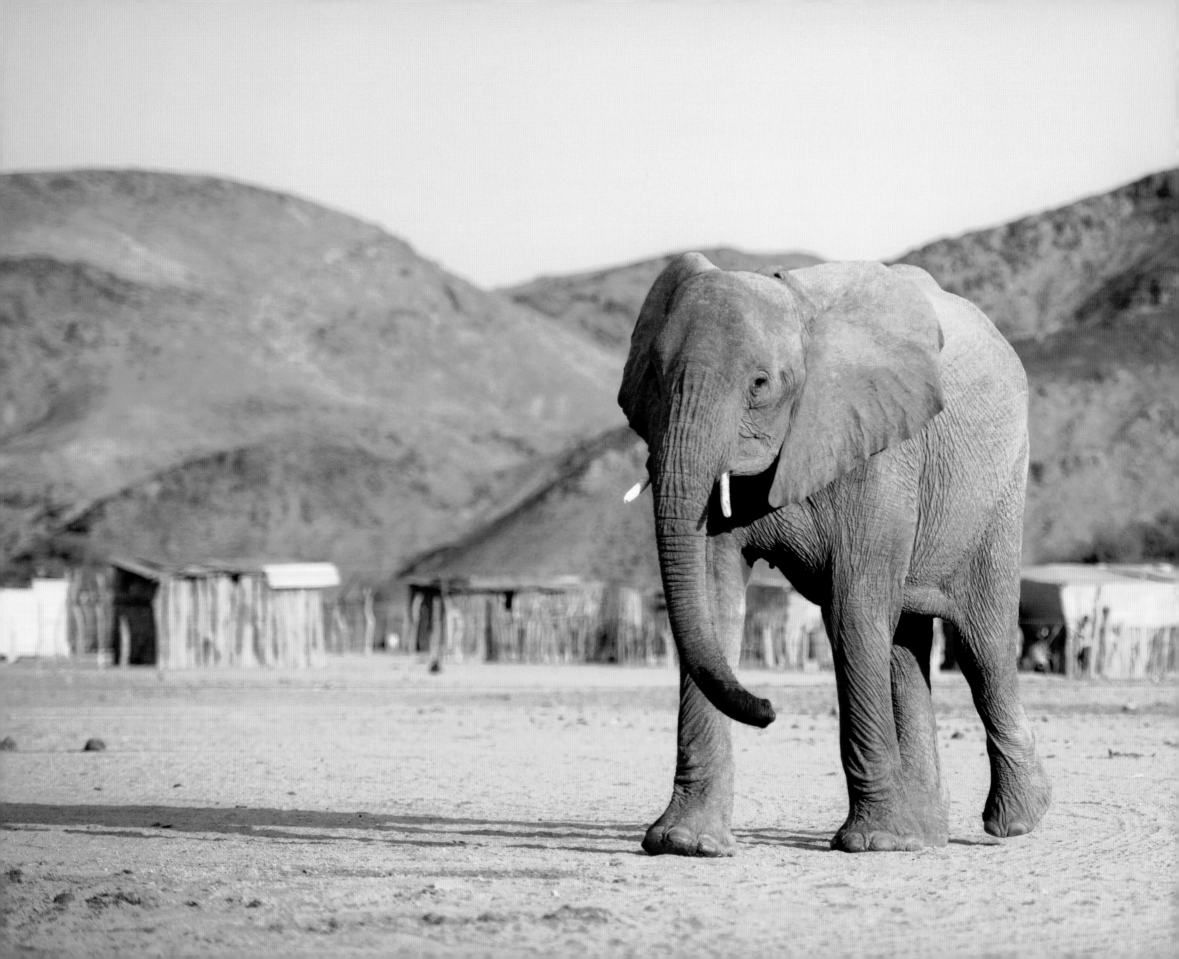

POCCHEN

As the Middle Ages in England unfolded, and the scope of property rights and class distinctions evolved, commoners began to trespass into royal forests to hunt game. Often, the illegally acquired meat would be hauled away in a bag; hence, the Old English word for 'in the bag', pocchen, became today's term for the illegal killing of wildlife, 'poaching'.

John Kaimoi of Kenya was a subsistence farmer and shepherd of a small herd of livestock in a typical African village during the early years of the 21st century. Kaimoi lived with his wife and six children under his wife's expectations that the family would sport a total of ten children as soon as possible. During a drought in Kaimoi's area, sustaining a huge family, the farm and the animals became difficult and he was forced to sell off all of his surviving livestock. However, the income from the sale didn't make ends meet for long. Soon, under the auspices of leaving the family home to go to work for someone, Kaimoi would disappear into the night with his spear, sometimes accompanied by a few other villagers. For a period of ten years he would go out into the night like this to hunt elephants in order to kill them and harvest their ivory tusks. Periodically he would make a 400-mile trip from his village to one of the world's centres of illegal wildlife trade, Mombasa, to sell the ivory. Finally, just after entering a nearby park one day to hunt elephants, Kaimoi was arrested by park rangers. He admitted to having killed 70 elephants and, under Kenya's lenient sentencing of the day, spent just two years in prison.

Hassan Idriss Gargaf of Chad grew up as the son of subsistence farmers just outside a town of 75,000 people that bordered the country's premier national park. In his youth, he worked as a guide for hire, shepherding livestock throughout the area and bearing witness to the migrations of elephants into and out of the park. As the carnage of civil conflict in neighbouring Darfur in Sudan escalated, Islamic hitmen, activated by the Sudanese government, began making treks into Chad to kill elephants for their ivory so they could finance their military operations. Eventually, the hitmen contracted Gargaf to guide them in locating the park's elephants. At this time, Gargaf had fathered seven children with two wives and welcomed the additional income. He joined forces with another local shepherd and soon saw the opportunity to start his own elephant poaching network. He secured weapons, developed logistics and found a buyer for ivory in one of the country's major cities. Hundreds of elephants died at their hands, often with the assistance of information provided by corrupt park guards. Finally, Gargaf was arrested – not once, but twice. However, to no surprise, he bought his way out of prison each time and went on to kill more elephants. Not long ago, Gargaf was arrested for poaching yet again but no one in Chad can say with certainty just where the former shepherd is today.

Joseph Kony of Uganda was born the son of subsistence farmers. In his youth, he was an altar boy and enjoyed

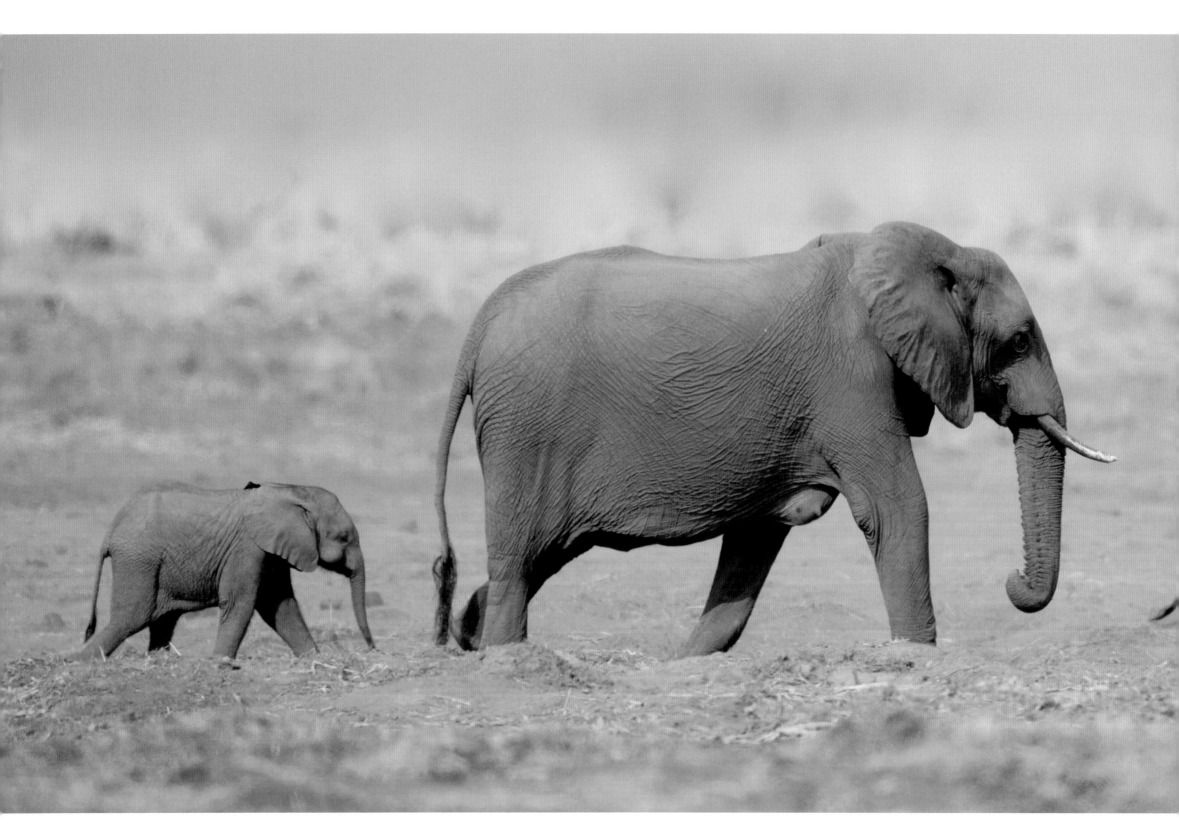

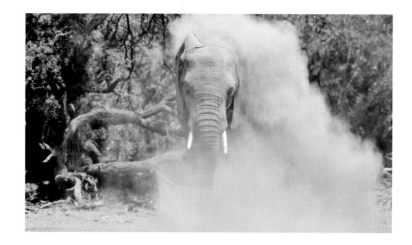

traditional dance. In the prime of his life, he witnessed the genocide of his ethnic group by the country's latest post-colonial, power-hungry government. Atrocities of all kinds were commonplace. In response, Kony rose to power, initially to defend his people by forming the Lord's Resistance Army (LRA). Claiming to be a prophet of God as well as a medicine man, in truth all that mattered to him was his position of power and the survival of the LRA. He soon turned his power on his own people. Supplies to fight the government were exhausted so he plundered, taking what he needed from whomever he chose. In his wake, two million people were forced from their homes, over 100,000 people were killed, countless were mutilated and 66,000 children were abducted to serve the LRA as soldiers and sex slaves. From his conquests, Kony took over 60 wives and fathered over 42 children. At one point, he was exiled from Uganda and given haven across the border inside one of the Democratic Republic of Congo's premier national parks.

This relocation proved only to benefit Kony further. Elephant poaching immediately spiked there as the LRA used the harvested ivory to trade for weapons, ammunition and food. In 2010, the first of many such times, the order was given by Kony to, "Kill all elephants and bring me the tusks." To this day, Kony reportedly sends hunting parties from wherever he may be in hiding in order to secure ivory to fund his operations. An indication of just how strong his survival mechanism is, Kony eluded a multinational manhunt bankrolled by the United States several years ago. Despite a 5,000-man multinational force, the expenditure of over $800 million and a $15 million bounty on his head, Kony stayed one step ahead. Today, his whereabouts are uncertain but LRA defectors continue to surface with news of him. And while those Africans whose lives were scarred by Kony continue to rebuild their existence, the hundreds of elephants his LRA brutally killed, along with the 100,000 human lives he erased, will not be coming back.

"Dear Elephant, Sir: ...The task of remaining human seems at times almost overwhelming and yet it is essential that we should shoulder on our backbreaking walk toward the unknown a supplementary burden: the burden of elephants. ... It seems clear today that we have been doing to other species, and to yours in the first place, what we are on the verge of doing to ourselves."

ROMAIN GARY
"Dear Elephant, Sir," *LIFE* magazine, December 22, 1967

Poaching in Africa, as with poaching in England, has occurred throughout human history. Even during the great western tide that overcame Africa in the 19th century, roving white hunters were arrested and tried by tribal kings for hunting on royal land without permission. However, the crisis faced by elephants today was set in motion by the wholesale commercial killing that took place once Africa was under colonial rule. During a 100-year period, 16 million elephants, over half of all those living at the time, were wiped out. The pace of killing continued until the late 1950s and 1960s when most countries on the continent embraced independence from colonial rule. Quite a few native Africans, though, had been watching the ivory trade and were more than ready to take over. The pace resumed with a mostly new cast of characters. Roughly one million elephants have been poached since 1979. In just three years alone, between 2010 and 2012, over 100,000 elephants had their lives snuffed out. Native African poachers for centuries had been hunting and poaching using poison arrows, spears, snares and game pits into which animals were driven. To these means of killing were added the use of guns, grenades and poisoned food and water. All means useful have been applied in the wholesale killing of elephants since the end of colonial rule and Africa's elephants have been taken to the brink of extinction. This includes countless local extinctions where elephants will never be seen again.

Today, as Africa's elephants continue to die at the hands of poachers every day, there is no gain to be made in pointing fingers at compromised native Africans or ignorant ivory collectors in Asia. In order to save as many remaining elephants as possible, innovative and thoughtful solutions have to be discovered. One such idea, based on community conservation, is in full bloom in the once ravaged land of Zambia. Since 2003, American wildlife biologist Dale Lewis has led Community Markets for Conservation (COMACO). Frustrated by the destruction he witnessed and acknowledging that poverty is one of the root causes of poaching for many native Africans, Lewis put the word out: Stop killing elephants, surrender your weapons and COMACO will teach you the necessary skills to feed your families and also provide you with income from the sale of your surpluses. With a supporting staff of 300 Zambians, Lewis today works with over 179,000 farmers to ensure their well-being which, in turn, leads to the well-being of many elephants. So far, more than 1,500 poachers have come forward to change their lives for the better.

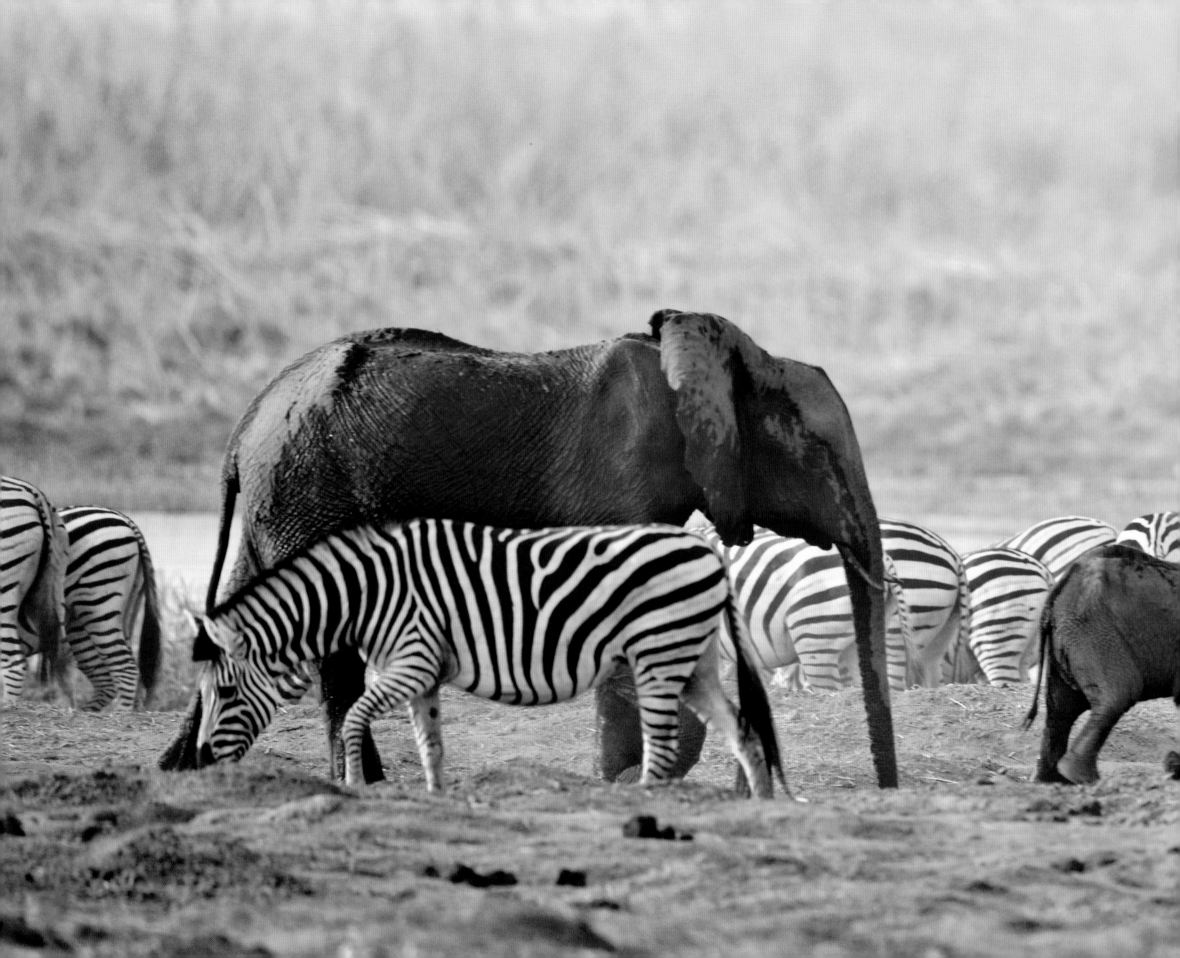

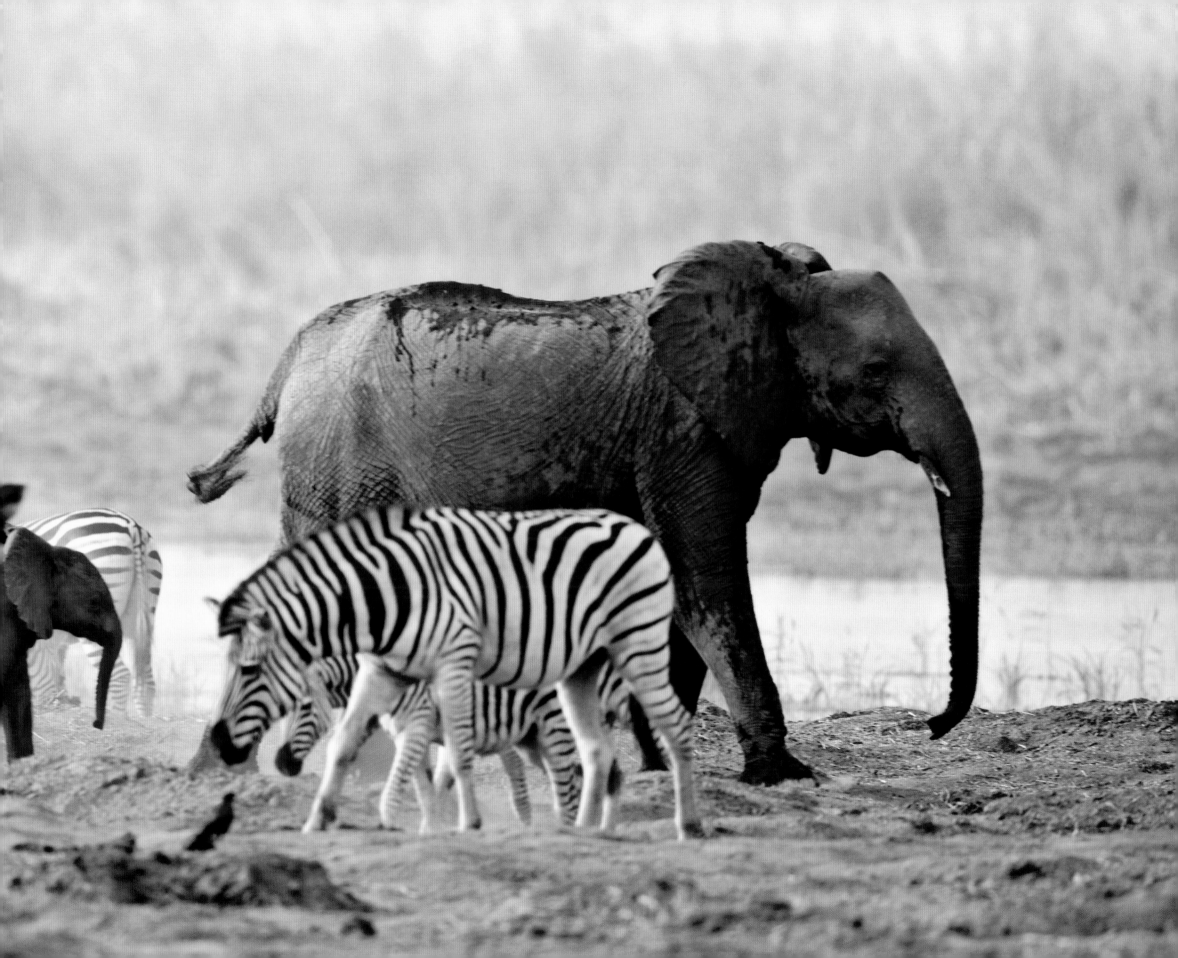

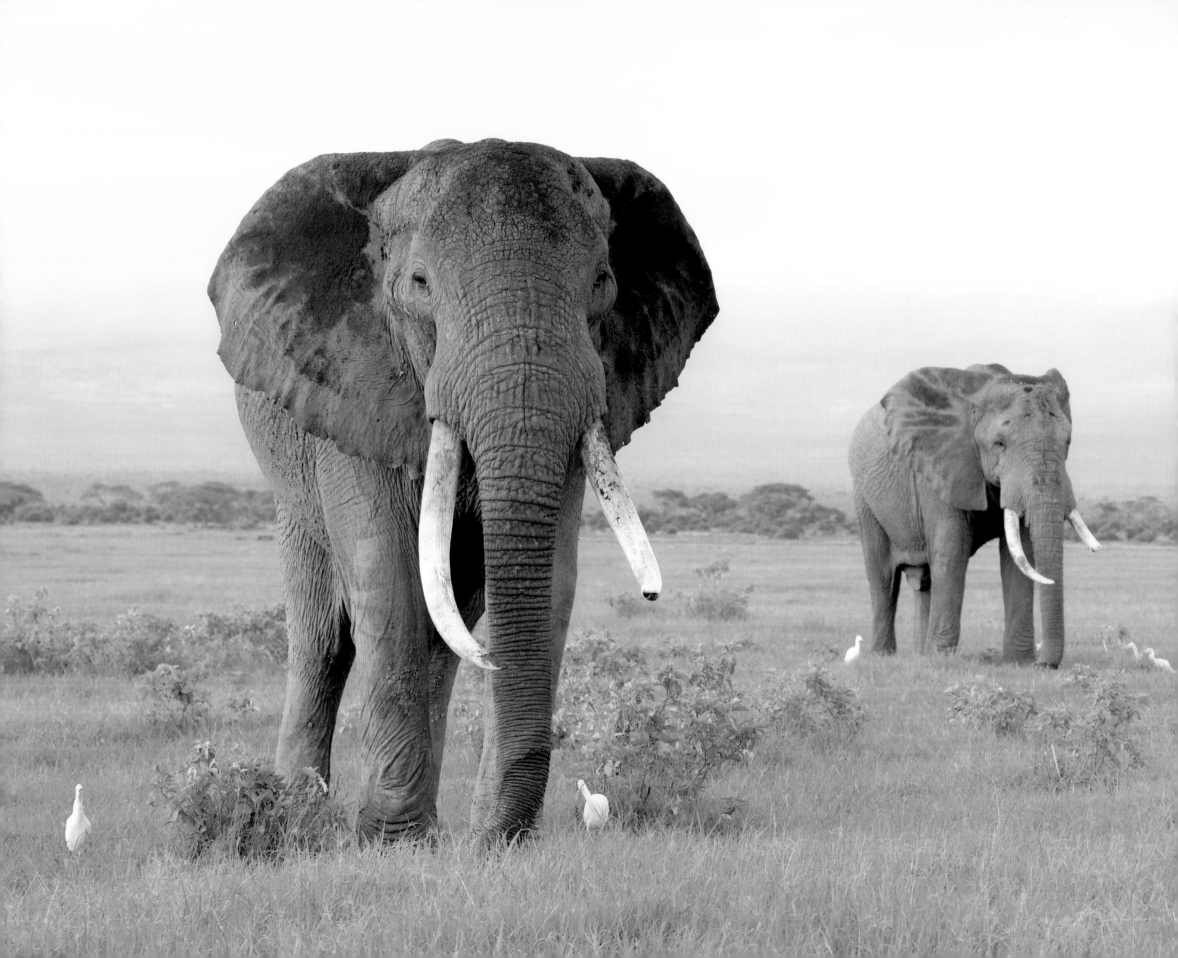

TSAVO

When people from around the world think of an African safari today, one of the most commonly thought of destinations is the nation of Kenya. Within Kenya, 8% of all land is protected by an assortment of 65 national parks and reserves, with the most popular of all in terms of attendance being the Maasai Mara. Not all that far from the Maasai Mara is Kenya's largest national park, a reserve nine times larger, the Tsavo East National Park, and its sister refuge, the Tsavo West National Park.

Mankind has lived in the Tsavo region for over 100,000 years. Scattered communities of hunter-gatherers lived alongside one of the two major rivers there for centuries until they were absorbed and displaced by the arrival of a tribe of pastoralists and their cattle in about 500 AD. Then, during the 18th century, members of the Maasai tribe, also pastoralists, arrived with their cattle. And in the late 19th century, the colonizing British came in with their determination to bring order and organization to the land by establishing property lines, building infrastructure and controlling wildlife.

While seasonal migrations of elephants continued throughout the region, there were increasing pressures on the elephant population. Some of the pressure came from a tribe of elephant hunters who lived nearby. Among them lived a local legend, Boru Debassa. Born in 1920, Debassa by his mid 20s was killing an average of 50 elephants each year and went on to a 25-year career of killing that included the lives of 12 giant tuskers.

In 1948, the colonial government established the Tsavo National Parks: Tsavo East and Tsavo West. In turn, human settlements were forced out and wildlife populations were forced in. David Sheldrick, the first warden of Tsavo East, faced an ivory poaching crisis right off the bat with two neighboring tribes leading the offenders. In a revolutionary set of moves that were repeated in parks across Africa, Sheldrick set up a network of local informants who supplied information on who was doing the killing and how they were going about it. Meanwhile, Sheldrick employed former poachers as game rangers, a tactic that not only gave these men a new purpose but took advantage of their superior skills in the bush. Except for the numerous hunting parcels established adjacent to the parks, all wildlife, especially elephants, multiplied and flourished.

By 1969, the Tsavo region faced a new problem. Due to the various pressures and artificial changes brought to the ecosystem, Tsavo East had become home to as many as 35,000 elephants. Significant portions of the park were essentially sterilized of vegetation by the hungry multitude of elephants. Critics began calling for a cull – a thinning of the herd. But then a multiyear drought hit the area in 1970, leading to the deaths of thousands of elephants. As if this wasn't enough, following the drought, the price of ivory rose. Braced by the common knowledge that Tsavo still held a sizeable elephant population, poachers came from far and wide.

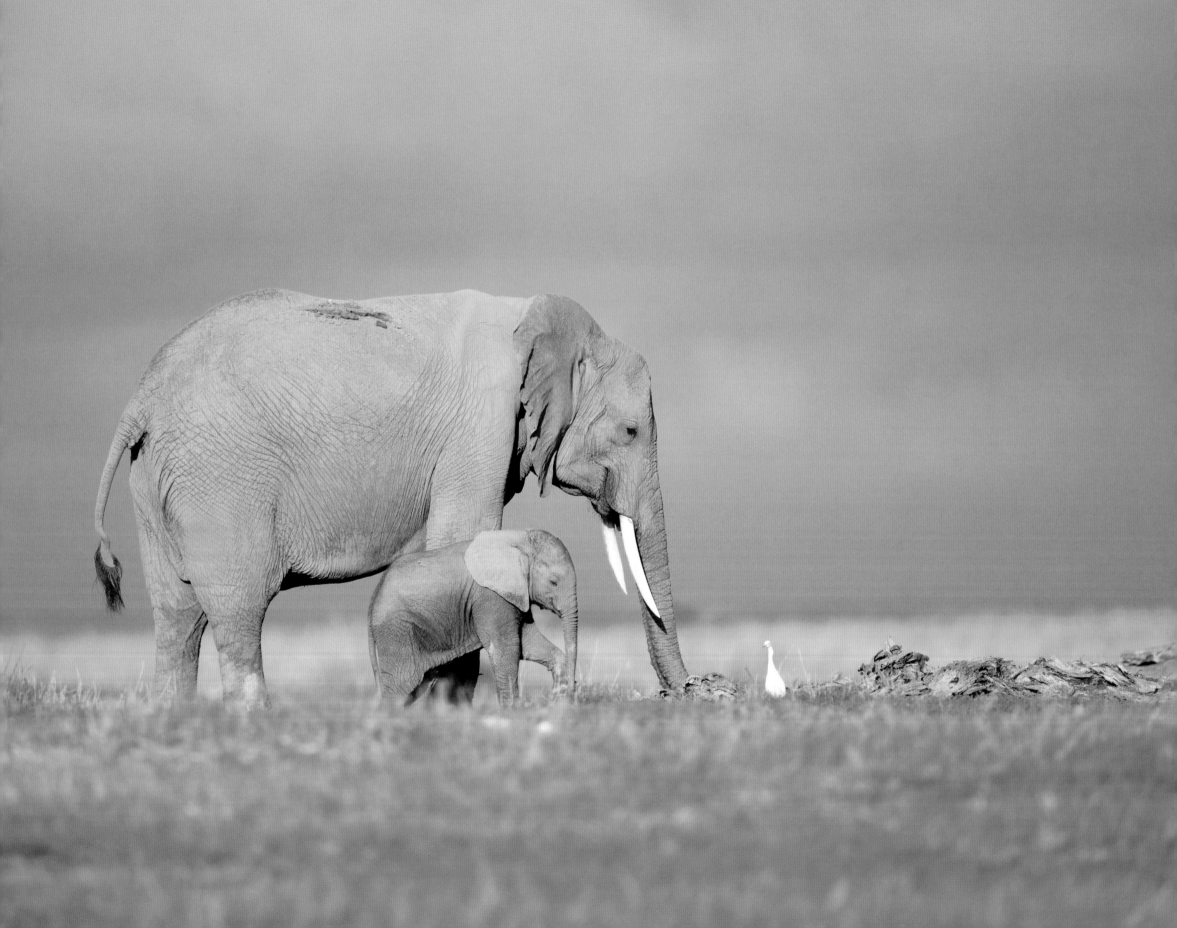

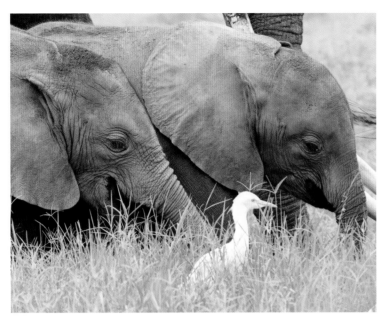
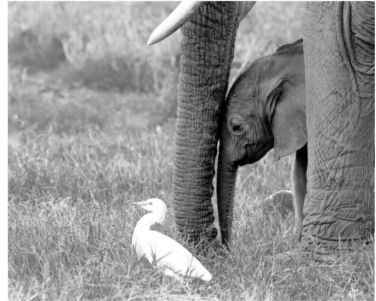

By the late 1980s, Tsavo's elephant population of 35,000 had been reduced by a lack of food, drought and poaching to 6,200, more than 80% lost. Further, parts of the park had to be closed to tourists as law enforcement personnel engaged in gunfights with poachers, primarily gangs armed with AK-47s from Somalia.

At each stage of elephant history in Tsavo, critics have cried foul. If the park hadn't been created, artificially providing a haven for elephants and other wildlife, many human beings would not have been displaced. If so many elephants had not come to be there, there would have been plenty of food for a sustainable population of elephants and other wildlife species, drought or no drought. And had so many elephants not been concentrated in one place, so many violent poachers would not have been attracted there, resulting in the deaths of even more elephants. To these historical interpretations, you can add today's ongoing real-life issues of Tsavo elephants raiding the crops of local farmers, the competition for water between the elephants and livestock of local pastoralists and the blatant disregard for the park by some of the local people as they routinely enter the park to poach small animals, gather firewood and graze their livestock.

The Tsavo National Parks' past and present concerns epitomize the threats that have faced most of Africa's wildlife reserves. First and foremost, reserves have had to contend with the fact that most native Africans living near a reserve have held no respect for it and what it stands for. Their general feelings are that it's their right to hunt, to poach, to pasture, to otherwise do as they see fit inside and outside a reserve. Further, reserve staff have tended to be viewed as enemies of the public and have been treated accordingly. These issues are compounded by a fundamental flaw in the establishment of many reserve boundaries; they usually don't account for the total ecosystem used for centuries by the animals the reserves were designed to protect. Instead, human political and economic compromises have generally dominated the creation of the lines that demark what is in a sanctuary and what is out. As a result,

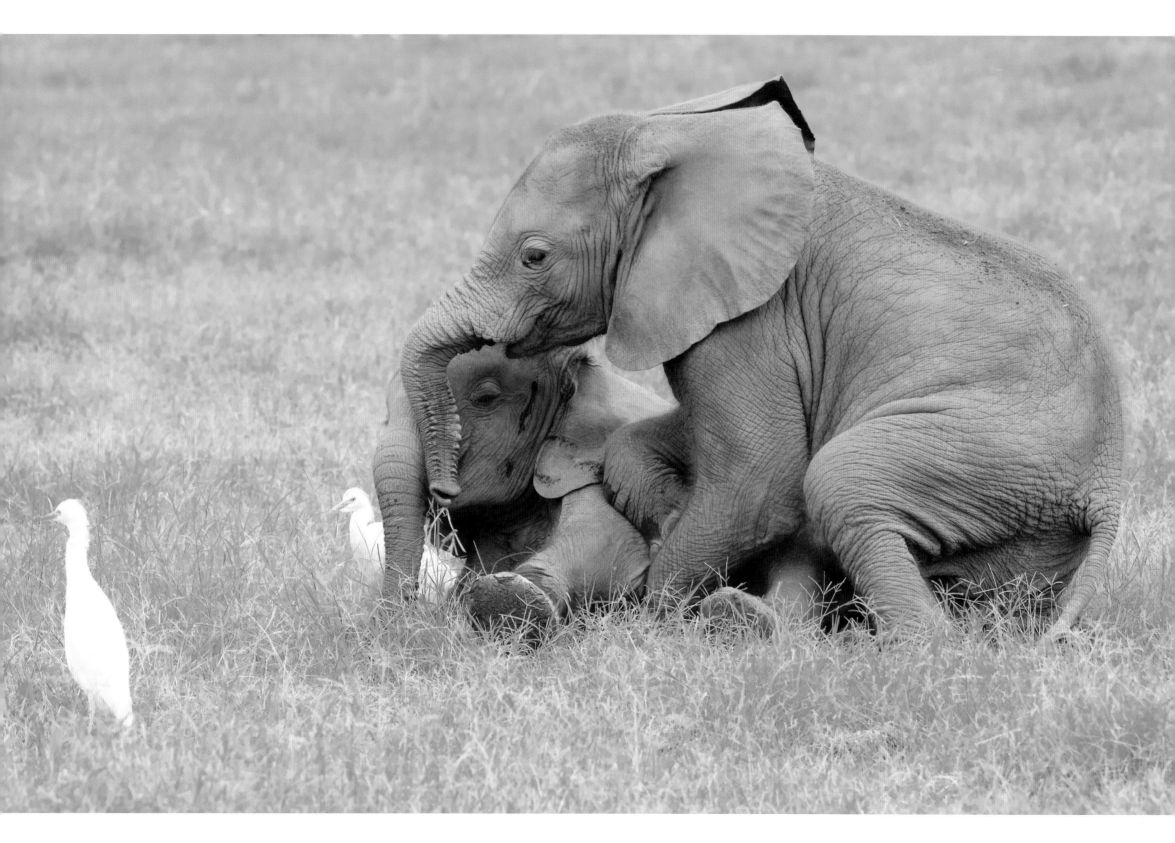

Kenya. White hunter George Hurst was killed in 1923 by a charging elephant that by all accounts he could have killed. In memory of his death, the famous beer that he had created just one year before was named 'Tusker', and today, George Hurst's lager is the most popular beer in Kenya.

as wildlife move in and out of the reserves during their search for food, water and mates, it's inevitable that conflict with the humans settling just outside the reserve is the result.

As humanity progresses through the 21st century, it has become apparent that wildlife populations have been and will continue to be increasingly confined within the limited and unnatural boundaries of parks and reserves. Extreme human population growth throughout Africa dictates this. And within these restricted areas, wildlife populations will tend to increase up to and then beyond the carrying capacity of the available food supply and beyond the patience of the humans who have settled along the reserve boundaries. For 40 years now, the citizenry and wildlife managers of East and Southern Africa have wrestled with this problem. Beginning in the late 1970s the only solution embraced was culling. The bloody record of one hunting company brought in by the government of Zimbabwe to reduce

the elephant population over a five-year period there epitomizes the process. The company utilized a spotter aircraft, three hunters on the ground carrying semi-automatic rifles, three gun bearers and trucks carrying 250 men who worked as skinners and butchers. On one occasion, 98 elephants were killed in less than one minute. Whole families and even clans were destroyed at once with the occasional exception of babies. Between 1981 and 1987, 25,000 elephants were culled in Zimbabwe alone.

In Zimbabwe, local conservationists insisted that in the culling there would be no witnesses. No elephants who witnessed the killing of other elephants were allowed to survive. This was thought to be a means of addressing the emotional scarring on any surviving elephants, which of course could have ramifications for the tourist industry. Additionally, there was to be no evidence of bodies left behind. But human knowledge of elephant communication was minimally understood at this stage.

It turned out that as elephants were being attacked and killed, they were sending frantic messages to other elephants, miles away, about the danger. Once the hunters and butchers had cleared an area, those elephants who had received the messages would converge on the killing sites and linger, milling about, communicating with one another. Then, after a period of time, they would move off and avoid coming near the area again for a very long time.

Today, the sizable and growing population of elephants of Zimbabwe's Hwange National Park is currently facing calls by some for yet another cull. In Botswana, long a haven for elephants threatened in neighboring countries, the largest population in Africa has been slowly facing growing opposition as well. While the elephants of Tsavo East those years ago unknowingly traded a cull for even greater horrors, their population is once again on the increase and has currently recovered to 12,000 individuals, the largest population in Kenya.

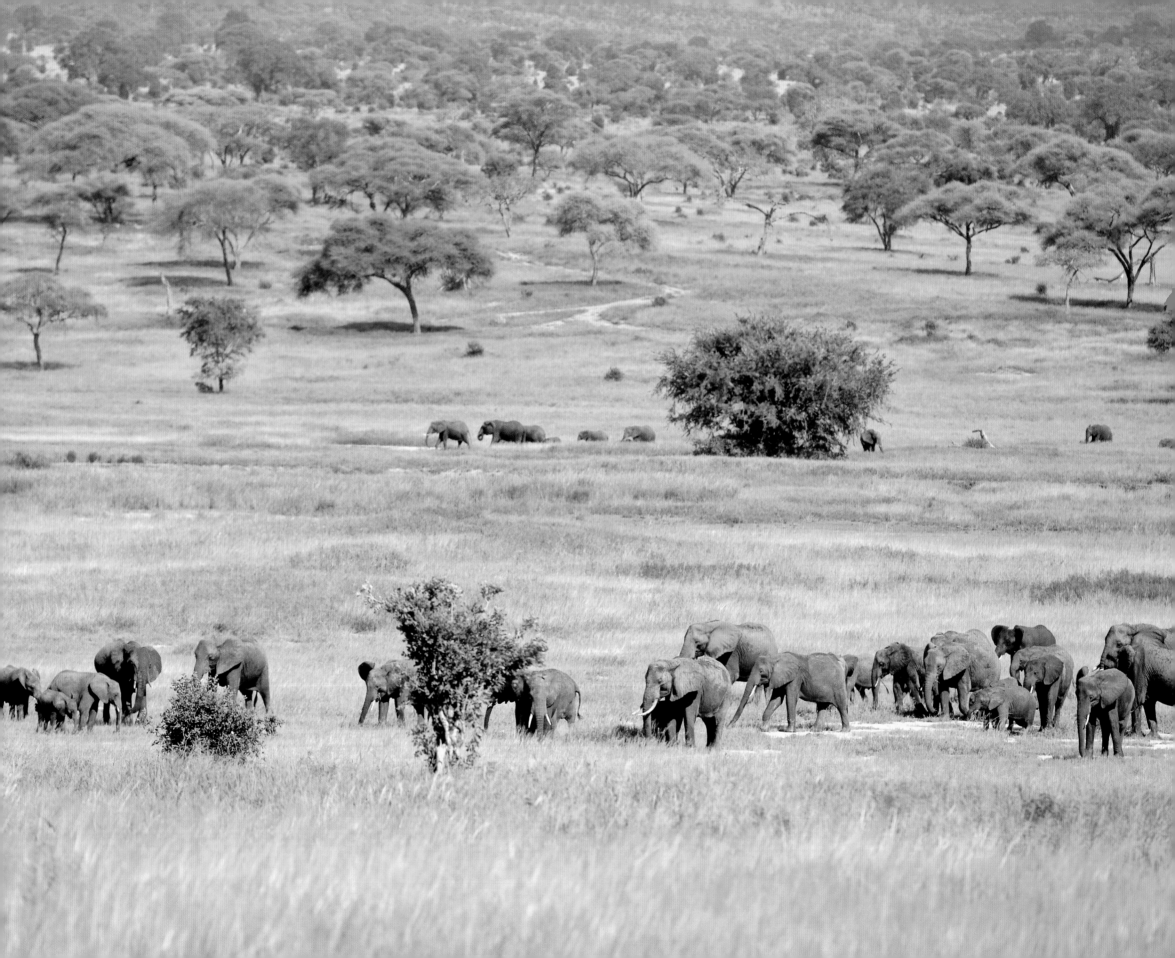

TATANKA

Across North America they roamed, from the Oregon coast overlooking the Pacific Ocean to the Florida Coast on the Atlantic. From south into Mexico to well up into Canada, they made their homes in the mountains and the plains. At one time, their population reached over 60 million, making them the most numerous large animals to ever live on the face of the earth. Their need for food was great and as one area would become temporarily depleted, they'd migrate elsewhere. So it went on for thousands of years and their migration trails, carved into the earth by millions of crossings, were used first by the native Americans and later by explorers and pioneers, some eventually becoming the roads and railways used by humanity today. The size of these beings and their shaggy brown coats distinguished them from all other souls alive, except the once common woolly mammoth that roamed the same landscape. The Native Americans of the Northern Plains lived side by side with these beings, respecting them for the food they provided and the shelter their hides allowed. When a life was taken by the Native Americans, every single part of the animal was utilized and thanks was given. The Native Americans of the plains region called these beings 'tatanka'. And later, the early European explorers and fur traders gave these beings another name, the name they are commonly known by today: Buffalo.

At first, the American Buffalo were killed by the European colonists for meat. Then, as the colonial populations grew and the United States was established, they were killed for their coats that were turned into extravagant outerwear for humans. As the growing nation pushed westward into the frontier, the buffalo were perceived as a pest, delaying wagon trains, delaying railroads, fouling water supplies and utilizing land that could otherwise be used for agriculture and livestock. More buffalo were killed. Then came the wholesale slaughter that followed the American Civil War. The nation's focus returned to expansion in the West. Standing in the way were the Plains tribes of the Native Americans and their brothers, the buffalo. The government determined that the only way to clear the frontier in preparation for settlement was to take away the food source of the Native Americans. Unemployed Civil War veterans were given guns. Tourists were encouraged to ride the transcontinental trains and shoot buffalo from their windows as they rode along. And the commercial trade in all parts of the buffalo, including their bones, led money-hungry citizens out to shoot as many buffalo as they possibly could.

So thorough was the killing, only 23 wild buffalo – yes, 23 of roughly 60 million – survived the onslaught by hiding out in the tiny Pelican Valley of Yellowstone National Park. It was a holocaust; the largest holocaust in the history of the world.

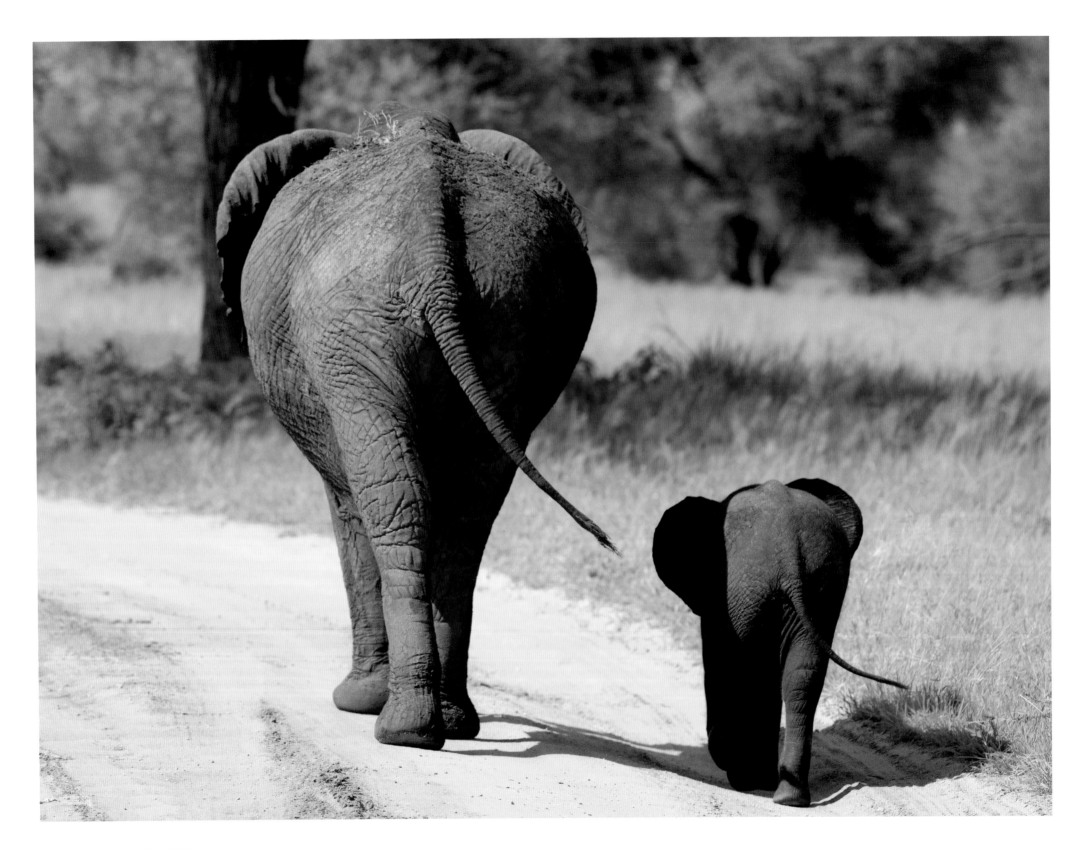

Tanzania. In August 2017, a Dar es Salaam taxi was stopped in traffic. Two men, one armed with a gun, opened the door of the taxi and fatally shot the passenger, Wayne Lotter, director and co-founder of a critical conservation and anti-poaching organization that supported the nation's elite wildlife crimes investigation unit. As a result of their efforts, over 2,000 poachers and traffickers, including the Queen of Ivory, Yang Peng Glan, had been arrested. Wayne Lotter had been receiving death threats for years.

In Africa, the waves of humanity have similarly come, and continue to come, altering the landscape while displacing and destroying wildlife. The Arabs, the Europeans, the Americans and, finally, as an agent of the Chinese, the native Africans, all have hunted the elephant down, killed him, run off to the big city with his ivory tusks, leaving his bones to bleach under the hot African sun. Meanwhile, the human population of the continent has steadily grown as native African women commonly give birth to four, six, eight, ten children or more. Today, Africa has the fastest growing human population of all the world's continents, with many African nations hosting the world's highest reproductive rates. In the process, all these millions of new people are needing a place to live and food to eat. The remaining elephants, just trying to survive endless poaching attacks for their ivory, are pushed even further and further aside, away into smaller and smaller pieces of land, all the while

viewed by most humans as nothing more than a pest.

When you consider the incalculable death toll of elephants across Africa, together with the fact that an elephant never forgets, the overwhelming majority left alive today are in a way half dead, living lives of pain and fear. So many of these beautiful souls have burning memories of the violent deaths of family members, brutally killed by humans. My heart has sunk numerous times as my vehicle has come in sight of a family of elephants only to watch them panic like a flock of sheep and run off into the bushes to hide. These are earth's largest, most powerful, most intelligent land beings, and we've reduced them to instinctively running for their lives!

In some odd way, when I'm out in the wilds with the elephants, I carry with me the debt that the human race owes them. No, I've never pulled a trigger, bought a piece of ivory or favoured hunting laws, but others of my kind certainly have. At the end of the day,

humanity must admit that there are no bounds to the ignorance and coldness of the human heart. We must learn from history, from the price paid by the tatanka and generations of elephants. It's therefore up to those of us of kind heart, with the strength to assume responsibility for the welfare of our world, of our elephants, to stand tall and act on behalf of these lovable, magical beings. Those who are on the ground in Africa, protecting elephants with their lives, studying elephants with their science and working with native African communities to educate them for a better coexistence with elephants, all need financial support. This is where the rest of us can help, by making donations. We can sign petitions when they cross our paths. We can write to representatives in government. We can follow news and conservation efforts on social media. This is the least we can do for such a wonderful being who has captivated us for centuries and endured us, just barely.

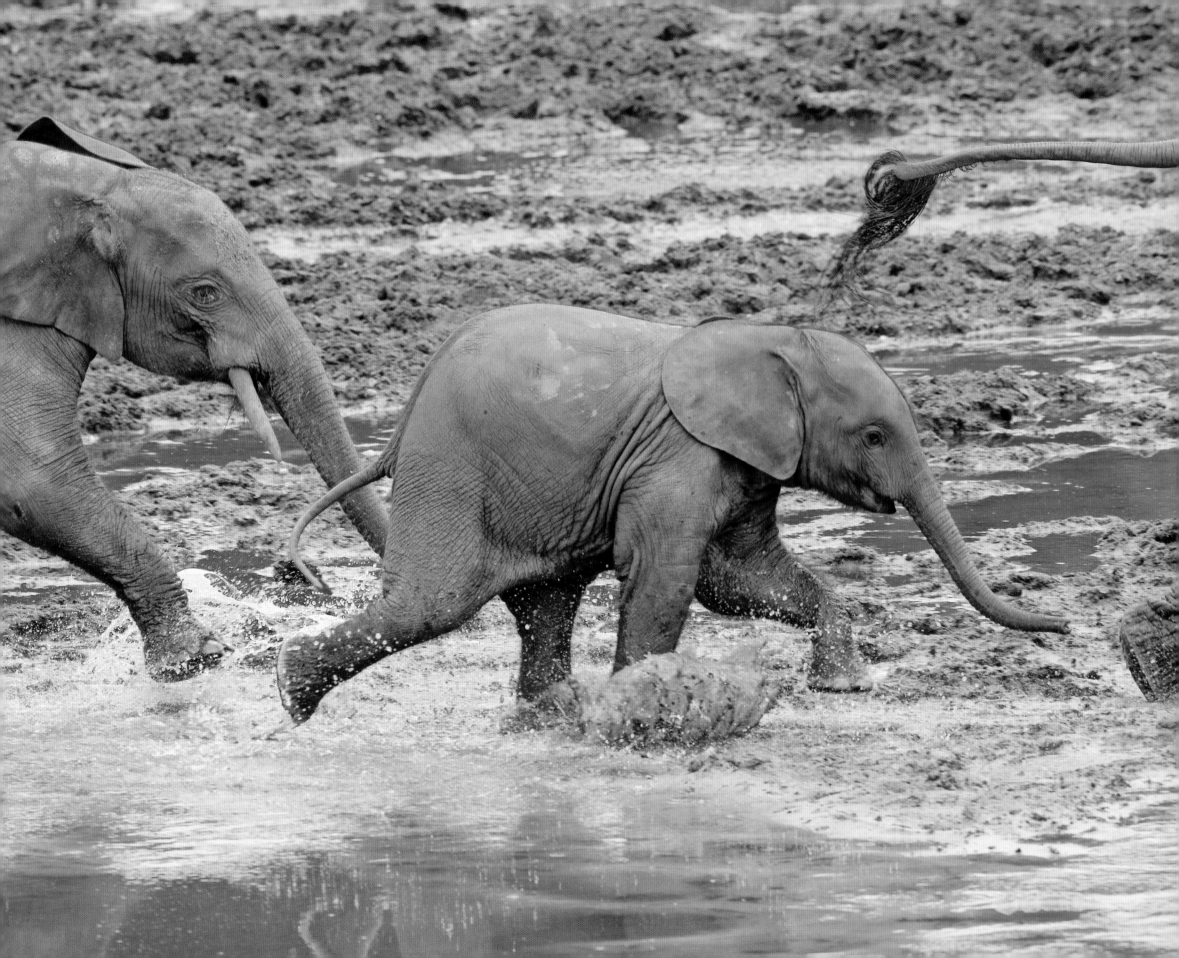

"We met for the first time almost a century ago in my nursery. We shared the same bed for many years, and I never went to sleep without kissing your trunk and then holding you tightly in my arms, until the day came when my mother took you away, telling me, with a certain absence of logic, that I was a big boy now and therefore could no longer have an elephant for a pet. Psychologists will no doubt say that my 'fixation' on elephants goes back to that painful moment of separation, and that my longing for your company is actually a nostalgia for my long gone innocence and childhood. And, indeed, you are precisely that in my eyes: a symbol of purity, a dream of paradise lost, a yearning for the impossible, of man and beast living peacefully together."

ROMAIN GARY
"Dear Elephant, Sir," *LIFE magazine*, December 22, 1967

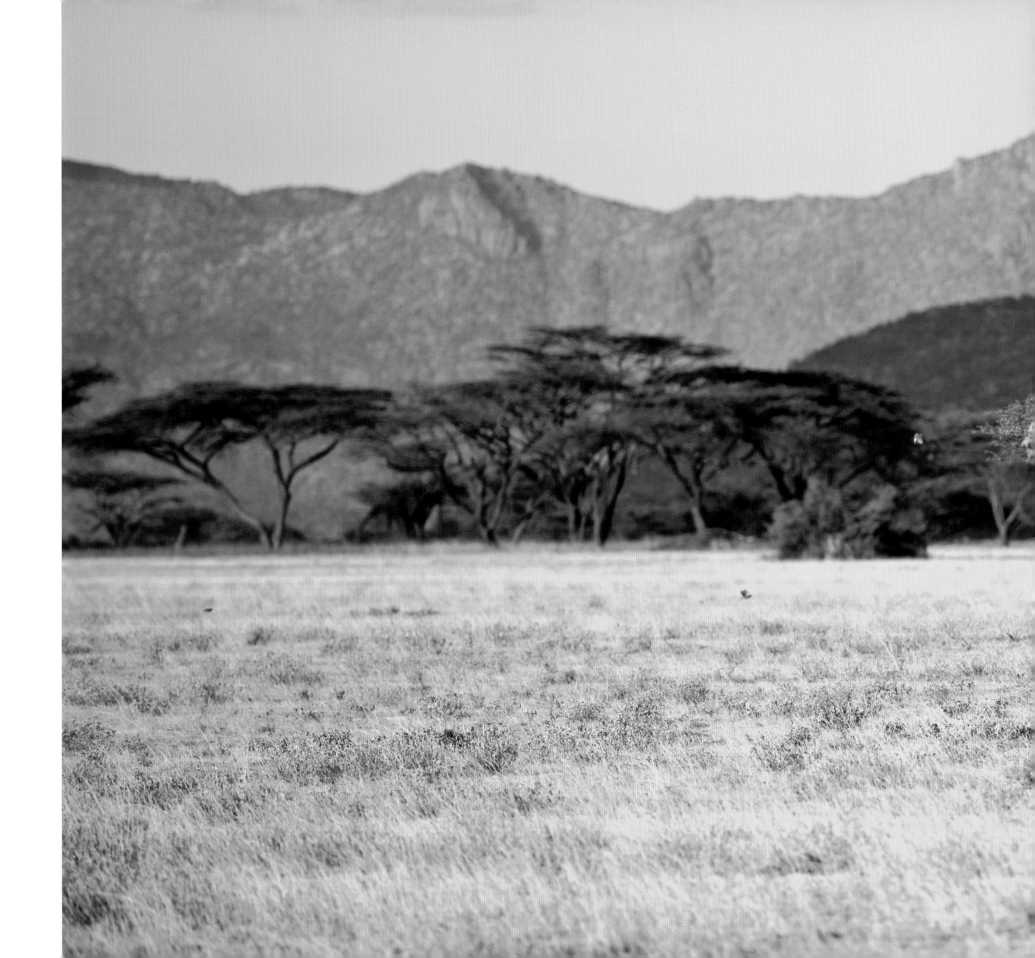

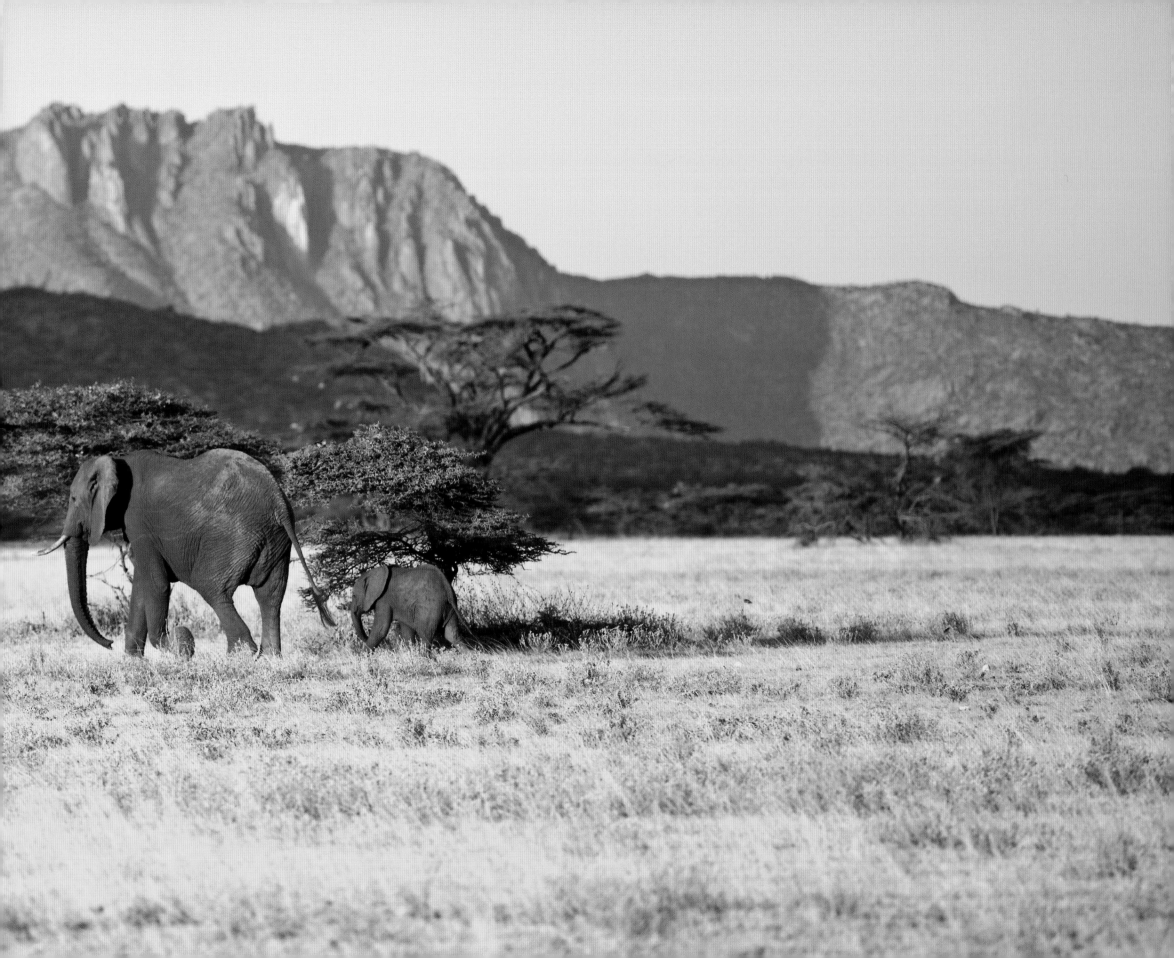

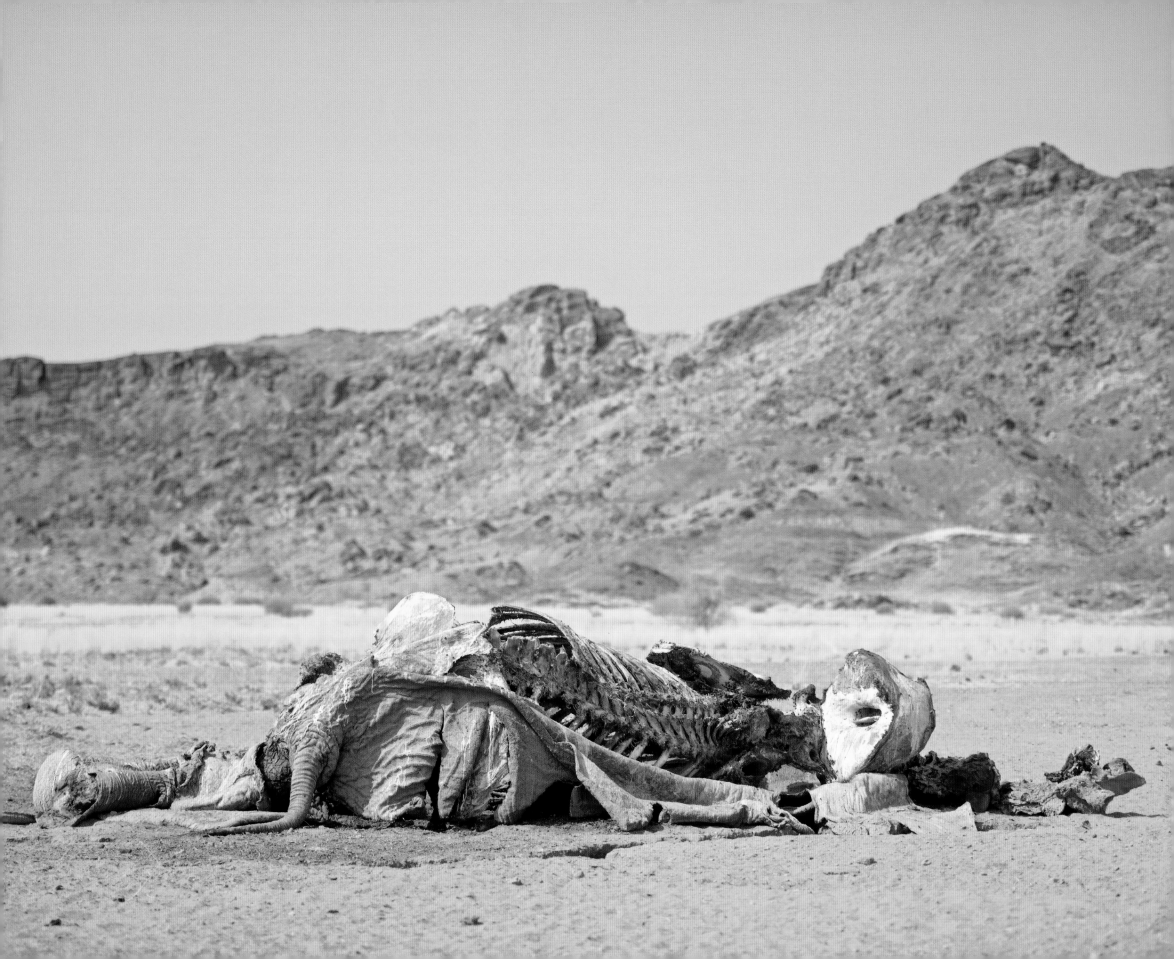

EXTINCTION

Around the world, a grave situation is slowly taking place that few humans are aware of, let alone care about. Every single minute of every single day, the human population grows by 140 people, or over 200,000 people per day. Given that earth has a finite amount of habitable space on it for humans to build shelters and grow food, the addition of each new human means less habitable land for the wild plants and animals who were here first. In no other place on earth is this tradeoff more acute than on the continent of Africa. In the year 2015 alone, Africa's population grew by 30 million. By the year 2050, the annual increase is expected to exceed 42 million, or 80 additional people every minute.

Outside of Africa, humanity, for the most part, still clings to dated images seen in movies and television of an Africa teeming with wildlife. The decline in almost every species you can name began well before these romantic images were recorded. It's the rate of decline in recent years that has finally raised worldwide concern. As studies by the likes of the Zoological Society of London, the University of Cambridge and the World Wildlife Fund have determined, from 1970 to 2005, African wildlife reserves lost roughly 60% of their large animals and signaled concerns for the future of wildlife on the continent. Further, it was determined that most wildlife would be confined to isolated pockets of land, surrounded by human settlements and dependent on international efforts for protection. Worst hit by the mass extermination

was West Africa, where up to 85% of wildlife has been lost. And even East Africa, long a mecca for wildlife conservation, has lost roughly 50% of all wildlife.

While roughly 90% of Africa's elephants have been killed off over the past 100 years, the statistics of other iconic African wildlife species are suffering a similar fate. The root causes of the decline for most of them are the same: loss of habitat due to human encroachment, hunting, poaching, traditional medicine and retaliation for conflicts with humans. A list of Africa's iconic animals joining elephants in decline follows.

ADDAX ANTELOPE: A population decline of over 80% since 1960. Today there are less than 300 alive.

AFRICAN WILD DOG: A population decline of over 95% since 1990, from 600,000 to 4,000 today. One hundred years ago, packs numbering 100 were commonly reported. Today, the average pack is ten in number.

AFRICAN PENGUIN: A population decline of over 90% since 1910 – from 1.5 million to 55,000 today.

AFRICAN LION: A population decline of 95% since 1960. In 1900 they numbered one million, by 1950 there were 450,000, and today there are less than 20,000.

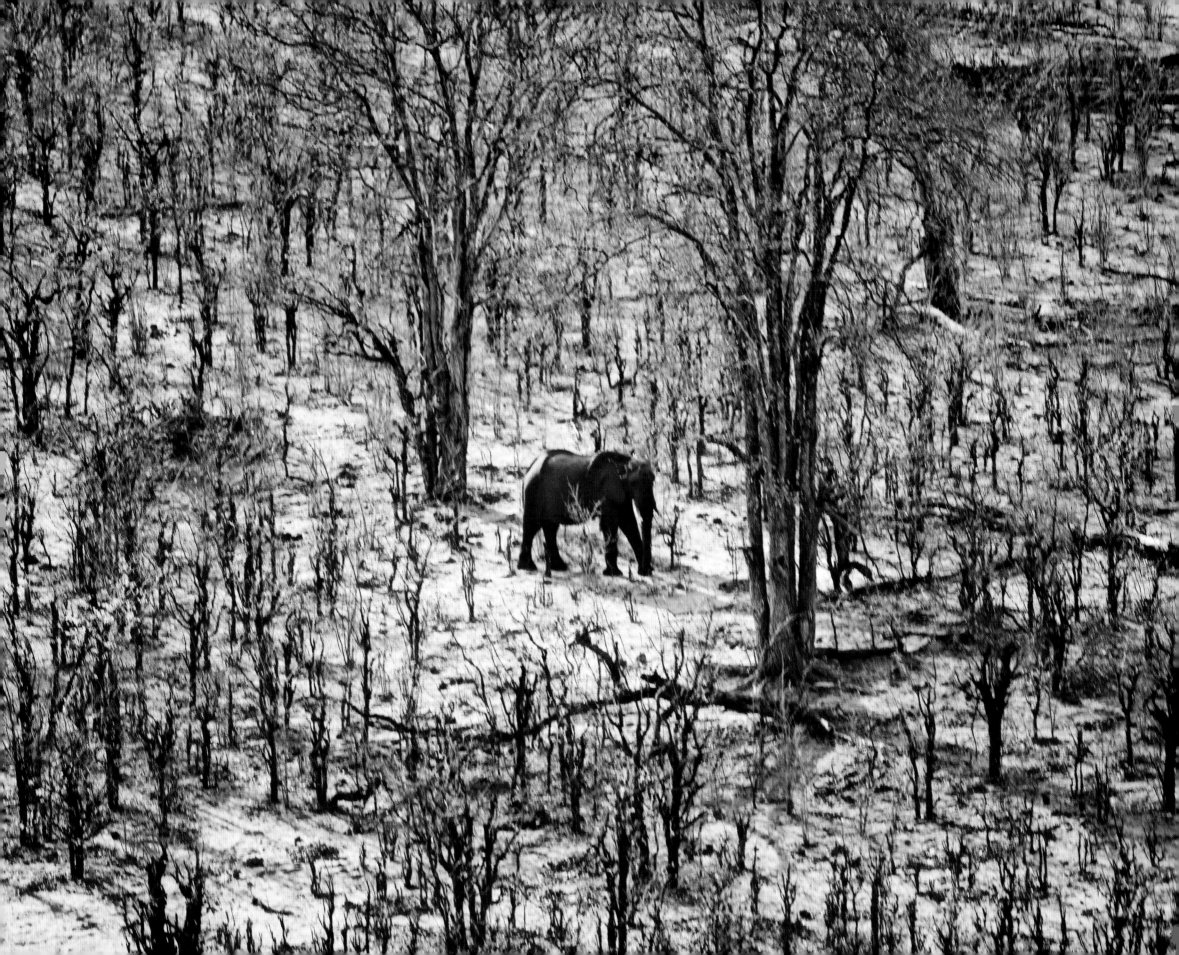

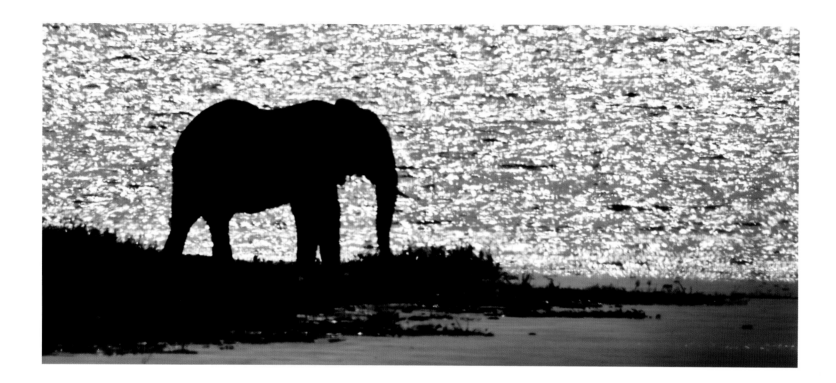

AFRICAN VULTURE: A population decline of 62% since 1985.

BLACK RHINO: A population decline of 90% since 1970. Once numbering over 100,000, today there are less than 2,800.

CHEETAH: A population decline of over 90%. In 1900, they numbered 100,000, today there are approximately 7,000. They have been pushed out of 90% of their former habitats in addition to sizeable declines in their prey populations.

GREVY'S ZEBRA: A population decline of 50% since the 1980s.

GIRAFFES: A population decline of 40% since 1980. At that time numbering 160,000, today numbering 97,000.

HIPPOS: A population decline of 20% since 2000. Today, 135,000 survive.

WESTERN LOWLAND GORILLA: A population decline of 60% since 1990.

The preceding numbers speak for themselves. Extinction speaks for itself. And above all, the unbridled human population growth speaks for itself. In our lifetimes, these destructive changes play out every day in Africa while memories of safaris and romantic documentaries carry our attention away to that paradise on earth where wildlife once was so abundant and life itself was far more peaceful. After all, this was the birthplace of life on earth as we know it. This is the place we've romanticized throughout our lives for so many generations. Long before humans came along, this was the home of the mighty gentle giant: the elephant.

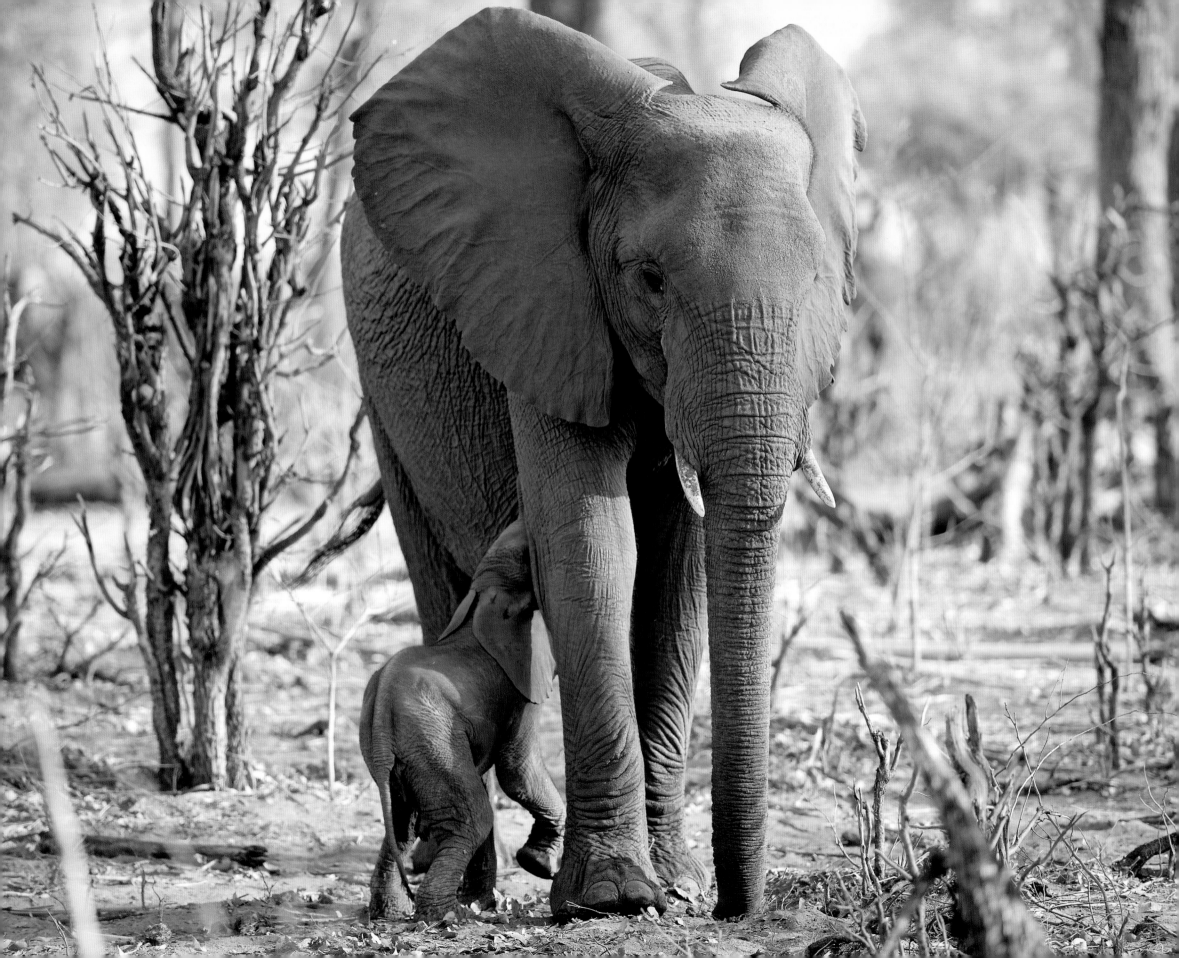

HOW YOU CAN HELP

The following organizations and roughly 20 others exist in full or in part to save the remaining elephants of Africa. I encourage you to support as many as you can in their efforts. Please feel free to contact me through my website **www.larrylavertywildlife.com** for a list of additional respected organizations.

AFRICAN PARKS
www.africanparks.org

This important organization pioneered a new and highly successful type of wildlife conservation. Founded in 2000 and now based in South Africa, their approach is to take full responsibility for the rehabilitation and long-term management of derelict parks. To date they have turned around 15 parks and reserves throughout Africa by amassing the continent's largest anti-poaching force, developing community involvement, improving infrastructure and cultivating tourism.

AMBOSELI TRUST FOR ELEPHANTS
www.elephanttrust.org

Founded by scientist Cynthia Moss in 1972, this organization represents the longest running study of elephants ever undertaken. Their contribution to the knowledge of elephants and elephant families is monumental. In addition to their research, Cynthia and her staff have great influence on community outreach, ecosystem security patrols for elephants and international advocacy.

BIG LIFE FOUNDATION
www.biglife.org

This organization was co-founded in 2010 by photographer Nick Brandt, conservationist Richard Bonham and entrepreneur Tom Hill. They have assumed the protection of over 1.6 million acres of land in the south of Kenya and the north of Tanzania, utilizing a force of 300 rangers deployed to over 30 outposts for the protection of wildlife, especially elephants. Working in cooperation with government authorities, they have affected the arrest of countless poachers and removed a staggering number of wildlife snares. Elephant poaching in their areas of operation has been reduced to near nothing.

CHENGETA WILDLIFE
www.chengetawildlife.org

Founded in 2014 by Rory Young and Lisa Groeneweg, the group operates to train local communities in wildlife protection, along with promoting community development that embraces the welfare of elephants. While they operate throughout the continent, their focus has been in saving the remaining few hundred desert-adapted elephants who live in war-torn Mali.

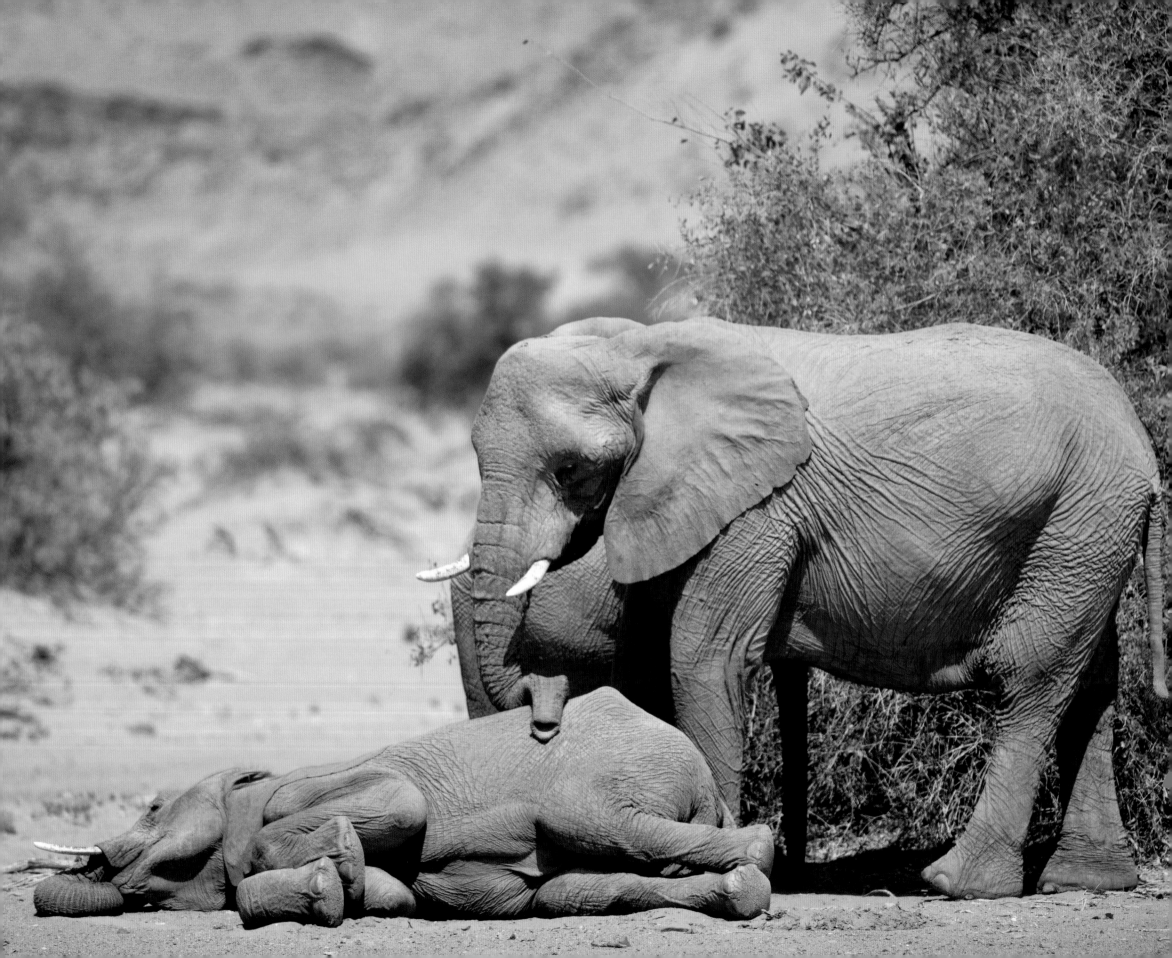

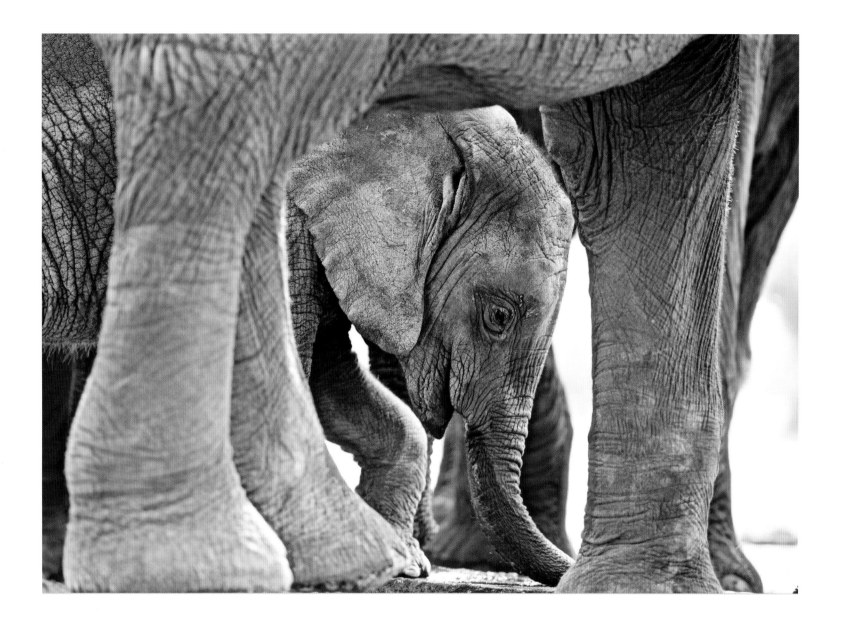

ELEPHANT HUMAN RELATIONS AID
www.desertelephant.org

The desert-adapted elephants of Namibia are a small, fragile population of elephants. Founded by Johannes Haasbroek in 2003, this unique operation is constantly working towards a long-term solution that will enable the elephants and local tribesmen to coexist. They participate in monitoring, community development and advocacy.

ELEPHANTS WITHOUT BORDERS
www.elephantswithoutborders.org

This very capable organization performs research and governmental advisory for elephants living in the ecosystem embracing the shared borders of Botswana, Namibia, Zambia and Zimbabwe. Founded by Mike Chase in 2004, they also work with local communities and led the Great Elephant Census, a three-year scientific study that involved 90 scientists and provided solid evidence of the dramatic decline of Africa's elephants.

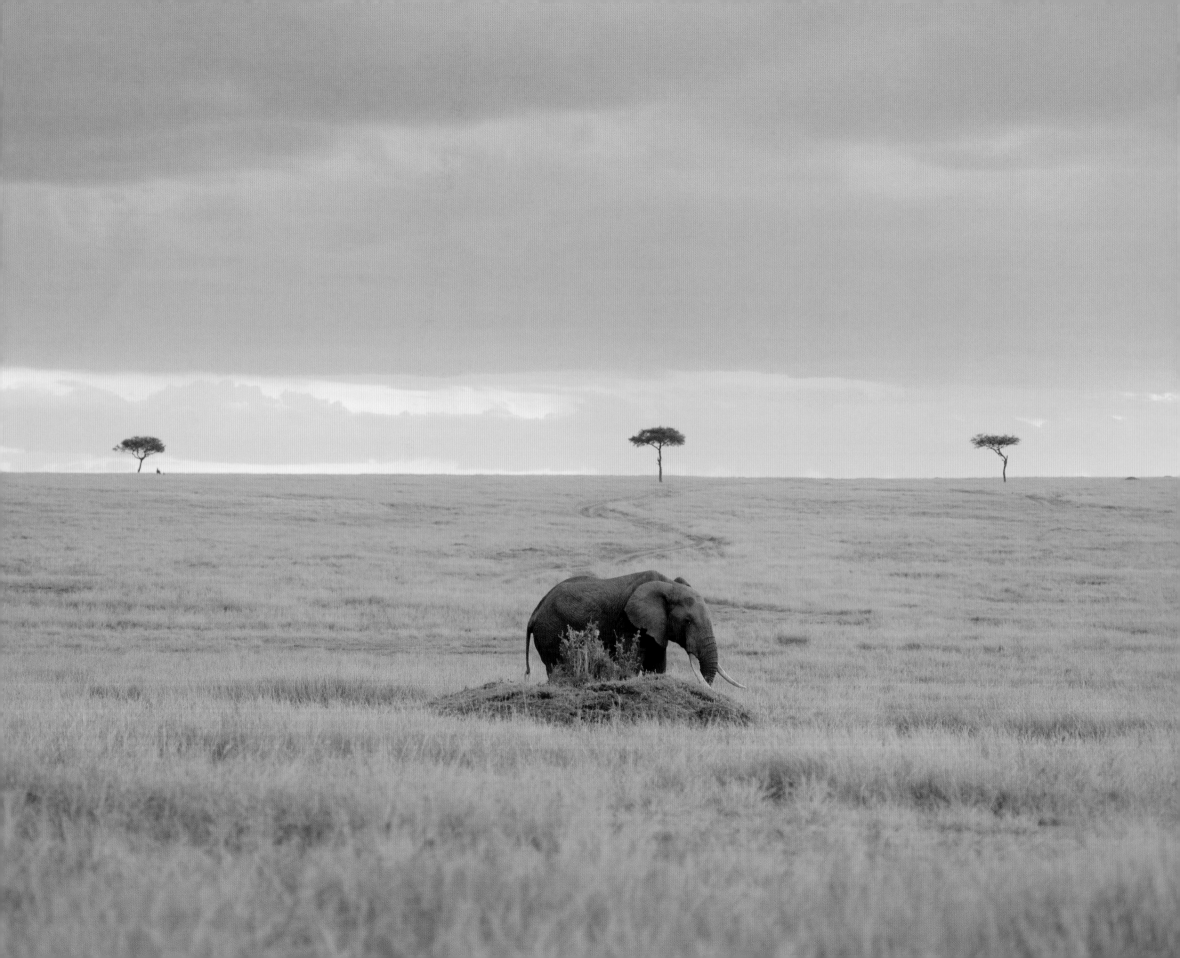

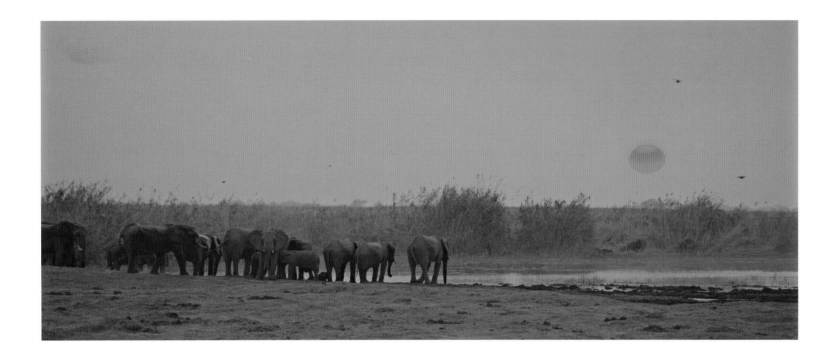

MALI ELEPHANT PROJECT
www.wild.org

Founded in 2007, this effort to save the remaining few hundred desert-adapted elephants of Mali is led by Dr Susan Canney. Community development is the focus in this war-torn area where fortunately there is a tradition of respecting elephants among the locals. As a program of the Wild Foundation, they also influence anti-poaching and local legislation on behalf of elephants.

SOUTHERN TANZANIA ELEPHANT PROGRAM
www.stzelephants.org

Like several now long-standing conservation organizations in Africa, this one began as a research project. Founded by Trevor Jones and Katarzyka Nowak in 2014, the group is now staffed by 23 scientists and locals who continue to research, along with their added duties of community development, elephant protection and advocacy.

SPACE FOR GIANTS
www.spaceforgiants.org

Established in Kenya in 2011 by Dr Max Graham, this international conservation organization is engaged in wildlife protection and community development with a focus on elephants. Dr Graham had previously spent ten years in elephant studies through the University of Cambridge.

TSAVO TRUST
www.tsavotrust.org

This field-based conservation organization was formed in 2013 by conservationists Richard Moller and Stuart Herd. Their purpose is to monitor elephants with their security in mind, throughout the greater Tsavo ecosystem. They are also involved in community building, along with a joint effort with Save the Elephants to keep a watchful eye on some of the last remaining tuskers on the continent.

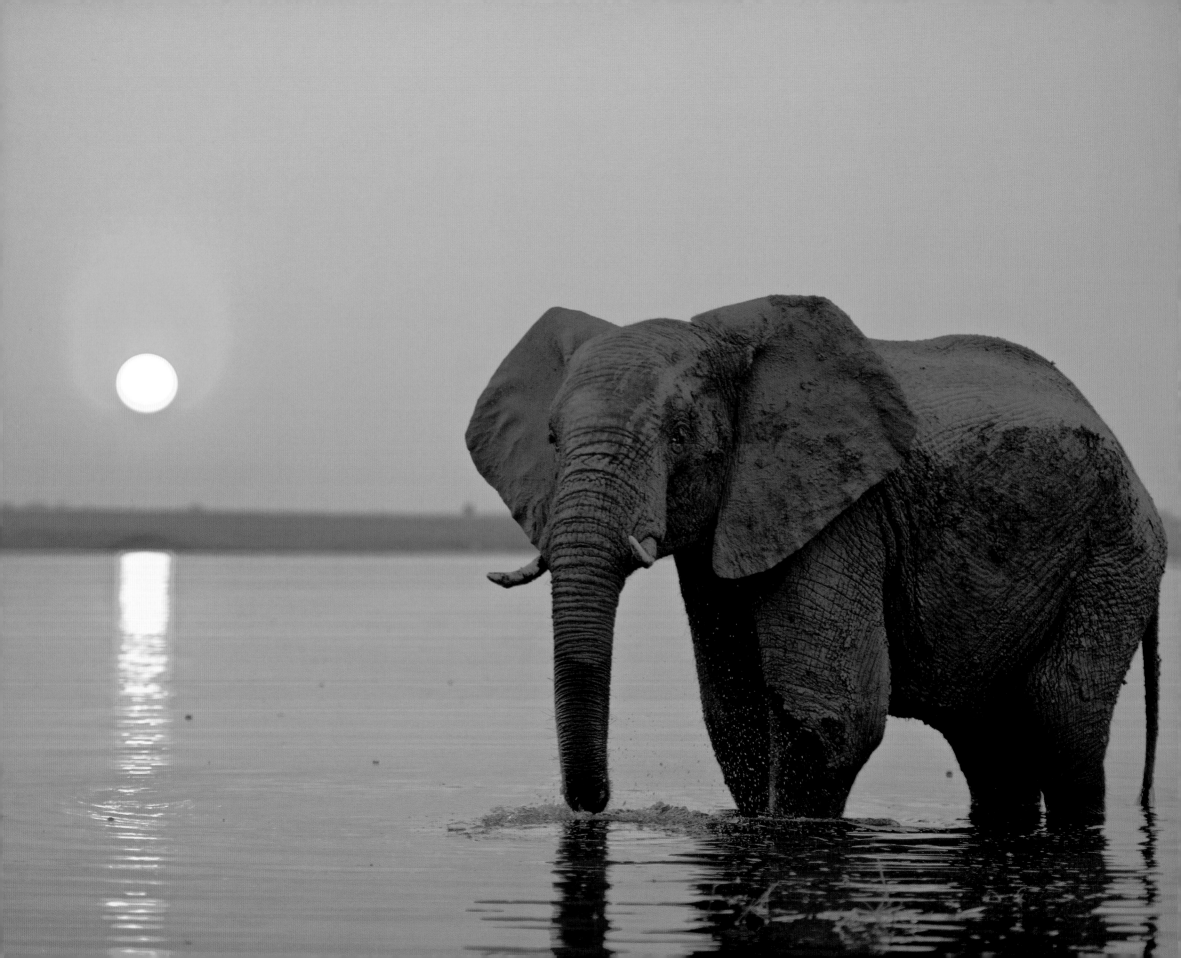

REFERENCES

Alexander, Shana. 2000. *The Astonishing Elephant*. New York: Random House.

Anthony, Lawrence, and Graham Spence. 2009. *The Elephant Whisperer*. New York: St. Martin's Press.

Beard, Peter. 1988. *The End of the Game*. San Francisco: Chronicle Books.

Brown, Robin. 2008. *Blood Ivory: The Massacre of the African Elephant*. England: The History Press.

Chadwick, Douglas H. 1992. *The Fate of the Elephant*. San Francisco: Sierra Club Books.

Douglas-Hamilton, Iain, and Oria Douglas-Hamilton. 1975. *Among the Elephants*. New York: Viking Press.

Dugard, Martin. 2003. *Into Africa: The Epic Adventures of Stanley & Livingstone*. New York: Doubleday, A Division of Random House

Eltringham, S.K. 1962. *Elephants*. England: Blandford Press.

Groning, Karl, and Martin Saller. 1999. *Elephants: A Cultural and Natural History*. Germany: Konemann Verlagsgesellschaft.

Haynes, Gary. 1991. *Mammoths, Mastodons, and Elephants*. England: Cambridge University Press.

Herne, Brian. 1999. *White Hunters: The Golden Age of African Safaris*. New York: Henry Holt.

Leakey, Richard, and Virginia Morell. 2001. *Wildlife Wars: My Fight to Save Africa's Natural Treasures*. New York: St. Martin's Press.

Meredith, Martin. 2001. *Africa's Elephant: A Biography*. London: Hodder & Stroughton.

Moss Cynthia. 1988. *Elephant Memories: Thirteen Years in the Life of an Elephant Family*. Chicago: University of Chicago Press.

O'Connell, Caitlin. 2007. *The Elephant's Secret Sense: The Hidden Life of the Wild Herds Of Africa*. New York: Free Press.

Owens, Delia, and Mark Owens. 1992. *The Eye of the Elephant*. Boston: Houghton Mifflin.

Payne, Katy. 1998. *Silent Thunder: In the Presence of Elephants*. New York: Simon and Schuster.

Poole, Joyce. 1996. *Coming of Age With Elephants: A Memoir*. New York: Hyperion.

Rich, Tracey, and Andy Rouse. 2004. *Elephants*. England: Evans Mitchell Books.

Sanchez-Arino, Tony. 2016. *Africa's Greatest Tuskers*. Long Beach, CA: Safari Press.

Sheldrick, Dame Daphne. 2012. *Love, Life, and Elephants: An African Love Story*. New York: Picador.

Shoshani, Jeheskel. 1992. *Elephants: Majestic Creatures of the Wild*. Sydney: Rodale Press.

Simmons, Pete. 1987. "Save the Elephants." *ABC's 20/20*. 12 Mar 1987. Television.

Turner, Myles. 1988. *My Serengeti Years: The Memoirs of an African Game Warden*. New York: W.W. Norton & Co.

AUTHOR BIOGRAPHY

Following a 30-year career as a Hollywood actor, Larry got down to business as a professional photographer. This change of priorities was the culmination of a lifelong concern for the environment and wildlife conservation. His dedication to elephants grew out of a rapidly growing understanding of their gentle nature and of mankind's unforgiveable crimes against them. *Power and Majesty* is the crest and combination of his longtime passions for photography and writing. He began taking photos at the age of five and writing as a columnist for his middle school newspaper at age 12. At about the same time, he joined the Audubon Society and the Sierra Club. Later, he wrote as a columnist for an Oakland, California newspaper. Larry holds a B.S. degree in Finance and a B.A. degree in Political Science. In his spare time, he continues his passion for mountain climbing begun as a teenager at the Yosemite Mountaineering School. He supports the work of conservation organizations in Africa through their use of his photographs and ongoing financial contributions. Larry makes his home in Oakland, California and religiously takes annual pilgrimages to Yellowstone Country and to Africa to be with his beloved elephants.